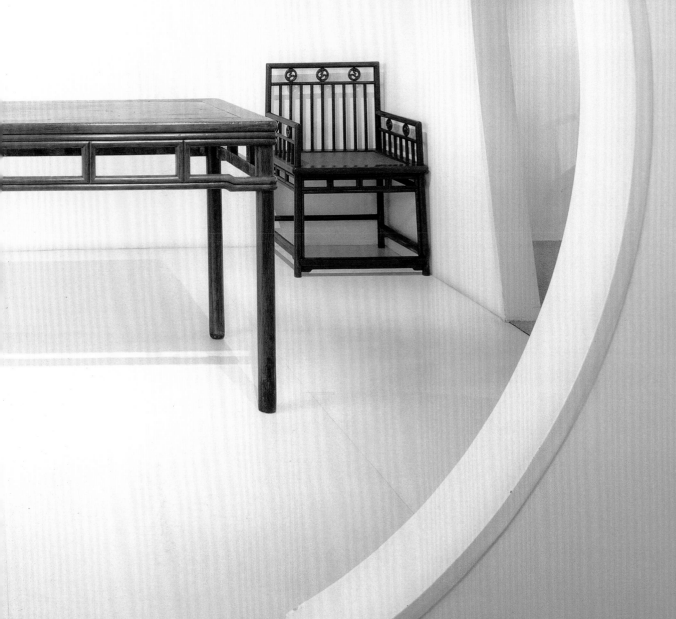

CHINA STYLE

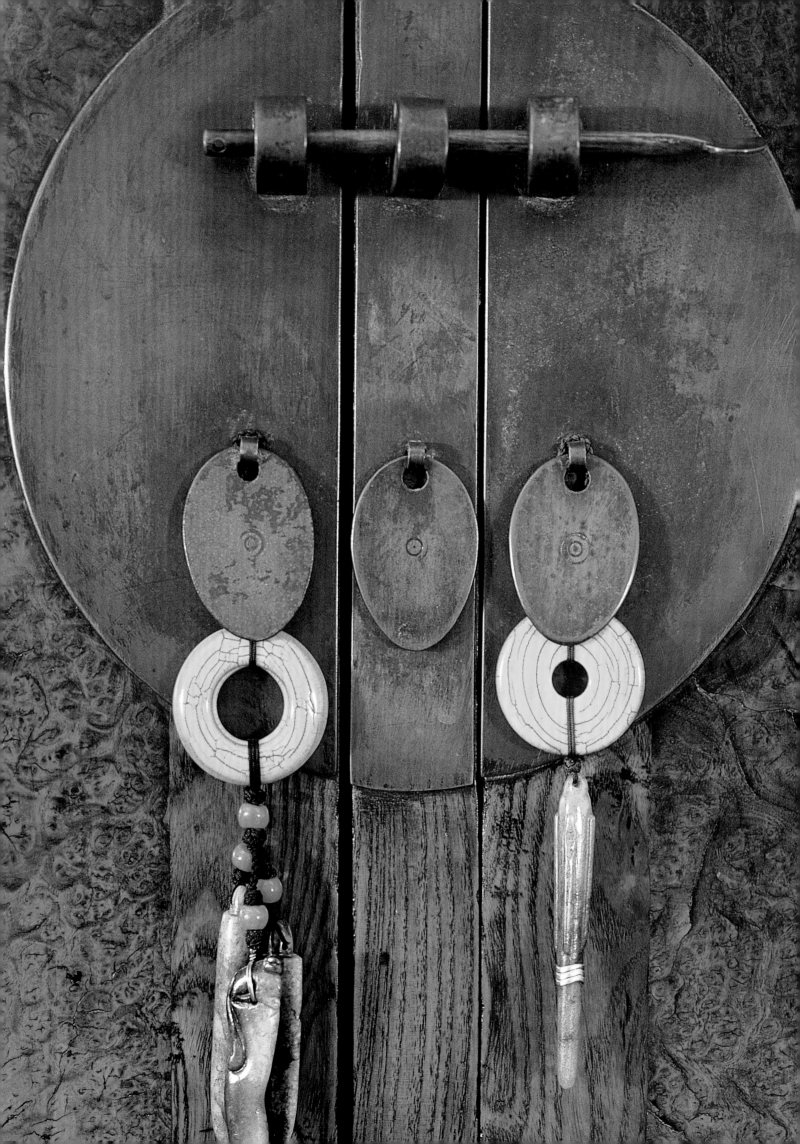

CHINA STYLE

by Sharon Leece
photos by Michael Freeman

PERIPLUS

Published by Periplus Editions (HK) Ltd

Copyright © 2002 Periplus Editions
Text © 2002 Sharon Leece
Photos © 2002 Michael Freeman

ISBN 962-593-457-X

Printed in Singapore

Editor: Kim Inglis
Designer: Mark Davis

Distributed by:

North America, Latin America and Europe
Tuttle Publishing, 364 Innovation Drive,
North Clarendon,VT 05759-9436, USA
Tel (802) 773 8930; fax (802) 773 6993
Email: info@tuttlepublishing.com

Asia Pacific
Berkeley Books Pte Ltd, 130 Joo Seng Road
#06-01/03, Singapore 368357, Singapore
Tel (65) 6280 3320; fax (65) 6280 6290
Email: inquiries@periplus.com.sg

Japan
Tuttle Publishing, Yaekari Building, 3rd Floor
5-4-12 Osaki, Shinagawa-ku
Tokyo 141-0032, Japan
Tel (813) 5437 0171; fax (813) 5437 0755
Email: tuttle-sales@gol.com

08 07 06 05 04 03
8 7 6 5 4 3

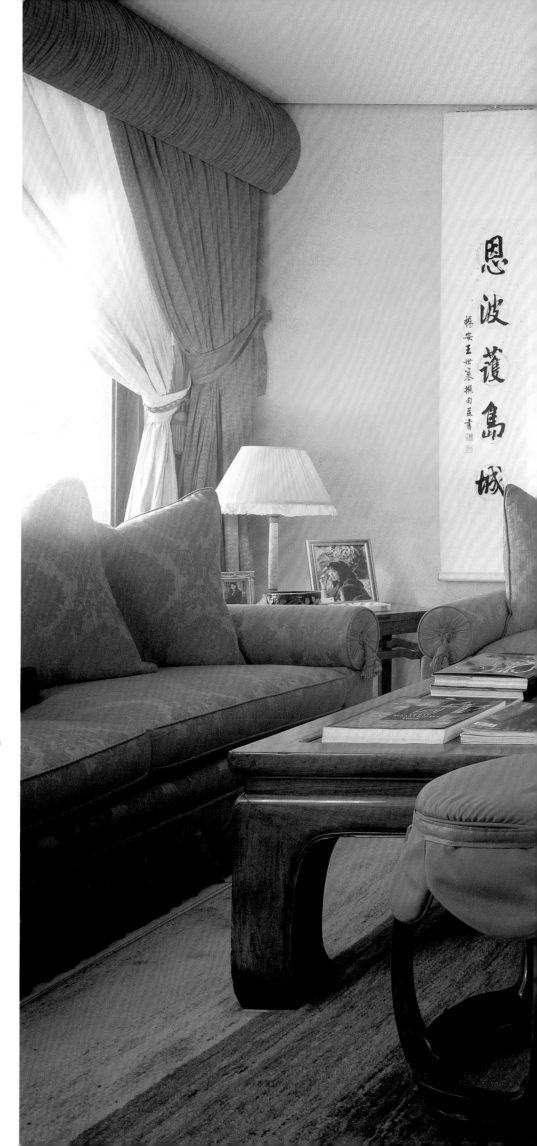

(Page 1)
Ming furniture dealer Grace Wu Bruce has
chosen a stark, all-white palette in her Hong
Kong gallery. Visitors pass through a modern
interpretation of a moongate into the serene
space which shows off the antique furniture's
fine architectural proportions.

(Previous page)
Traditional implements used for unpicking
sack stitching are reincarnated as cabinet
door decorations in collector Kai-Yin Lo's
Hong Kong apartment.

(Right)
In the comfortable living room of Grace
Wu Bruce's Hong Kong home, a pair of
calligraphy hangings by Wang Shixiang
flanks a scroll painting by well-known Hong
Kong artist, Harold Wong. The table is a
late Ming day bed; in foreground are a pair
of drum stools.

(Overleaf)
The living room in furniture dealer Jean-
Philippe Weber's house contains a cane-
topped table with a white leather Qing
dynasty hatbox from Beijing and a collection
of opium pipes made of turtleshell and ivory.
The black lacquer cabinet is from Beijing,
early 19th century. On the rear wall is a
colourful oil painting by artist Pang Yong Jie.

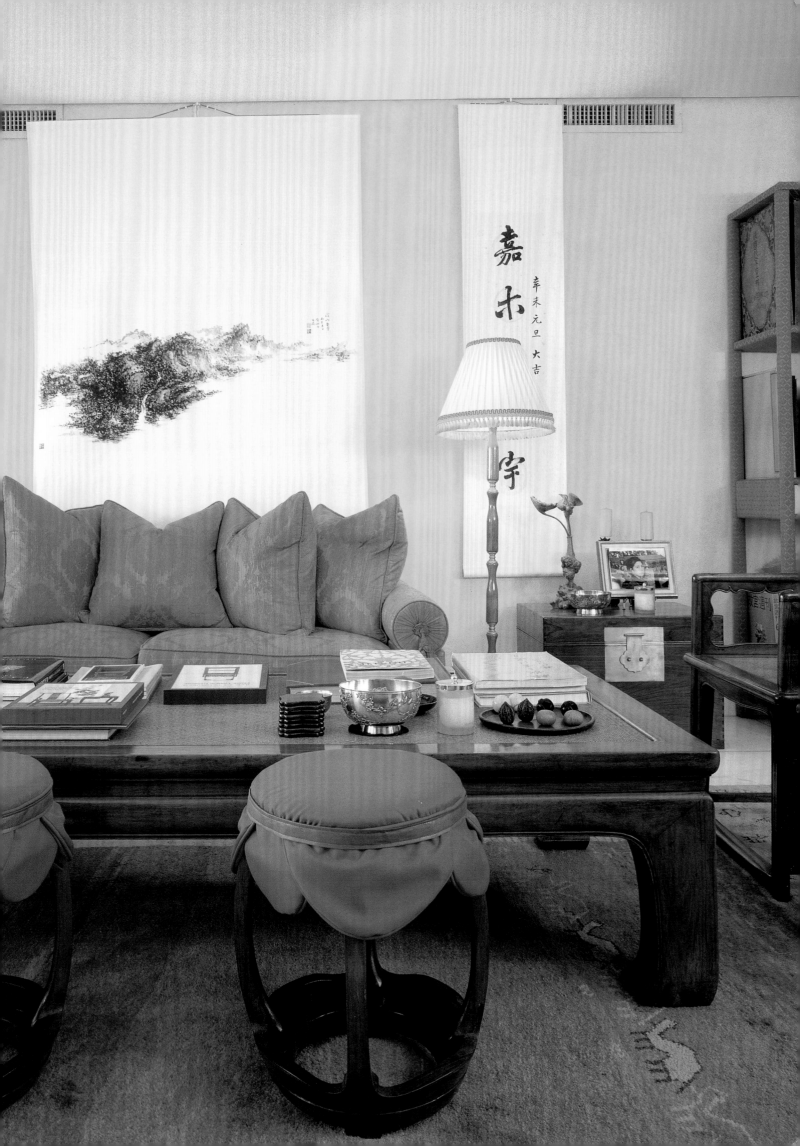

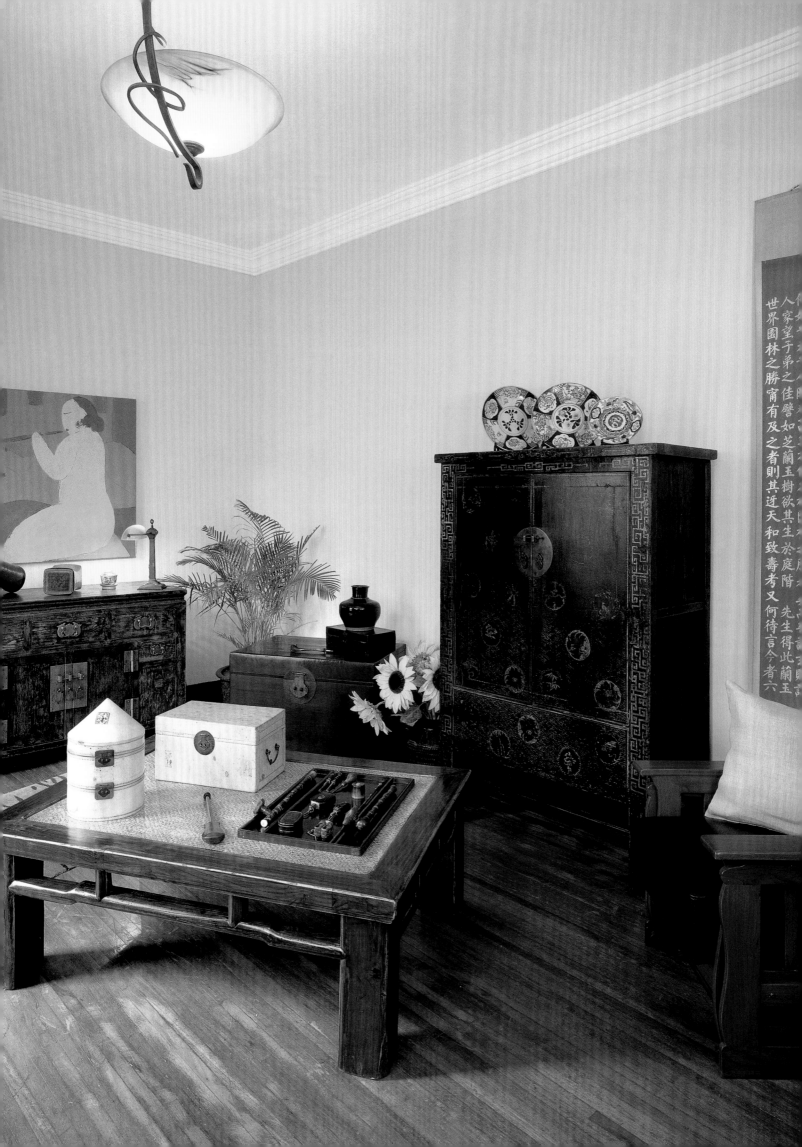

CONTENTS

China Style
Goes Global

Chinese style is most often associated with ornate carvings, complex patterns and a searing palette of rich reds and glitzy golds. But what is often overlooked is that there is a deep-rooted modernity inherent in Chinese design—an age-old classicism with a sense of balance, order and harmony that appeals to the most modern of minimalists.

With the current global preoccupation with Asian style—from food to interior design to philosophy—it was only a matter of time before attention came to rest on the Chinese aesthetic. Since the opening up of post-Cultural Revolution China in the late 1970s, the country has changed beyond measure. Today, 21st-century China is firmly focused on the race to become a major world player and, in architectural terms, much has been—and is being—destroyed. Traditional dwellings are being replaced with gleaming banks of skyscrapers, but within this cacophony of change, there is a growing band of designers who prefer to look to their roots to find valid decorative directions for the future.

Such designers, many of whom have studied overseas, are blending an international outlook with a pride in their Chinese heritage to produce a new vocabulary of design. Tending to steer away from the ornate, opulent approach, they are basing their ideas on a new kind of Chinese-influenced modernism, which incorporates balanced lines, natural textures and muted colours.

This restrained approach is not entirely a new one. The Chinese philosophy-cum-religion of Confucianism (551–479 BC) taught that propriety and ritual are the key to social order. Slightly earlier, Taoism, advocated by the Chinese scholar Lao-Tse (604–531 BC) stressed the importance of a simple existence and the need to live in harmony with nature and the world. As the pace of modern life gains tempo, more and more city dwellers—both in China and around the world—are finding that such classical serenity fits neatly into contemporary living.

In today's interiors, space and light are key. We want comfortable, relaxed spaces that feel as good as they look. This may account for the current international preoccupation with feng shui, an ancient Chinese practise that focuses on achieving the perfect balance. Feng (meaning wind) and shui (water) emphasizes living in harmony with your environment to enable energy (chi) to work for you to promote well-being and good fortune. In the East, feng shui is an integral part of life practised by all, from the most powerful tycoon to the regular person on the street. Whilst it is an ancient art, many of its precepts are based on simple common sense: an uncluttered home is likely to leave you calmer and more productive; light interiors are good for the soul; and water features and plants in the home reflect our basic desire to live in conjunction with the natural world.

With such a rich history and culture that goes back thousands of years, China provides a vast bank of references to draw on. And we can merely touch the surface of a few within this book. In the Han dynasty (206 BC–220 AD) architecture was an accomplished art; under the Tang dynasty (618–907 AD), literature, painting, ceramics, lacquer and metalwork flourished. The Ming dynasty (1368–1644) is known for its fine porcelains and furniture, for its sophisticated society dominated by literati and prosperous merchants. By the time of the final Qing dynasty (1644–1911), more ornate, colourful works were embraced and Chinese objects and themes had a lasting influence on European architecture and décor.

But it's not just interior designers who are currently focusing on Chinese history. The film industry, too, has brought Chinese style mainstream. Take Ang Lee's

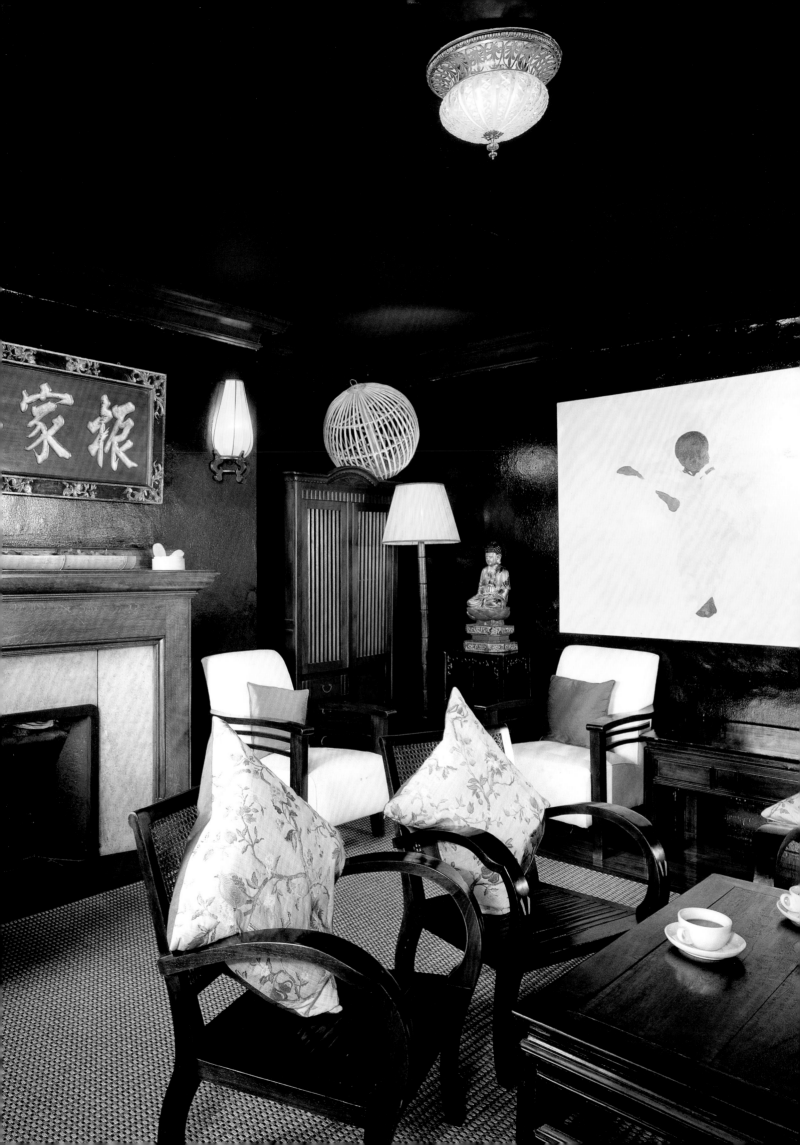

Chinese calligraphy, carved woods, latticework, lacquer and open fireplaces define the series of intimate lounges and dining room which make up BAM-BOU restaurant (left) in London's Fitzrovia. Vietnam and China have interwoven histories and today the ethnic-Chinese (Hoa) constitute the largest single minority group in Vietnam. It is common to find Chinese temples and homes that once belonged to rich mandarins still intact across the country today.

Shanghai-based designer Wan Pierce produces soft furnishings inspired by Chinese motifs for her label Zayu. This cashmere cushion panel (right) with dragon design was produced by Han craftspersons, using traditional methods of embroidery.

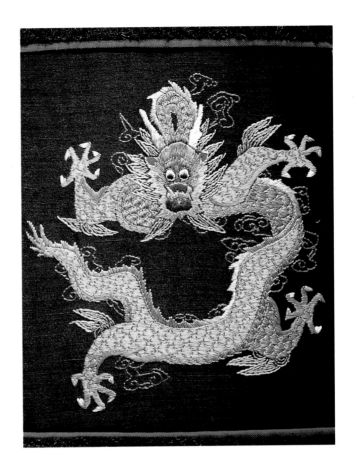

multi Oscar-winning movie, *Crouching Tiger, Hidden Dragon*, starring Michelle Yeoh and Chow Yun-Fat, or Zhang Yimou's earlier *Raise the Red Lantern*, starring actress Gong Li. Both did much to bring the richness and enduring appeal of traditional Chinese design and architecture to the fore in the eyes of the world.

Today, classic hardwood furniture, ranging from ultra-minimal to elegantly ornate, is one of the most instantly recognizable examples of Chinese design; some of it is so modern-looking that it could have been designed today. Among collectors, interest in such furniture is at an all-time high, spurred on by auction house Christie's record-breaking New York sale from California's Museum of Classical Chinese Furniture in 1996. It totalled over US$11 million and until this sale, experts agree, Ming dynasty furniture was perhaps the best-kept secret in the world of Chinese arts. Today, Ming furniture is increasingly rare—and prices are correspondingly high.

Most Ming pieces feature clean, Bauhaus-like lines and have a system of assembly that rely solely on joinery without the use of nails. At this time, the proportional harmony of the furniture often paralleled that of classical architecture and experts agree that the preference for an exposed frame—whether it supported the roof of a reception hall or a corner leg—was shared by carpenter and cabinet-maker alike. As Robert D Jacobsen, Curator of Asian Art at the Minneapolis Institute of Arts, points out: "The reliance on wood to provide both structure and decoration, the respect for natural materials and the evolution of efficient designs apparent in classic furniture are deeply rooted in the architectural tradition." As time went by, furniture veered towards the ornate, becoming bolder during the Qing dynasty, and reaching its height in the mid-18th century when detailed carvings, bright lacquering and inlay became common.

In addition to its aesthetic appeal, furniture provides a direct insight into how people lived hundreds of years ago. It also indicates status and rank as classical furniture, for the most part, was made for the social elite, being refined in construction, finishing and decoration and conforming to aristocratic standards of elegance and craftsmanship. As the culture evolved from floor-level to chair-level seating in the late Tang period, a huge variation of furniture was produced on which people would dine, learn, work and sleep. There were cabinets, tables, day beds, clothes racks, folding stools, screens and chairs; many of these items remain practical, versatile and particularly well suited to contemporary living. Furniture designers today have picked up on such characteristics and are producing collections based on minimal lines with an Oriental feel. Low-level seating and multifunctional pieces draw inspiration from ancient traditions and when they are reworked using materials such as leather, suede, stainless steel and Perspex, they appeal to modern sensibilities.

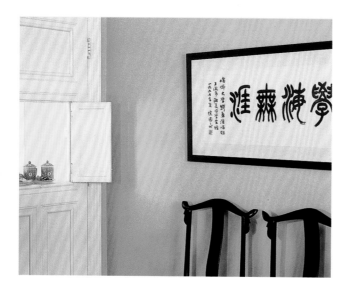

With its high ceilings, spacious rooms and private garden, residences like Jean-Philippe Weber's 1930s-built *longtang* house (right) are fast becoming a popular choice for Shanghai dwellers. After extensive renovations, and a commitment to preserving its original art deco features, Weber's home retains an aura of old Shanghai style. Hanging above a cabinet found in Beijing is a red and gold calligraphy scroll (one of a pair) on which is printed a poem about life. Dangling from the green jar is an old spectacles case.

(Left) A serving hatch leads to the kitchen area in David Orenstein's apartment in King Alberts Apartments, Shanghai.

The same applies to sumptuous silks, elegant ceramics and glossy lacquerware. Such rich colours, patterns and textures were last embraced on a major scale outside China in 18th-century Europe when the East India trading companies imported these wares to the West and houses were filled with blue and white Ming porcelains, textiles and delicate teaware. European craftsmen soon caught on and imitated Orientalism as they saw it with exotic motifs of pagodas, scenery, human figures and birds and flowers. Known as the Chinoiserie movement, it is once again experiencing a resurgence in popularity. Modern interpretations of Chinese silks embroidered with dragons, phoenix and flowers now decorate everything from clothes to curtains to bedding.

China has also been at the forefront in the development of world ceramics. Colours and styles are vast—from the Tang dynasty's (618–907 AD) bold multi-coloured pottery (known as *sancai*, or 'three-colour lead glaze') to the Song dynasty's (960–1279 AD) elegant monochrome wares, such ceramics are equally appealing today. There are bold cobalt blues, blood reds, imperial yellows, serene ivories, celadons and duck egg blues, many of which retain a classical elegance that is timeless in its appeal. Other famous ceramics include the Ming dynasty's blue and white porcelain followed by the Qing dynasty's delicate *famille rose*, *famille verte*, *famille noir* and oxblood red *sang de boeuf*. Ceramicists today take their inspiration from such ancient arts, preferring simple colour treatments over complex patterning.

As the following pages show, Chinese decorative elements—furniture, ceramics, textiles, calligraphy, contemporary art, jade and bamboo—are increasingly being incorporated into modern homes. From cool city apartments to retro art deco spaces to elegant, antique-filled interiors, this book shows how Chinese style has been combined with a global decorative vision—in China, across Asia, in Europe and the United States.

Such globalization of style takes many forms: some designers choose to offset a loftlike space—all white walls and industrial finishes—with a few pieces of minimal Ming furniture. Others mix styles and eras with ease, weaving subtle Chinese influences deftly into a contemporary palette. Shanghai, China's most fashionable city, has produced decorative directions that are as unique as its cultural history. An intriguing mix of 1930s art deco mansions, modern skyscrapers and traditional Chinese architecture, Shanghai retains an aura of mystery and decadence. Some residents enjoy living in large art deco 1930s apartments and *longtang* (lane) houses complete with high ceilings and original fittings which provide perfect backdrops to a blend of Chinese and Western art and antiques. Meanwhile, collectors of Ming and Qing furniture around the world enjoy the thrill of living with precious pieces. Some choose a pale backdrop, others employ vivid colours to offset the rich wood pieces. But both exemplify scholarly living 21st-century style, with elegant proportions and beautiful symmetry taking pride of place.

Today, Chinese style has well and truly permeated the Western aesthetic with centuries-old ideas being reworked into valid directions for modern living. It is a movement which is gaining pace as more and more China-based designers and architects are drawing on their heritage to provide viable directions for the future. This book showcases some of the most innovative and inspirational contemporary Chinese-inspired interiors both in the East and West, revealing the huge variety of decorative influences that Chinese style provides.

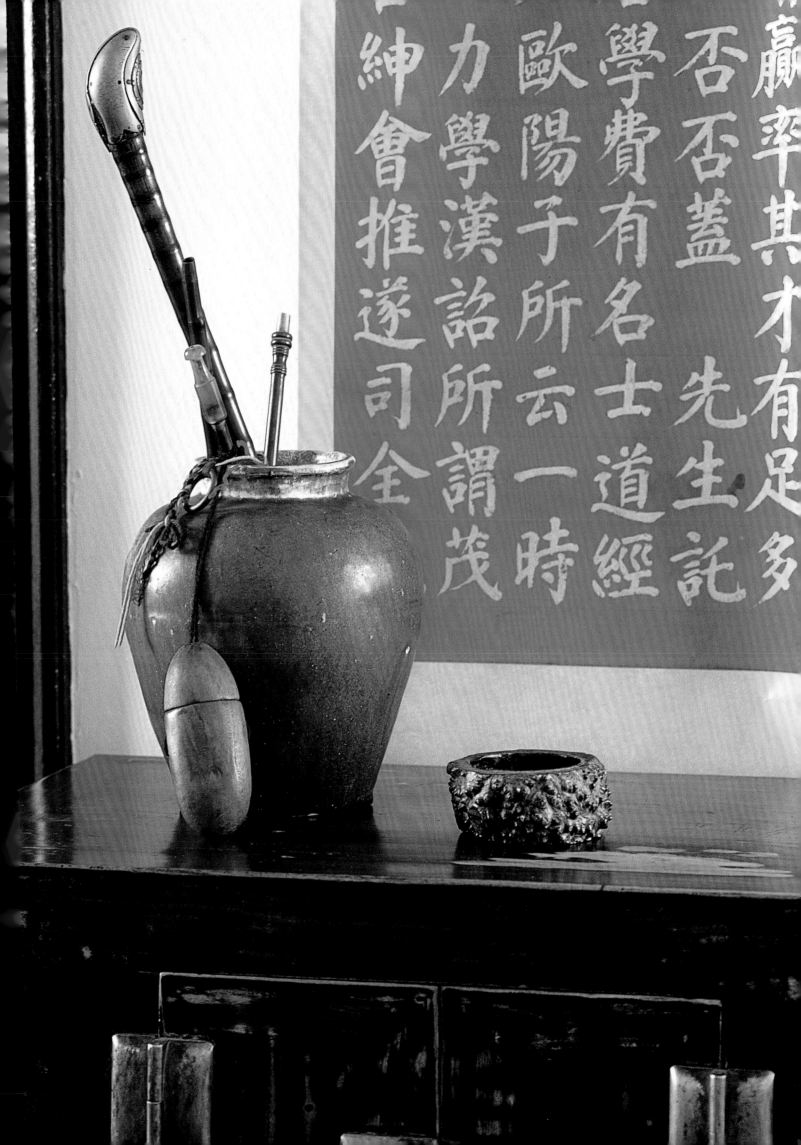

(Right) An antique gold and black painted rice cannister featuring birds, gardens and pagodas stands in the corner of Wan and David Pierce's *lao yang fang* (old style house) in the heart of Shanghai's French Concession district. Such cannisters were made in the same shape as traditional garden furniture stools and can also be used for seating.

In the 1930s Shanghai-inspired China Club in Hong Kong (opposite), the twisting staircase runs up three flights. It is lined with a spectacular collection of contemporary Chinese art by leading painters from the mainland, Hong Kong and Taiwan. The club has over 350 works in its collection, from avant garde post-revolutionary paintings to socialist realist oils.

Hong Kong's contemporary homeware store GOD (the phonetic translation means 'to live better' in Cantonese slang), draws on traditional Chinese and Asian influences (below). Here, a pair of Ming-style chairs are juxtaposed against modern sofas and armchairs.

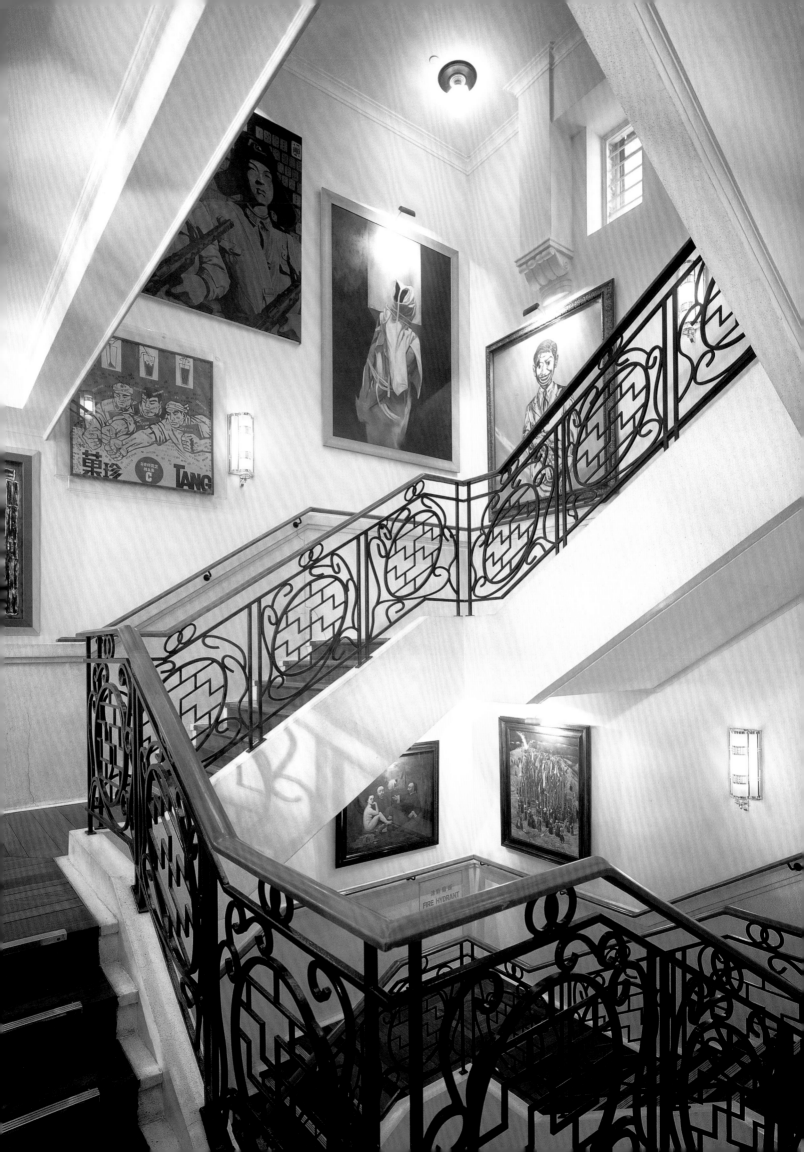

Ming and Qing Elegance Redefined

TRADITIONAL CHINA IN A CONTEMPORY SETTING

Today's fashions increasingly embrace simplicity and purity of line. No wonder, then, that Ming dynasty (1368–1644) furniture is experiencing a resurgence. Produced during what was considered to be the golden age of Chinese furniture, Ming's clean classic lines and architectural elegance are coveted by collectors prepared to pay vast sums for rare, highly grained and intricately constructed pieces. "It is the timelessness of Chinese classical furniture which places it in the forefront of modern tastes," says Hong Kong-based premier Ming dealer Grace Wu Bruce.

But it wasn't always like this. While Ming's famous blue and white porcelain has long been highly valued in China and the West, the almost unbelievable thing about the dynasty's furniture is that it has only been considered collectable during the past few decades. The breakthrough came with a detailed study on Ming furniture published in Beijing in 1986 by the renowned scholar Wang Shixiang, which captured the attention of Chinese collectors.

Before that, Ming furniture had only been recognized by Westerners who lived in Beijing before the 1949 Communist revolution and a small group of connoisseurs in the West. They appreciated its Bauhaus-like lines over the flashier, ornate and heavily carved furniture typical of the Qing dynasty (1644–1911). Although some early Qing pieces feature clean lines, from the mid-Qing period (around 1736), sumptuous carvings, bright lacquering and inlay were common. Splendour and massiveness were the order of the day.

When China's doors closed, the Westerners left and took their furniture with them. Outside China, interest in the genre remained constant. Then came China's economic liberalization in the late 1970s and the market for Ming furniture began to grow dramatically.

Ming furniture's basic structure possesses distinctly classical attributes. Restraint, balance, clarity and grandeur are seen in a system of assembly that relies solely on joinery without the use of nails. Other features are economy of line, lustrous surfaces, and colour and grain of woods such as huanghuali (yellow rosewood), zitan (purple sandalwood) and jichi mu (chicken wing wood).However, Ming is not just aesthetically pleasing to the modern eye: it also provides an understanding of Chinese culture during an affluent era and offers glimpses into the sophisticated lifestyle of the scholar officials and wealthy merchants of the 16th and 17th centuries. Many lived a quietly ordered life, pursuing artistic and intellectual interests. The scholars preferred plain wood furniture to that featuring Chinese decorative techniques, although some examples of the latter are found in this period.

Private collectors around the world enjoy the thrill of living with these special pieces. But as classical hardwood furniture becomes increasingly rare and expensive, more experts are turning to softwood furniture and re-evaluating its position in the domestic environment. Hence, country style Chinese furniture made from elmwood, cedarwood and camphor wood has become more popular. In addition, light, strong, durable bamboo is making a comeback in the home. China is known as the kingdom of bamboo as it has the most species of any country (more than 400) and for centuries it has been used for furniture, baskets and mats.

For those who like the look of Ming but don't have the financial resources needed to live with the real thing, there is a vast amount of reproduction Ming furniture around. It may not have the aura—or the value—of the antique, but can, if the quality is high, be exceptionally beautiful. Such streamlined, sculptural pieces fit perfectly into a modern decorative scheme.

A Scholar's Office

The owner of this Beverly Hills office has an interest in Chinese decorative art, with particular emphasis on Six Dynasties (220–589) ceramics. With this in mind he chose to surround himself with Chinese furniture and accessories which could be enjoyed during the working day.

To enhance the collection of predominantly *hong mu* furniture in this office, the interior was painted a deep turquoise which belies the bright Southern Californian sunshine outside. It is a warm, cocoon-like space, condusive to concentration. The furniture includes a spindle-back settee, four horseshoe armchairs and a desk featuring a cracked ice pattern (often seen in window designs in Ming architecture).

The wooden ceiling and wall mouldings were stained to match the owner's *huanghuali* table and document box. On the table is a 15-piece collection of Northern Wei dynasty (386–534) tomb musicians. Such tomb figures were part of the elaborate burial rites practised by China's Imperial families. Burial customs adhered to the belief that the spirit of the departed must be provided with all that he or she possessed, or would have liked to possess, in earthly life. Ceramic figures from this time are characterized by an inclusion of detailing which helped make the models look more realistic. In so doing they provide a rich legacy of what Imperial life was like in ancient times.

With its clean, architectural lines, built-in bookshelves hugging the walls and refined classic air, this serene working environment is a successful contemporary adaptation of the traditional Chinese scholar's study.

The furniture of this office (right) was sourced from antiques dealer Nicholas Grindley in London; there is a 19th-century *hong mu* desk with cracked ice design and a set of four horseshoe armchairs (three pictured) dressed with stylish contemporary padded cushions for extra comfort. On the wall is a pair of ancestor portraits, purchased in Hong Kong, which look down over the modern day business proceedings. At the end of the room is a spindle-back settee, also made of *hong mu*.

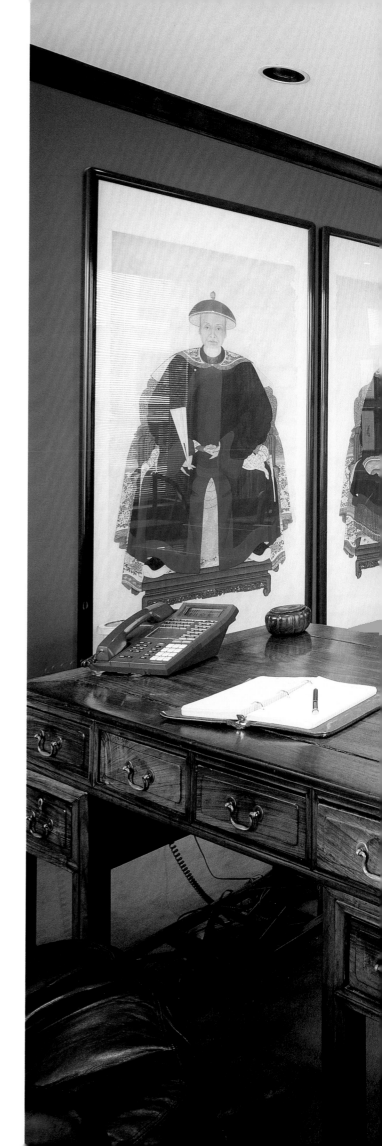

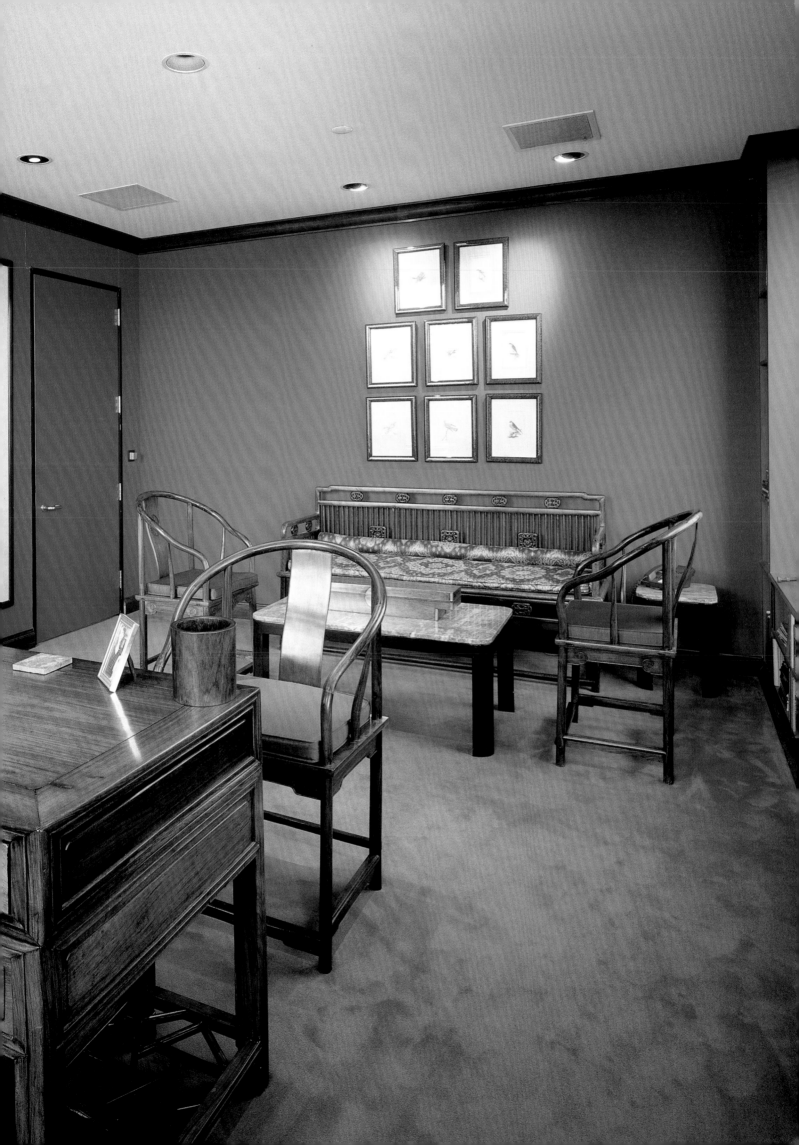

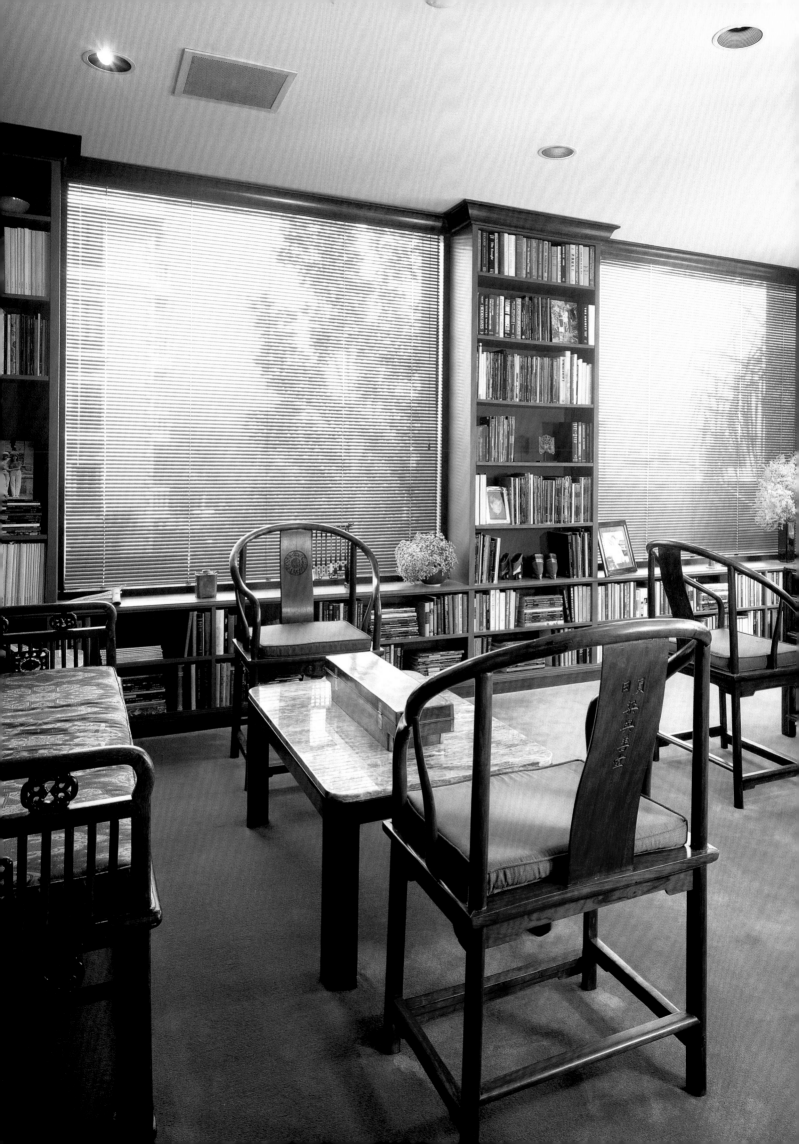

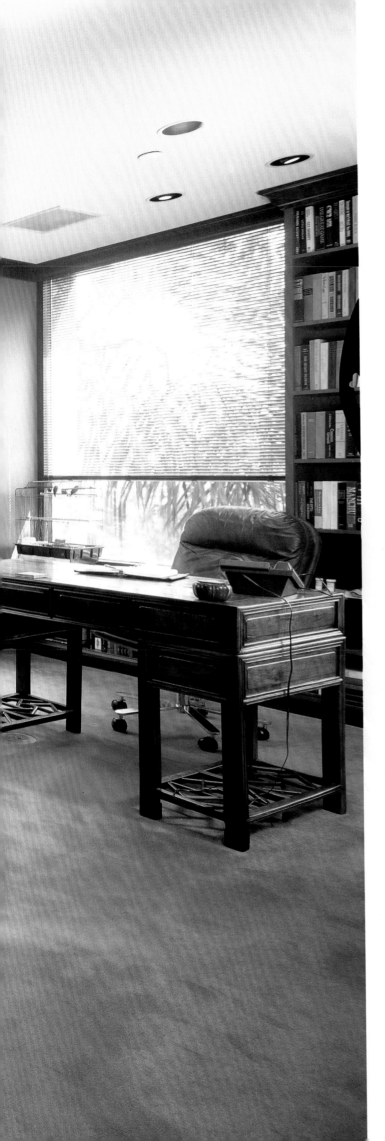

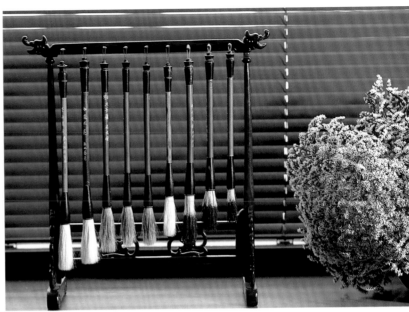

Light filters into the office (left) through three large windows shielded with blinds. The wooden ceiling and floor mouldings have been stained in the same shade as the *huanghuali* document box (on the marble coffee table) and the *huanghuali* table (below, detail), which hosts a 15-piece group of seated tomb musicians from the Northern Wei Dynasty (386–534). The calligraphy brush set and rack (top, detail) was a gift and is merely decorative.

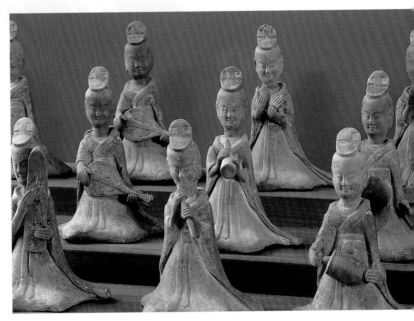

A Personal Passion

Famed Asian art dealer and collector Robert Hatfield Ellsworth lives in the largest single-floor apartment on Manhattan's Fifth Avenue in New York City. Some say that the impressive 20-plus roomed space—which takes up 1,280 sq m (13,780 sq ft)—resembles a grand American museum of the best of Chinese art. But Ellsworth is keen to point out that he sees it as a bachelor pad that is very much lived in. "The furniture and furnishings have been in the same place since I moved in, but it is not a museum setting. It is very much a home," he explains, adding that the apartment is at its best when it is filled with 150 people, all having a good time.

Ellsworth moved here in 1977 and spent a year totally restoring the apartment back to its original format, which included the tiling in the kitchens and pantries. The block was built in 1929, the year of his birth, which was, he says, "a happy coincidence". The expansive space has been filled with Southeast Asian bronzes, sculpture and paintings, his special passions. "Someone once wrote of my home that it was the only apartment big enough in town to accommodate my ego," says Ellsworth, happily agreeing that this is probably true.

Distinguished in his field, Ellsworth, now 71, is an adviser to the Chinese Ministry of Culture and in 1993 was made an honorary Chinese citizen as result of his preservation work on Ming dynasty buildings in Anhui province. He is also the author of a number of books, including *Chinese Furniture: Hardwood Examples of the Ming and Qing Dynasties*, published in 1971.

In a corner of the living room (right) is a Japanese screen which dates from the late 16th century and depicts the Imperial horse stables. The carpet is late 17th-century Chinese and the pair of *huanghuali* horseshoe back chairs are part of a set of four 17th-century pieces.

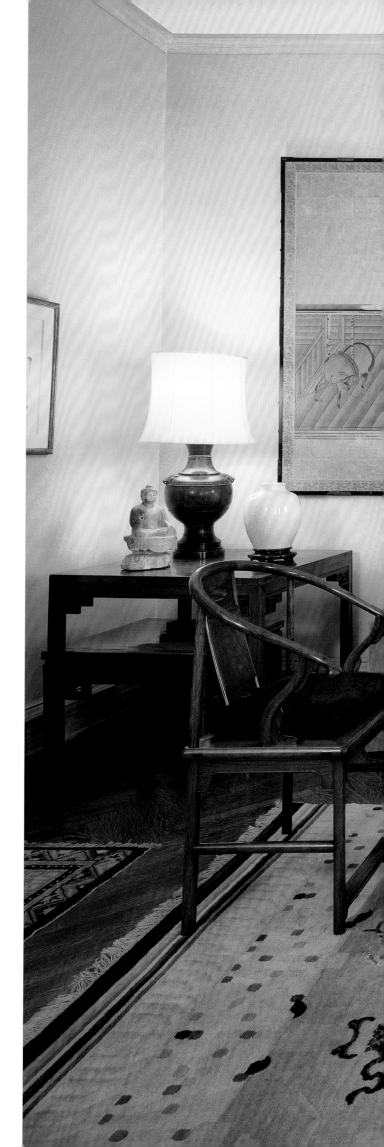

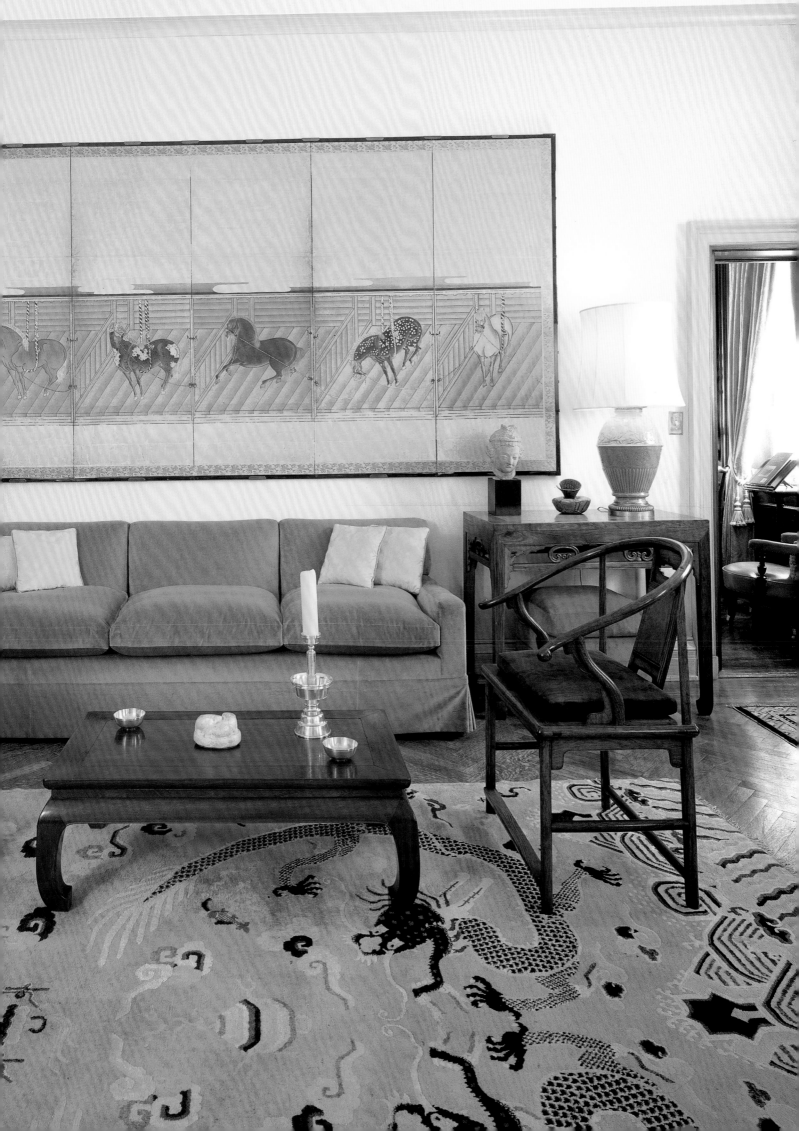

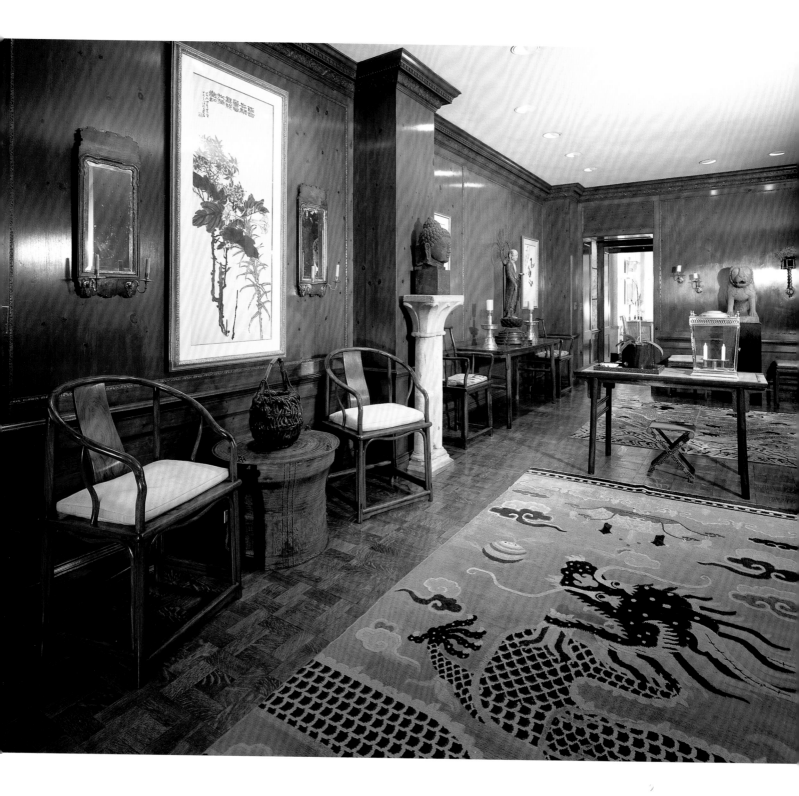

The panelling in the entrance hall (above) is original and is made of Georgia pine, the most popular timber for panelling when the apartment was built in 1929. The carpet with dragon motif was not woven for the floor; it would have been wound around a pillar in an Imperial palace hall. When the two sides join the dragon's body becomes complete. The painting is from a set of 20th-century Chinese paintings; the rest, over 90 of them, are hanging in the Metropolitan Museum of Art, not far from Ellsworth's home.

The impressive dining room table (above) was one of the first types of mechanical furniture ever built and features a 0.25-m (10-in) flap all around. This can be folded down so the table becomes nearly half a metre (1.5 ft) smaller. In the middle is a 'Lazy Susan' on which stands a Worcester china pot, part of a collection. The pair of 17th-century Chinese cabinets is made of *huanghuali* and camphor woods.

A 10th-century Chinese wood sculpture of Kuan Yin, the Goddess of Mercy (right), the most popular deity in Chinese Buddhism. It was found in a Chinese temple.

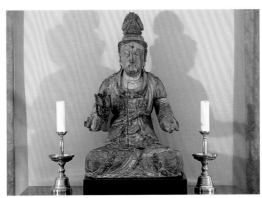

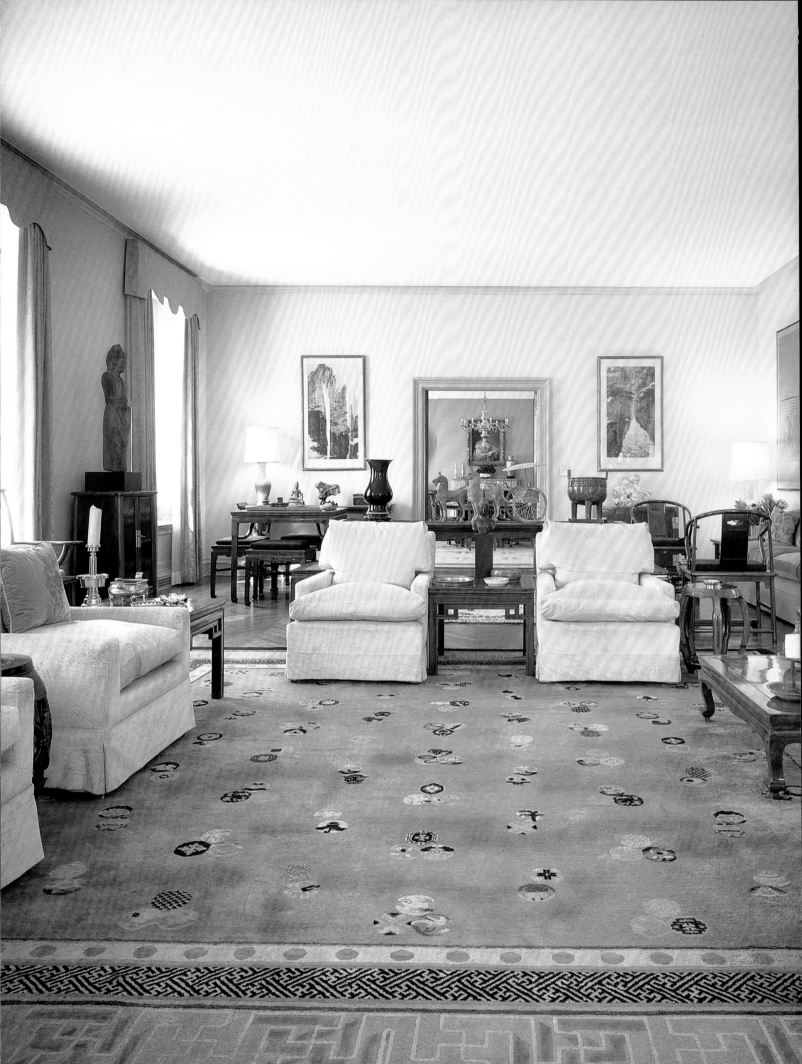

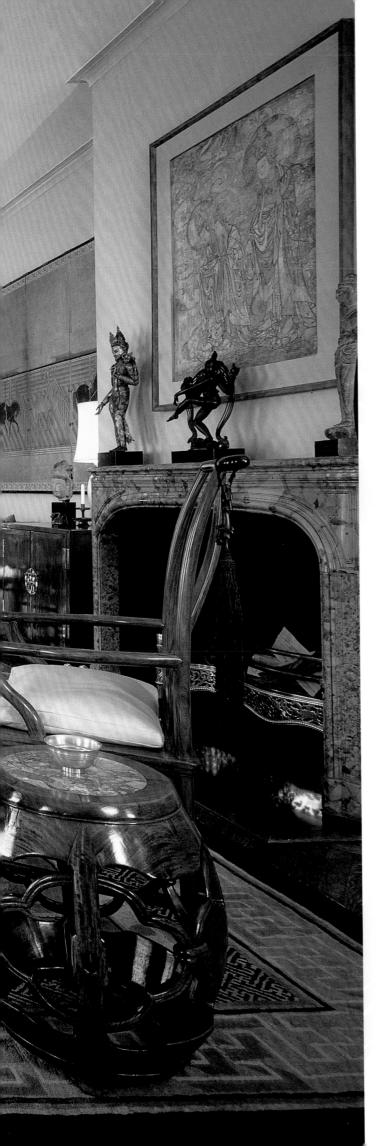

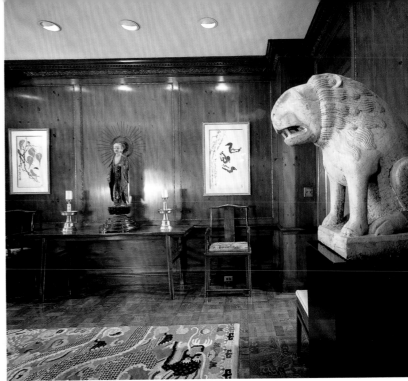

Looking through the living room into the dining room (left): flanking the door is a pair of mountain landscapes by Fu Bao Shih, 1940. The large figure on the left is 12th-century Japanese; the Chinese carpet is late 17th century/early 18th century. The barrel stool in the foreground is made of *laohuali*, a type of rosewood. Such stools were originally made of bamboo, hence their shape. The top is marble—"very good as it doesn't leave stains when people put their drinks down on them," notes the owner.

An impressive 11th-century North Italian lion (detail, top right) guards the entrance hall.

The New Mandarin Style

As a scholar, patron and collector of Chinese furniture and art, Kai-Yin Lo pours her energies into broadening the understanding of Chinese culture around the world. Although perhaps best known as a jewellery designer, she is also the author of a number of books on Chinese art and culture.

Lo is interested not only in furniture's aesthetic properties but also in how it would have been displayed and used at the time. Her private collection, which incorporates both classical and vernacular furniture, is testament to her design eye (with its well-honed sense of proportion and line). Although most of her collection has been loaned to museums, such as Singapore's Asian Civilisations Museum, her Hong Kong home brims with a remarkable collection of furniture and artifacts.

Lo believes that vernacular pieces can hold their own in terms of look, appeal and interest. In her Mid-Levels apartment, she uses luxurious textures and pale colours as a backdrop to display impressive pieces, such as a pair of 18th-century northern elmwood and burlwood compound cabinets from Beijing; a rare 18th-century cedarwood low platform in three pieces from Jiangnan; and a pair of 17th- or 18th-century window lattice panels from Suzhou decorated with carved persimmons.

Her sense of design also comes into play through creative interpretations of traditional Chinese style and she mixes and matches with panache: Song dynasty figures stand alongside Ming ceremonial tablets; jade, coral and gemstones hang from cupboard locks; and her own-design Buddhist knots of destiny make an interesting table centrepiece. All have clean lines, toning colours and a modern presentation, lending the antique collections a modern air.

Clean lines, lack of ornamentation and a subtle colour scheme characterize Kai-Yin Lo's living room (right), where Chinese art is hung on the walls with architectural precision. A pair of window panels (one shown here) features the persimmon in a four-petal design. "One of the earliest plant motifs used in China, the persimmon dates more than 1,800 years to the Han dynasty," she says. On a Ming side table at the back of the room is a pot filled with 200-year-old fungus called *lingzhi* found in Anhui province.

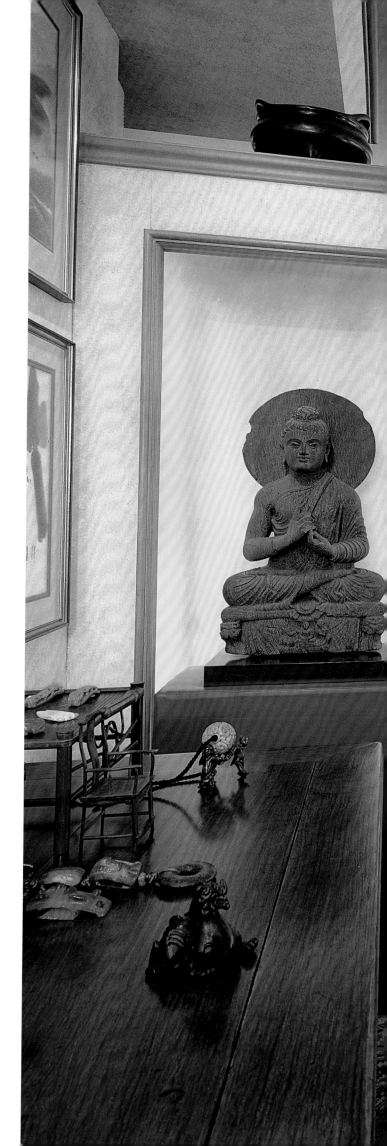

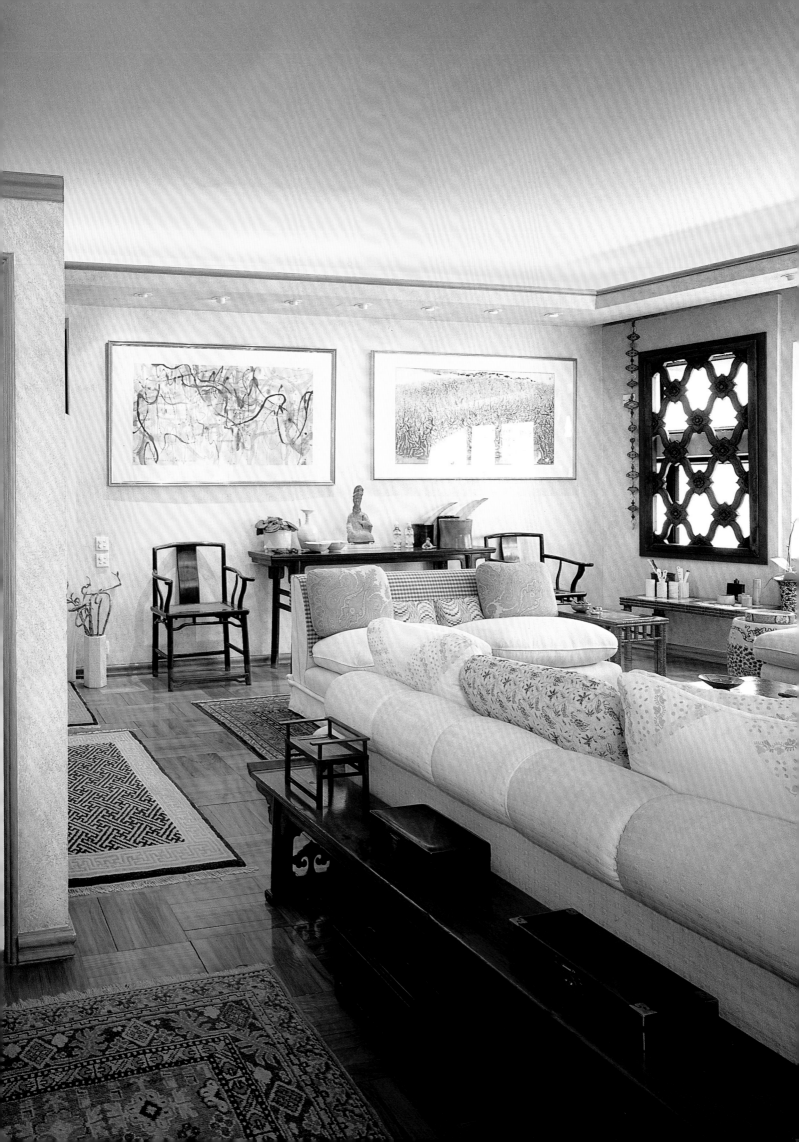

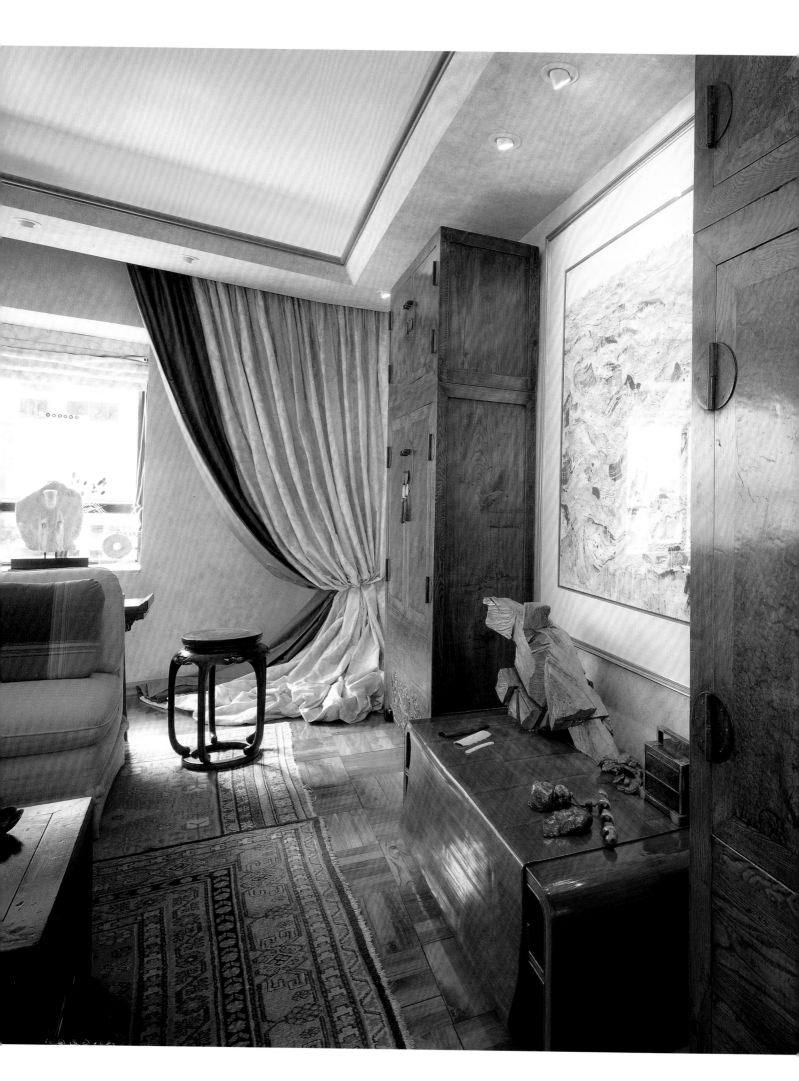

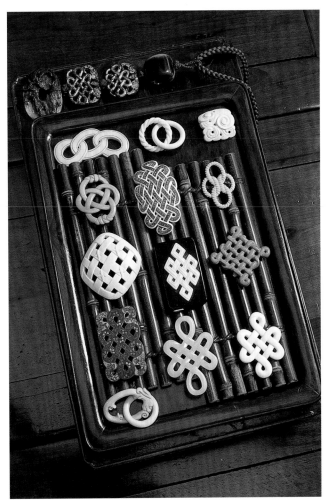

A pair of 19th-century compound cabinets in *yu mu* (northern elmwood) and *hua mu* (burlwood) stand tall at the end of the living room (left). Traditional Chinese houses were not constructed with closets so cabinets and chests of different sizes were used for storage. This pair of cabinets would have been used as wardrobes; today they have been lined with fabric and fitted with lighting. When the doors open they function as display cabinets for part of Lo's ceramic collection. The table between the cabinets is covered with an opium mat; on top stands a Ju Ming sculpture. The painting on the wall is of the Grand Canyon and is by Wu Guanzhong, known for his exciting contemporary work. Wu exhibited at the British Museum in 1992, the first time the museum held a one-man show for a living artist.

On the miniature display table in the living room (above, detail) is a collection of Lo's own designs, including Buddhist knots of destiny made of jade, ivory, wood and porcelain.

A pair of sofas dressed in pale textured fabrics stand in the centre of Kai-Yin Lo's living room (right), defining the seating area in the flowing, open plan space. Recessed and spot lighting illuminate her extensive collection of Chinese art and furniture. A low platform functions as a coffee table; it was originally one of the earliest types of raised seating in China. This rare piece dates from the 18th century and is made of *nan mu* (a variety of cedarwood). It is constructed of three modular sections which can function as a single platform (pictured here), or used separately as smaller seats, stands or low tables. On top is a miniature Ming display table featuring a collection of Buddhist knots of destiny. A silk padded screen, featuring artworks in ink and colour, shields the dining room from the living area. A 3rd-century Gandhara Buddha from the Indus Valley stands serenely in the entrance hall.

(Above, detail): On a table stand Song dynasty figures and three Ming ceremonial tablets housed in brush pots. (Below, detail): 18th–19th century Beijing glass pendants make attractive door pulls on a bamboo cabinet.

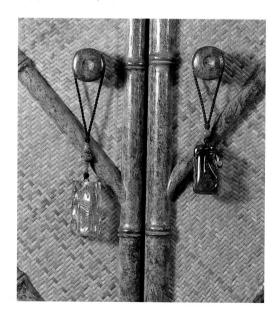

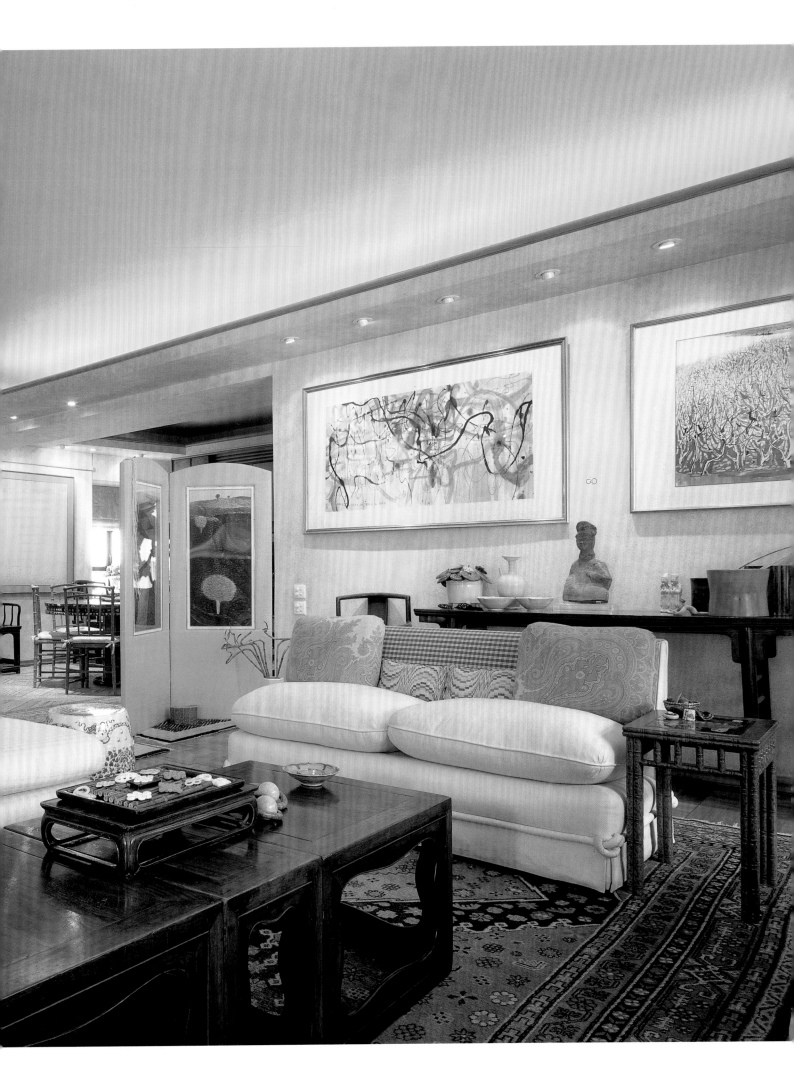

An Eclectic Mix

Softwood furniture made from northern elm (*nu mu*), southern elm (*ju mu*), cedar (*nan mu*) and camphor (*zhang mu*) woods is an increasingly popular choice for contemporary living. Through the centuries, these woods were available in many of China's regions and were used widely to produce vernacular furniture. As classical hardwood furniture such as *huanghuali* becomes increasingly rare and expensive, more and more experts are turning to softwood furniture to re-evaluate its position in the domestic environment of the time.

Chunky, country-style furniture fills the Singapore home of Michael Fiebrich and David Hoss, who are both avid collectors of Chinese antiques. Their three-bedroom, 167 sq m (1,800 sq ft) colonial bungalow built in the 1920s is a typical 'black and white', a term used to describe such buildings whose structural elements were typically painted black and the panels white, in the Jacobean manner.

Fiebrich and Hoss chose their home because of its large garden and mature trees which offered total privacy and peaceful views. "Although we both love to entertain, the house and garden are an escape from demanding careers and busy travel schedules," explains Fiebrich. "So we surrounded ourselves with strong but simple pieces of furniture that reflect the calm, comfortable mood of the house."

The Chinese pieces in their home are an interesting mix of styles, put together from years of travel throughout Asia. "We particularly enjoy combining Western and Asian pieces although as the years go by the house slowly becomes more and more Chinese in flavour." These include a whimsical antique bamboo kitchen cabinet in the entrance hall, a large red lacquer wedding cabinet which adds regal splendour to the master bedroom, and an ornate carved and gilded canopy bed which provides a strong focal point and contrasts well with the interior's muted fabrics and colour scheme.

Balancing the furniture is a light-hearted combination of accessories, including a terracotta elephant from a Shanghai flea market, a traditional bamboo ladder from a local Singapore hardware store and a Texas longhorn skull hanging on the wall in the bedroom. They provide warmth and visual interest. "There is a peaceful simplicity to the pieces that allows them to blend well with a contemporary interior," says Fiebrich. "The strong colours and textures as well as the chunky scale of the Chinese country furniture give them an almost modern feel."

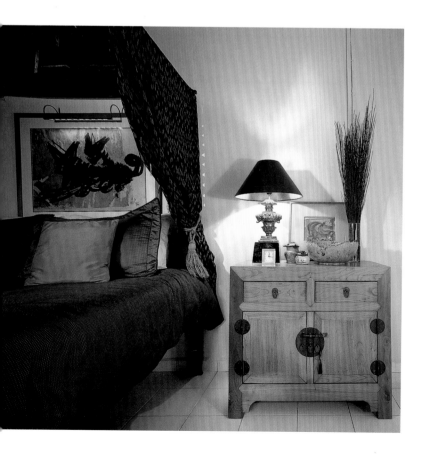

The strong lines of a large Qing dynasty cabinet dominate the living room (right); resting against the wall is a bamboo ladder which was found in a local Singapore hardware store. Accessories such as the red lacquer box and antique ivory vase have a rich patina of age and add colour and texture to the room.

An antique country style cabinet (left) acts as a sturdy bedside table.

(Above) "Its heavy scale and blocky proportions add a modern simplicity to the room," says Michael Fiebrich of the late Qing cabinet in the living room. On top are two lamp bases made from antique balustrades taken from an old Singapore shophouse. The ceramic dragon planter on the floor was selected for its rich, dark colour and pattern.

In the master bedroom (right), a red lacquer wedding cabinet purchased in Singapore adds regal colour to the room and contrasts well with the white walls and white-tiled floor. It has been juxtaposed with a Western Texas longhorn skull mounted above.

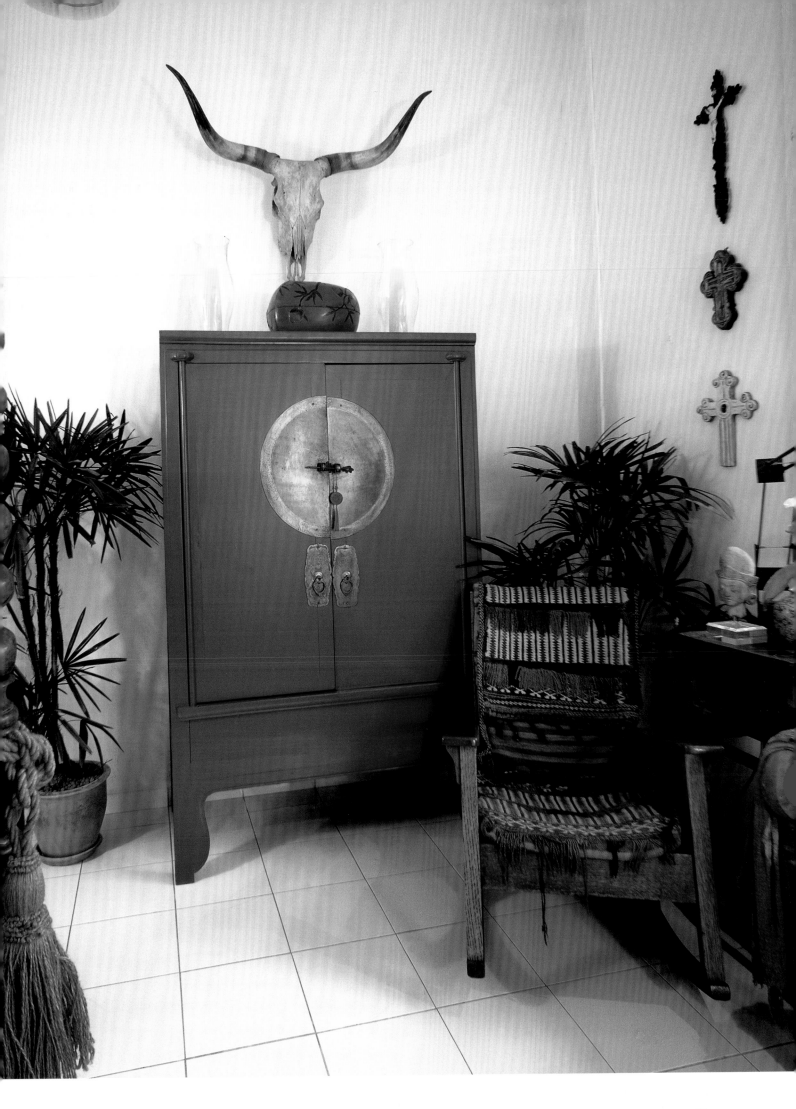

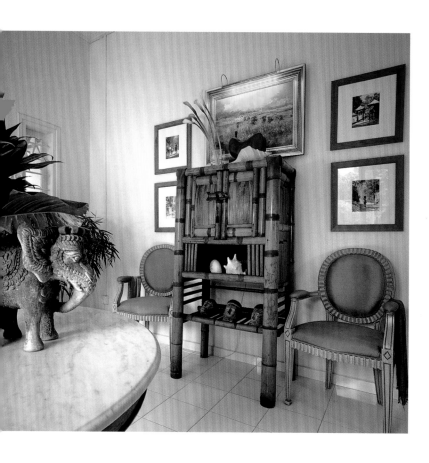

Lighthearted touches add to the relaxing feel of the interior. An antique bamboo kitchen cabinet (above) is placed at the entrance to the living room. On the circular table in the foreground is a terracotta elephant found in a flea market in Shanghai.

This antique Qing dynasty canopy bed (right) is a favourite piece and was purchased locally in Singapore. "It not only offers a restful perch for reading or napping but its ornate carved and gilded frame gives a strong focal point in the living room and adds a nice contrast to the simple fabrics and colours used elsewhere in the room," says Fiebrich.

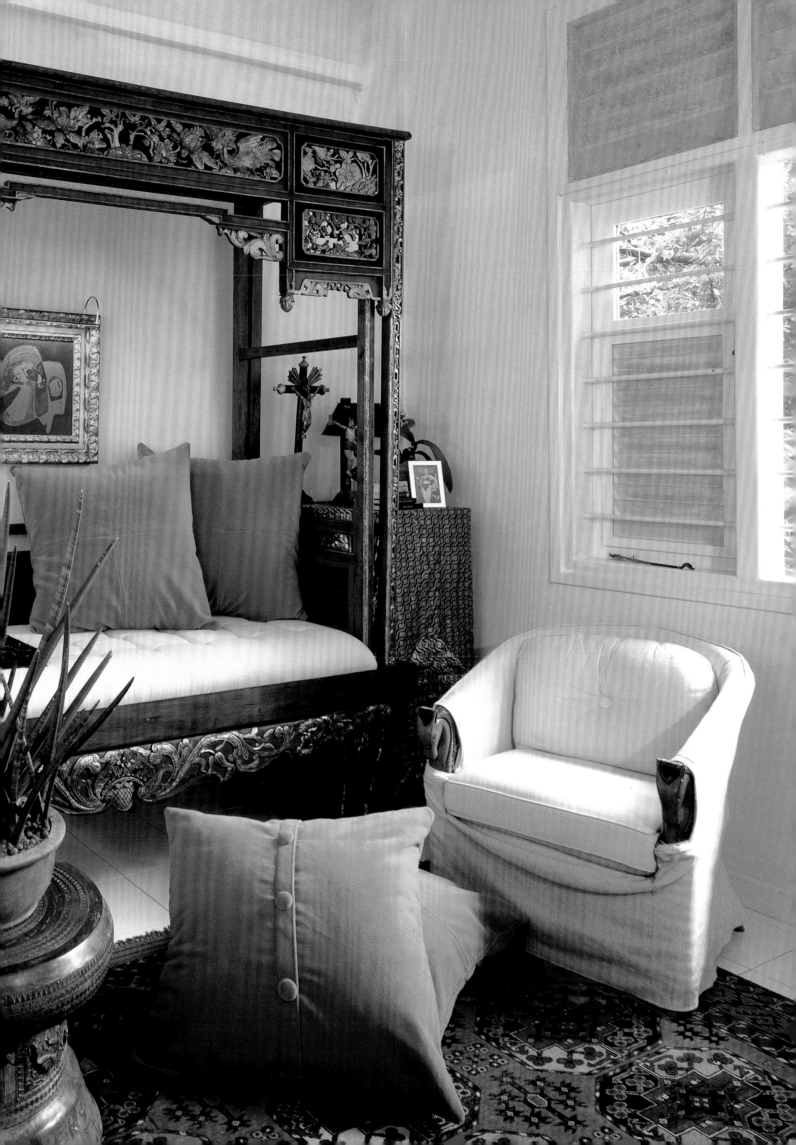

Classical Precision

The London pied-à-terre of a prominent Hong Kong family features a modern, minimalistic interior furnished entirely with classic Chinese furniture. The four-storey house in Chelsea is an exercise in restraint, with ordered groupings of furniture inside a series of rooms accessed by a central staircase.

An intricate, late Ming *huanghuali* canopy bed fits neatly into an alcove in a corridor; a formal grouping of four horseshoe back chairs surrounds a table in the white walled dining room; and a clean-lined Ming canopy bed with built-in back is positioned adjacent to a glass wall overlooking the stairwell. In every area of this home, precision is key.

Recessed spotlights throughout highlight the warm, lustrous woods and extraordinary craftsmanship that make up each piece of furniture. The use of natural materials — such as wood and travertine marble flooring, silk carpets and dashes of bold soft furnishings — serve to offset the museum quality feel of the space. Here, the architectural lines of the interior and the furniture combine to produce a serene, quiet and intelligent decorative scheme.

Floor-to-ceiling glass panels overlooking a central stairway help open up the interior of this four-storey London house. In the living room (right), things are kept architecturally minimal with white walls, a pale wood floor and spot lighting. The clean-lined approach is maintained with select pieces of pared-down antique furniture. A Ming *luohan chuang* (couch bed) — which would have originally been used for relaxation, meditation or conversation, often moved onto a terrace or into a garden to enjoy nature from — stands against the rear wall; to the left is a carved candlestand.

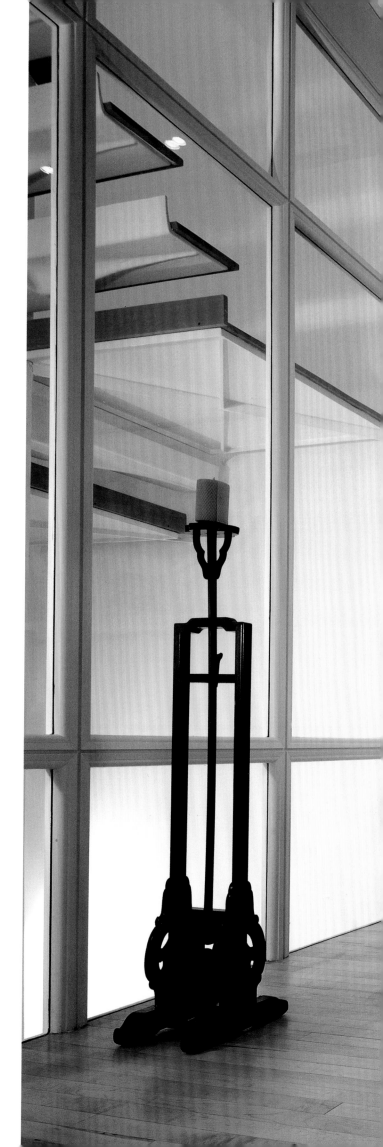

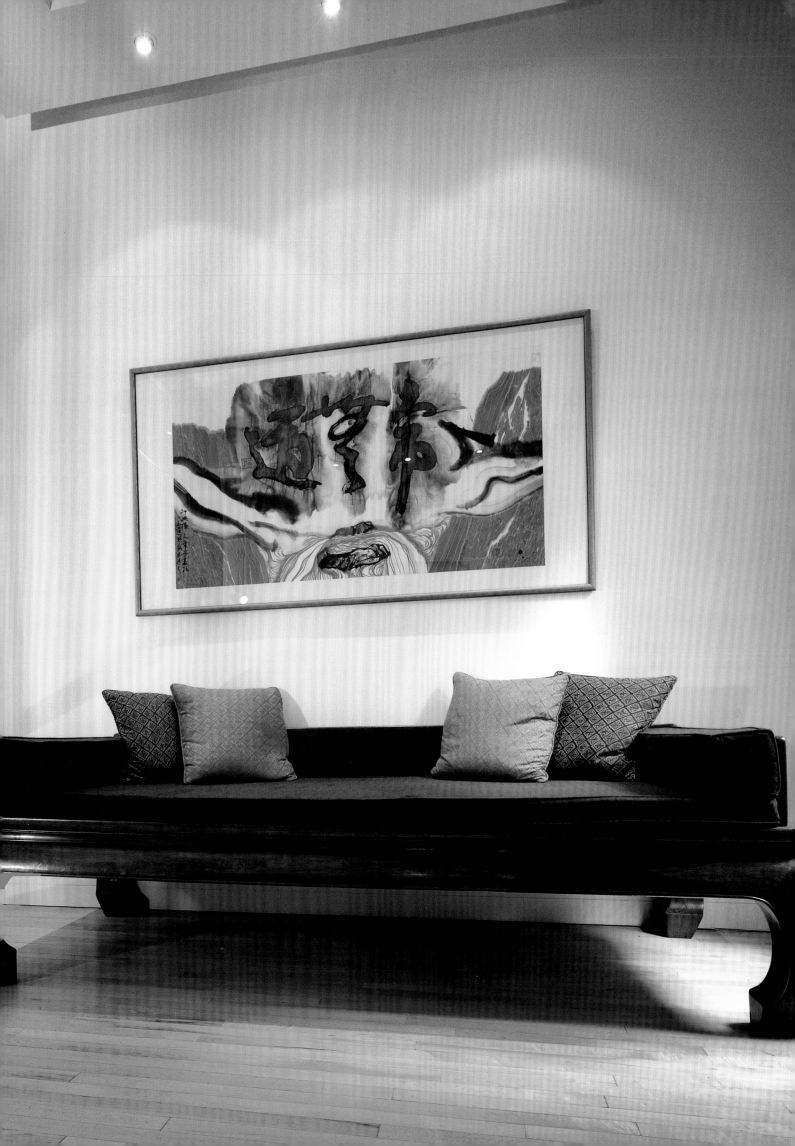

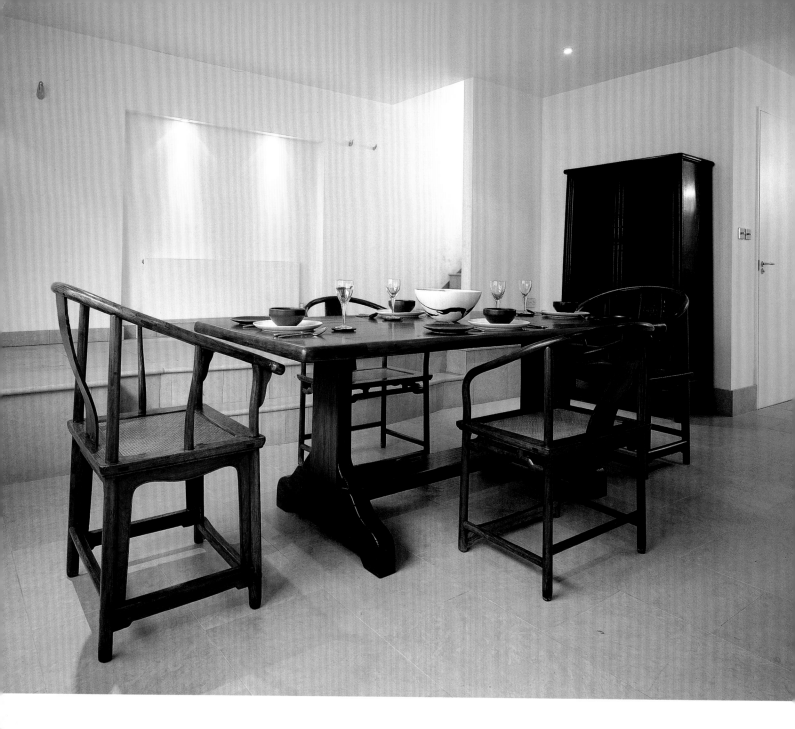

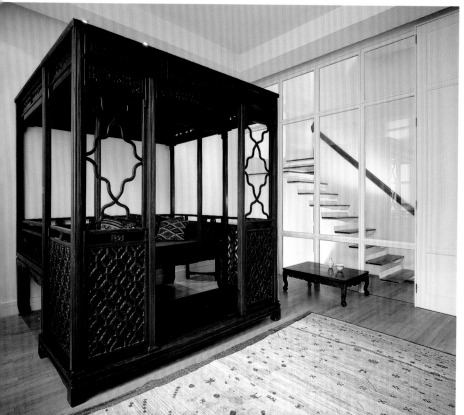

An impressive Ming dynasty canopy bed with decorative latticework stands in the corridor leading to the internal stairwell (left and right). Such beds would have been placed in alcoves and used not only for sleeping but also for leisure, study and household tasks during the day. Typically, they would have been draped with fabric to suit the season—silk or cotton for the winter months; gauze netting in the summer to allow breezes to filter through.

The minimal dining room (above) showcases four *huanghuali* horse-shoe armchairs. Against the rear wall stands a sloping stile wood-hinged cabinet. The travertine marble floor heightens the industrial feel of the space.

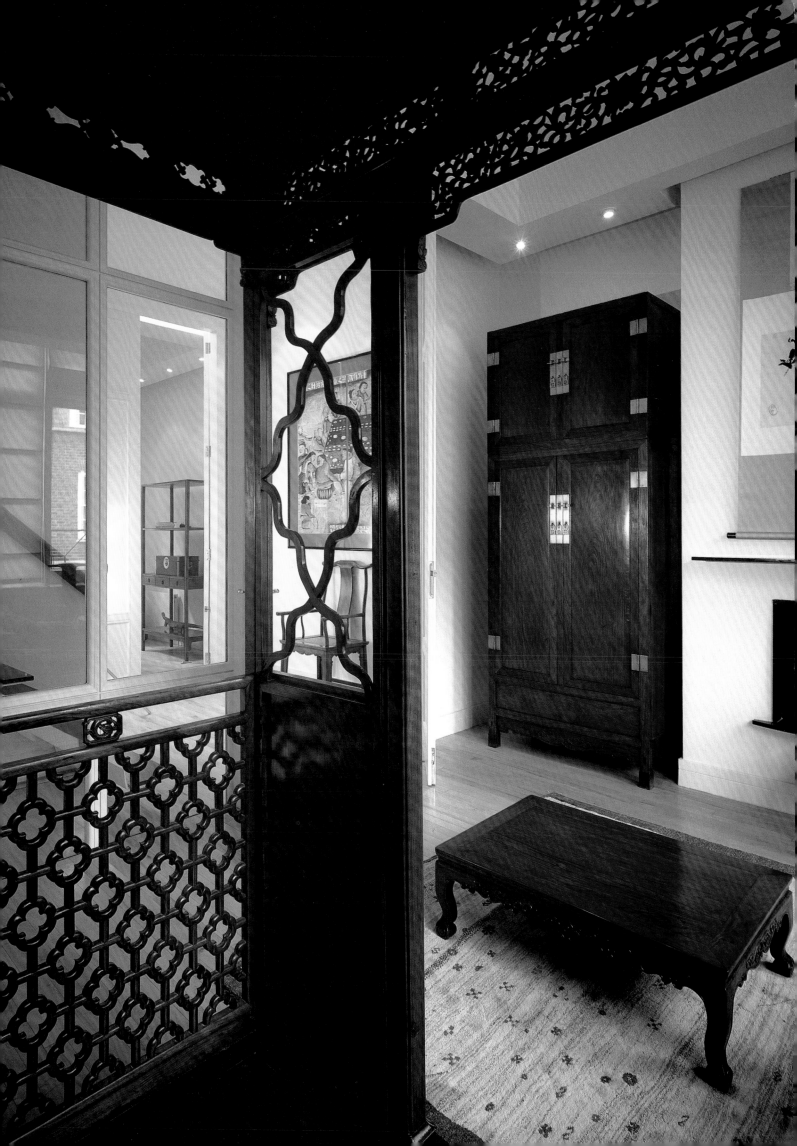

Designer Ming

"People ask me, is this modern? But it is 400 years old. It really does transcend not only time, but also place," says Grace Wu Bruce, with reference to the premier quality Ming furniture which fills her Hong Kong home.

The internationally renowned Ming furniture collector and dealer has a passion for the genre that she loves to share. With galleries in Hong Kong and London, she admits to a love affair with the furniture that has never decreased in intensity. "I came upon Ming furniture by accident and from the beginning I was smitten."

Proof that Ming's subtle elegance blends harmoniously with 21st-century interiors can be found in her spacious apartment with its bold yellow and red walls, colourful Iranian carpets and lush fabrics, which complement the rich *huanghuali* wood furniture. On the walls hang an impressive collection of traditional calligraphy (the highest form of art in China), whose visual beauty and rhythm is clear even to those unaware of the cultural contexts and meanings inherent in the writing.

A driving force behind much of the work to increase public knowledge of Ming furniture, Wu Bruce combines her work and home lives. "I was probably one of the first of my generation (Chinese) to collect Ming," she says. "My own collection and work are intricately tied up with the development of Ming furniture in the field."

The fine architectural proportions and pure designs of Ming furniture are perfectly portrayed in this pair of sloping stile wood hinged cabinets from the 16th–17th century (right). "They are particularly beautiful because the door panels have matching grains, so were appreciated by connoisseurs of the period and once again by collectors," says Wu Bruce. The fan paintings above are by Chen Pei Qiao; the gold and blue calligraphy scroll is by premier calligrapher Qi Gong of Beijing. Wu has installed a groove around the false ceiling, which houses a flexible hanging system for her artworks so they can be moved around easily, usually according to the season.

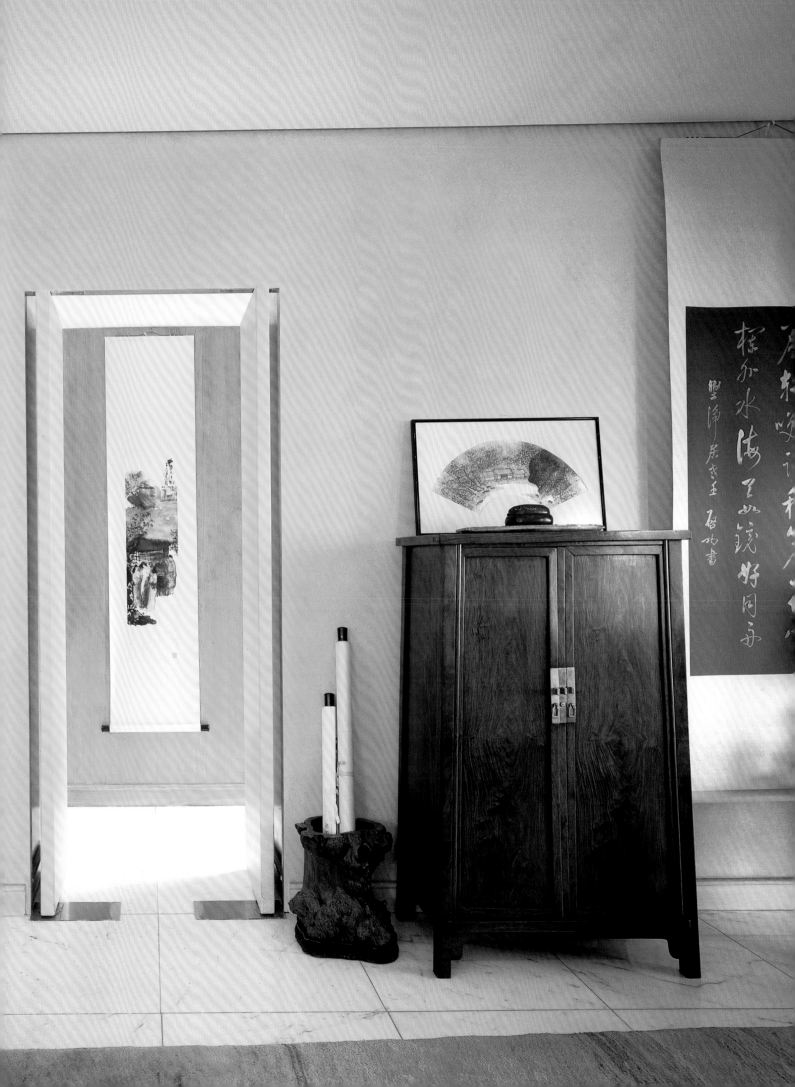

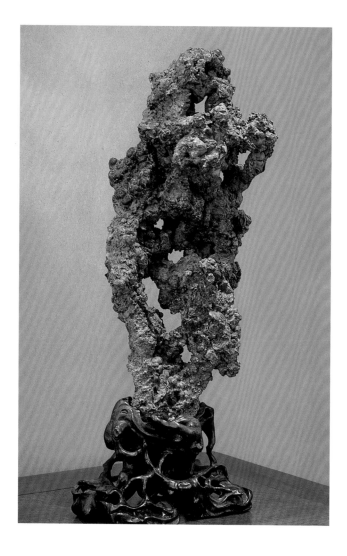

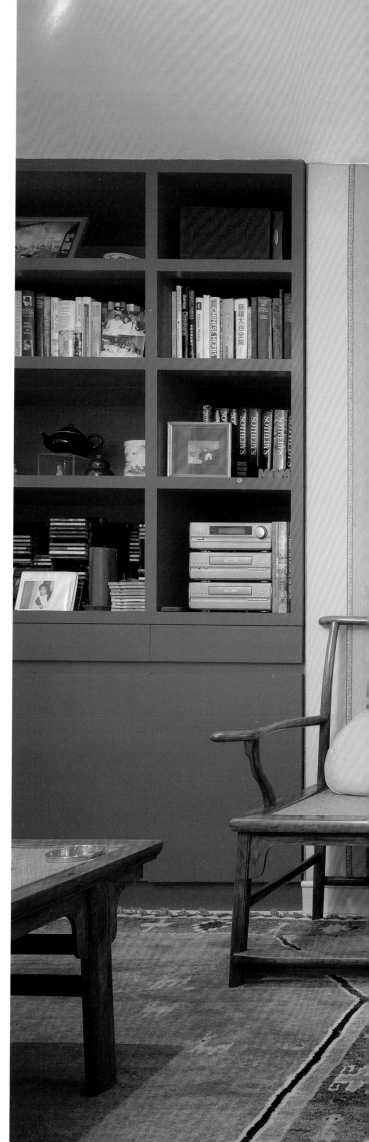

"Rocks are treasured by Chinese collectors as objects of art," explains Wu. "They symbolize nature and can be brought inside so one can contemplate nature indoors." This malachite stone from Shilu Mountain (above, detail) is an impressive example.

A classic 16th-century Ming lute table stands against the far wall (right); it would have been an important part of the scholar's accoutrements of the time. Calligraphy is regarded as the highest form of art in China and Wu Bruce has a spectacular collection. Hanging behind the lute table is a 16th–17th-century scroll by Zheng Da Qian which depicts the lone scholar in the mountains. The pair of calligraphy couplets are by early 20th-century calligrapher Lin San Zhi; they refer to furniture. In the foreground, a dash of contemporary style is added with colourful Iranian rugs. The extremely heavy yellow wax 'Lashi' stone symbolizes nature being brought inside.

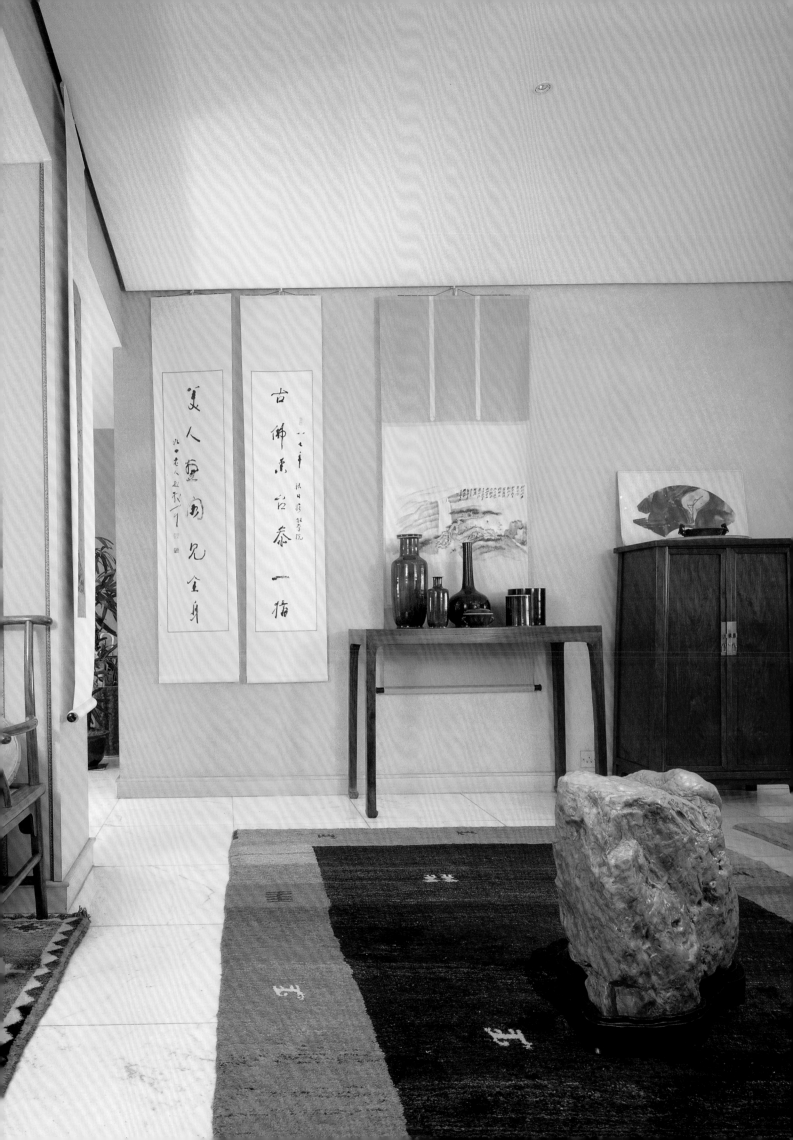

Exquisite *huanghuali* Ming dynasty pieces may feature in every room, but this is also an interior meant for comfort and relaxation. In the feminine master bedroom (right), a Ming bed has been dressed in the manner of a Western four poster with swagged fabrics and piped detailing. "I find colour is a good balance for my life," says Wu Bruce, explaining that in her galleries she goes to the other extreme and uses a stark, all-white palette to show off the furniture's architectural lines. Both decorative approaches are equally valid. "I have the gallery in the day and home in the evening. It is perfect for me."

In the warm, red-walled hallway hangs a dramatic, abstract painting by grandmaster of modern art, Wu Guangzhong (detail, below).

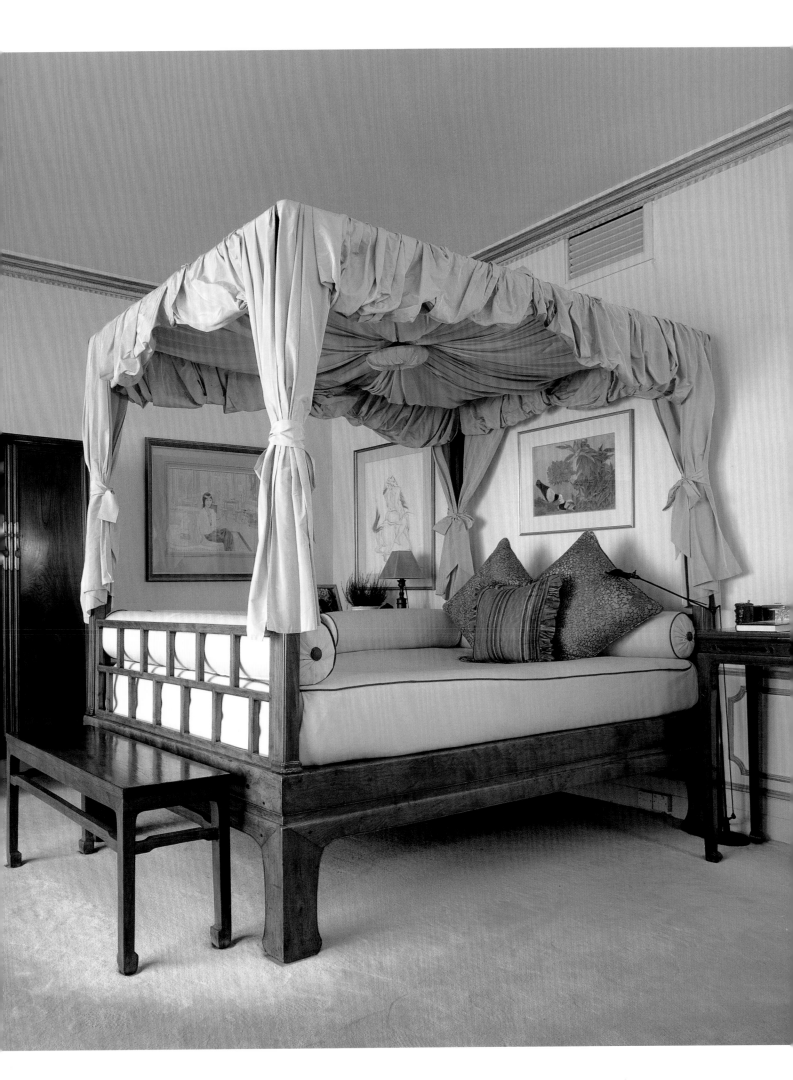

A Love of Order

A fondness for Chinese furniture and a desire for ordered living come together in this pre-war apartment in New York's Upper East Side. The quietly elegant space comprises a large entrance hall from which the library, living room and dining room lead off. The owner, who at one time was in the antiques business, has an elegant collection of Ming and Qing pieces, sourced by premier London-based dealer Nicholas Grindley.

The owner's preference for formality is echoed in the interior's decorative plan. Clean lines, a sense of symmetry and a logical arrangement of furniture are the perfect foil for the elegant Chinese pieces housed here. But this is no impersonal showcase: understated colours and textures have been used to bring warmth to the space and enhance the classical modern feel. The spacious light grey entrance hall features a large reproduction carpet based on a 17th-century Chinese design; celadon-coloured walls in the dining room offset the herringbone parquet floor; and grey green painted walls add visual interest in the living room and library.

Clever combinations of Ming furniture and Western modernist designs are positioned throughout this apartment: a group of 1950s Italian glassware sits on a 17th-century *huanghuali* Ming cabinet; a Ruhlmann desk is juxtaposed with a mid 19th-century Chinese drum stool and a Brice Marden print; and a Ming everted altar table has a Georg Baselitz drawing hanging above. They may be from different eras and cultures but these carefully selected pieces celebrate the skill of the craftsman and the value of a logical approach to design.

Eastern and Western classics combine in this New York apartment. In the living room (left and right), an elegant 17th-century *huanghuali* sloping stile wood-hinged cabinet is juxtaposed with a set of three 1950s Italian decanters. Both celebrate the tradition of quality craftsmanship. There is a conscious lack of ornamentation in the furnishings chosen here: clean lines and simple shapes appeal to the modern aesthetic.

The owner's fondness for Chinese furniture is also revealed here, where she combines antique pieces with restrained modern furnishings. A love of order defines the space, lending an elegant, formal air. The pair of 18th-century *huanghuali* chairs is unusual, as the chairs have convex seating rails at the front.

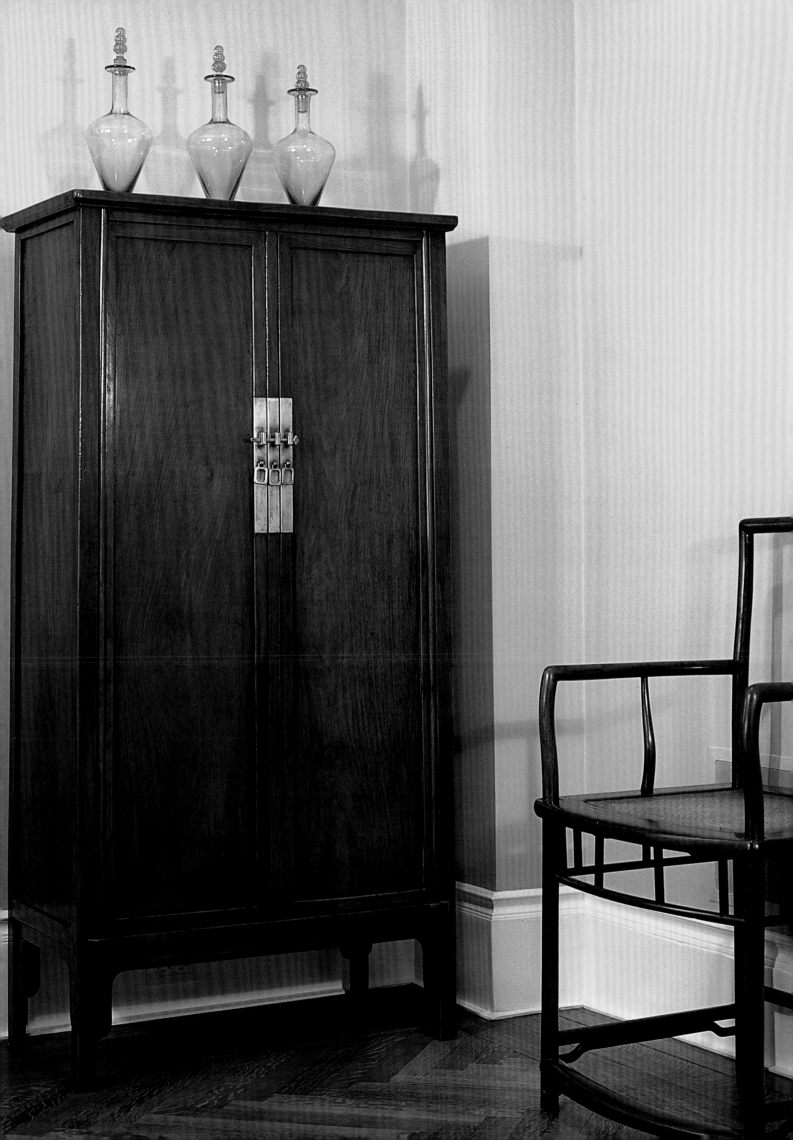

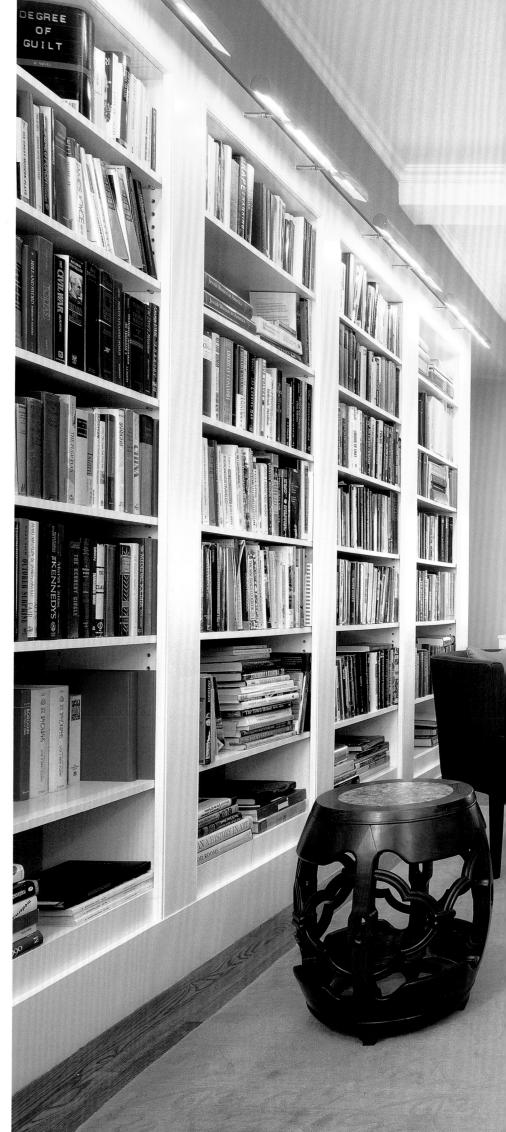

The library (right), which opens off a huge entrance hall, features gray green walls, the most vivid of the muted colours that permeate the apartment. On one side is an entire wall of bookshelves; furnishings include a mid-19th-century Chinese drum stool made of *hong mu* and marble and a Ruhlmann desk. On the wall is a Brice Marden print from the 'Cold Mountain' series.

Art too is a mix of modern and classic; (above, detail) a Chinese scroll painting takes pride of place. Elsewhere in the apartment hang works by George Baselitz and Brice Marden.

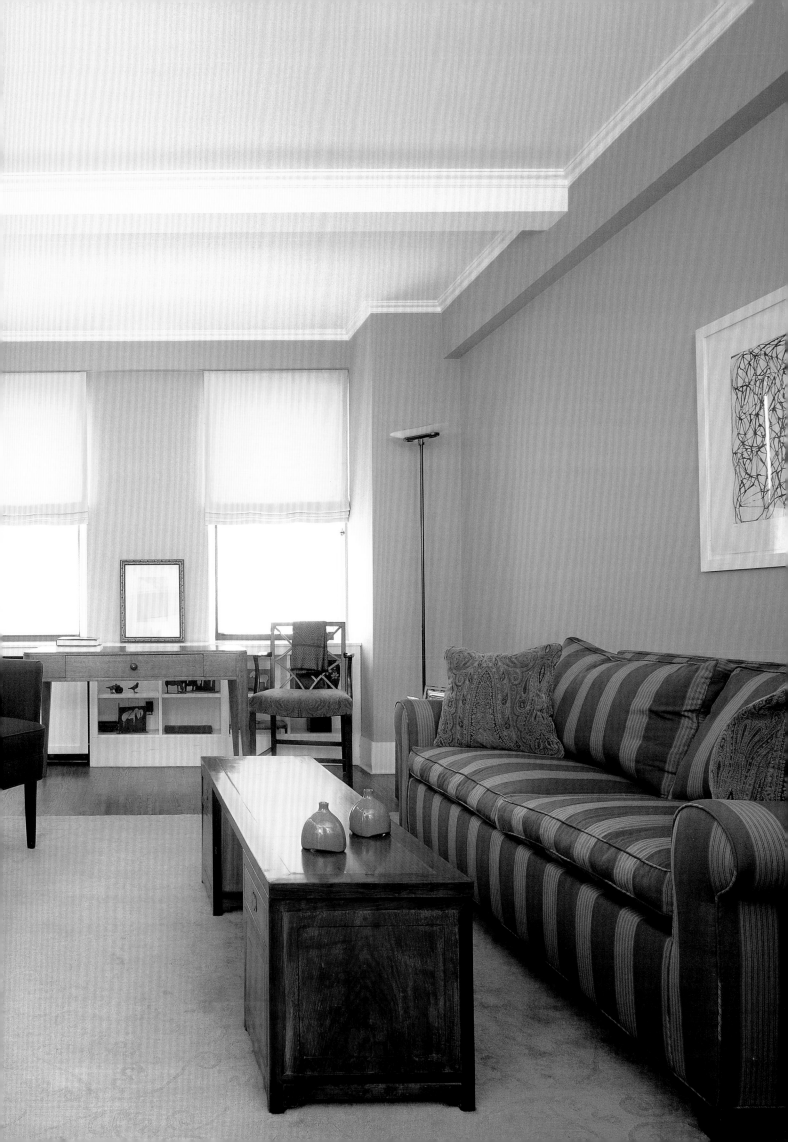

A Collectors' Haven

A mix of antique Chinese, American and modern pieces fill the Chicago home of Jack Bulmash and Michael Schnur. Their Queen Ann style house near the southern edge of Lincoln Park was built in 1887 by the architect AMF Colton and comprises some 604 sq m (6,500 sq ft) of space on four floors. Although originally a single family dwelling, it was converted into an apartment building sometime in the 1940s, and, when the current owners took it over, it had stood empty for some six months. They reconverted it into one home and, while not particular fans of Victoriana, opted to retain many of the original features, including the doors, window trims and an elegant staircase. These features were given a modern edge by enlarging the existing rooms, custom-building bookcases and cabinets and installing tract lighting to illuminate the collections of art.

As collectors, Bulmash and Schnur were originally interested in textiles, in particular antique Anatolian carpets. Their exposure to Chinese furniture began in 1990 after meeting London-based Chinese furniture and art dealer Nicholas Grindley, who educated and informed them about the subject. "Since that time we have purchased pieces in auction, from dealers in New York and from Grace Wu Bruce in Hong Kong," explains Bulmash. "I think the beauty of the furniture speaks for itself. Its style fits any number of interiors and is quite adaptable." In his home, the clean white walls, lack of ornamentation, and built-in shelving and display cabinets add a sense of calm and order which complements the furniture. "Despite our love for hardwoods it is the form rather than the media that is the most important feature of the furniture."

Bulmash and Schnur admit to adhering to a Western taste for simple forms when compiling their collection but express a liking for all styles of Ming and early Qing. "Only the currently prohibitive cost, lack of really genuine pieces and lack of reasonable space has kept us from getting roomfuls!" they say.

Jack Bulmash and Michael Schur took a minimalist design approach to provide a clear backdrop for their collection of Ming and early Qing furniture, antique Anatolian carpets and modern pieces. A guest bedroom (right) has been filled with Chinese antiques. There is an 18th-century four poster Chinese bed made of *jichi mu* (chicken wing wood) covered with a 17th-century woollen Anatolian kilim. A pair of 18th-century horseshoe chairs flank a black lacquer elmwood incense stand. On top is an unglazed Han dynasty pot. On the wall is a pair of Qing marble panels in *hong mu* (redwood) frames and a 19th-century Japanese calligraphy scroll. Minimal tract lighting is both effective and unobtrusive.

A neolithic pot (left, detail) sits in a niche in the master bedroom.

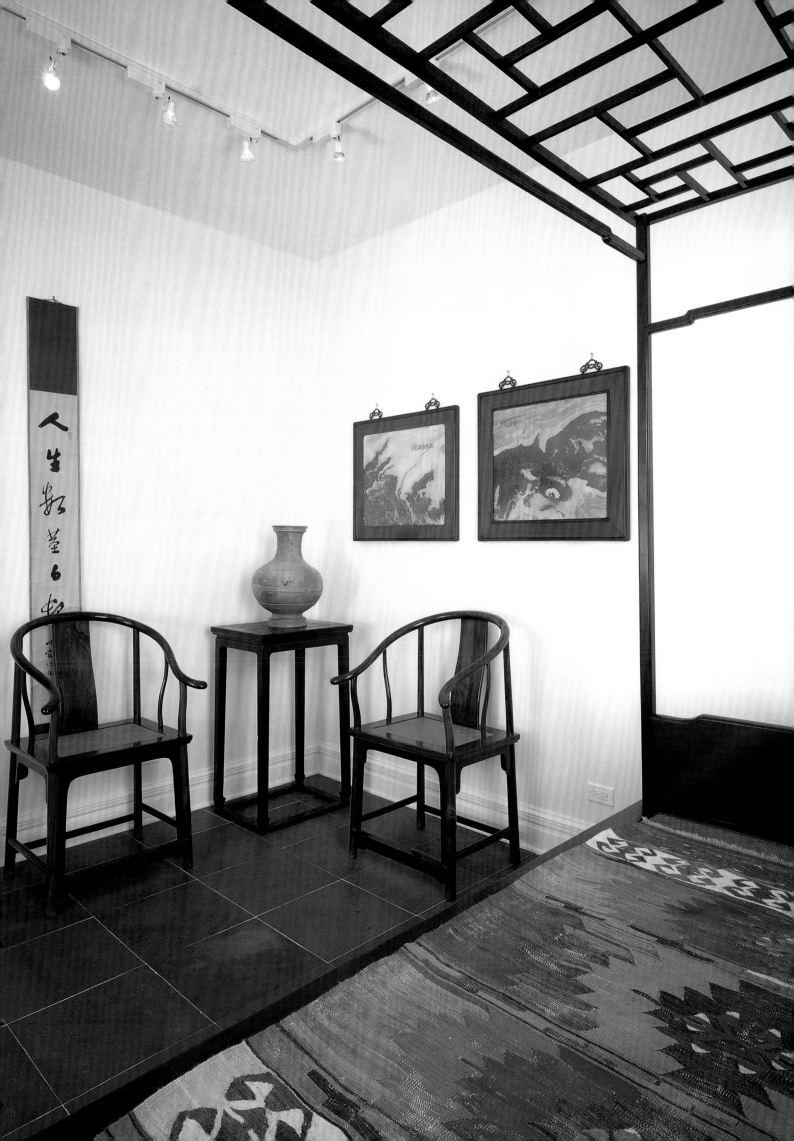

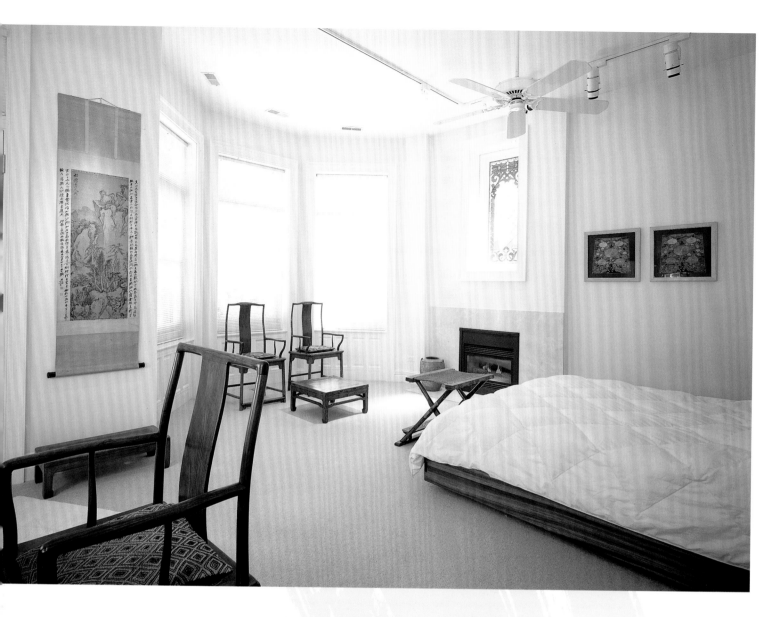

Warm woods enhance a sense of harmony and calm in the pale-hued master bedroom (above and left). Beneath the windows (which still feature the original trims) stands a pair of 16th–17th-century yolk-back chairs and a Kang table made of *huanghuali* wood. At the foot of the bed is a 17th-century folding stool with footrest; on the wall at the head of the bed is a vibrant Anatolian pile carpet; to the side is a pair of Chinese silk embroideries from the 14th or 15th century.

In the library (right), a 19th-century Anatolian kilim hangs on the wall; to the rear is a 17th-century *huanghuali* painting table and a 16th–17th-century southern official's armchair. In the foreground, an elmwood and red lacquer 19th-century ladder rests against the bookcases. The occupants prize the form of the furniture over the media used to create it as the most important feature in their collection.

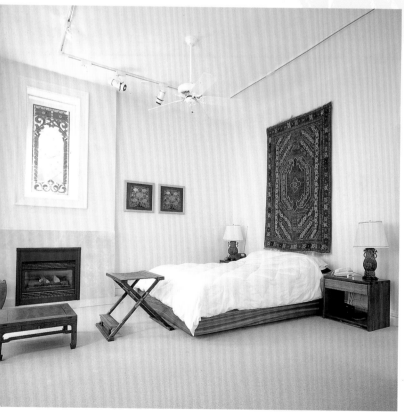

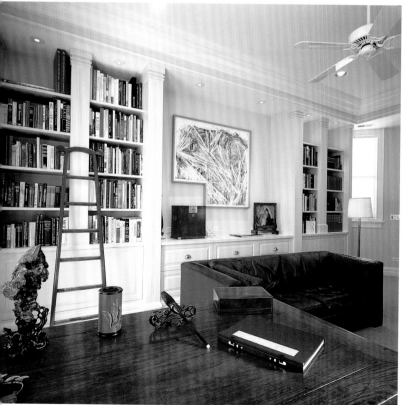

Living with Ming: in a corner of the master bedroom (above), a *huanghuali* Ming table and a southern official's armchair function as a desk area; above the desk hangs a textile from the Kaitag region of Daghestan, dated to the 18th century or earlier. Neolithic pots, Japanese 19th-century baskets and a modern pot by Jeff Shapiro fill shelving units on either side. The landscape painting on silk is by Fu Shan (1607–1684).

Precious objects (left): on top of the table in the library is a scholar's rock, a carved bamboo brush pot from the 18th century carved by Feng Ching (1652–1715), a 17th-century bronze brush holder and an 18th-century *hong mu* calligraphy brush. The painting on the rear wall is by Mel Bockner, entitled 'Argent'.

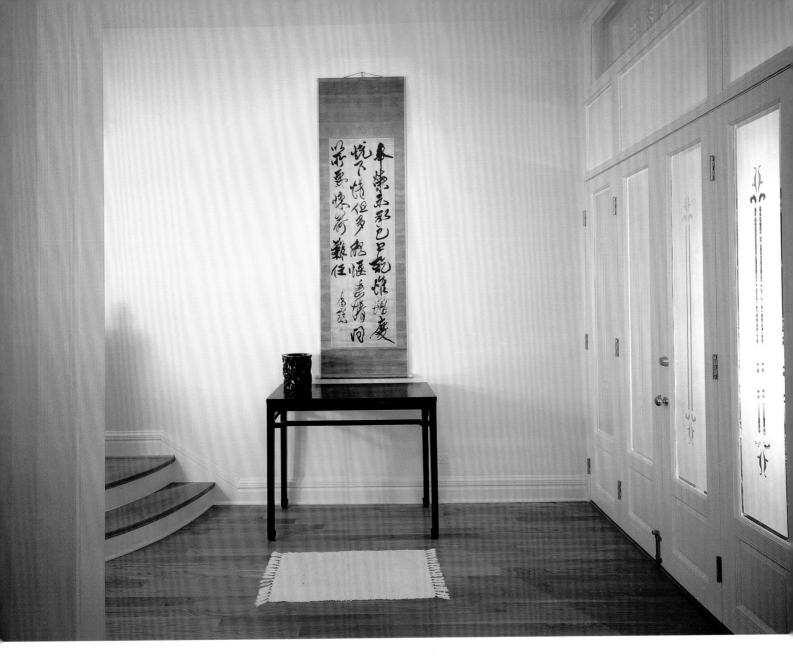

The entrance hall (above) sets the decorative tone for the antique-filled house. The 16th-century Eight Immortals' (*baxianzhou*) table is made of *zitan* wood. On top is an 18th-century brush pot, also made of *zitan* wood; behind is a 17th-century calligraphy on silk by Fu Shan.

Near the fireplace in the master bedroom (left) is an impressed clay pot, Chinese Warring States.

Classical Style

The Hong Kong home of Amanda and Stephen Clark is an exercise in restrained elegance. "Our apartment is really an amalgam of classical style from both Europe and China," explains the antique dealer. "My husband is a trained art historian and artist who changed direction and went into finance. His roots are in the great classical European traditions of the 15th century onwards, while I have spent 20 years developing the market for fine traditional Chinese furniture specializing in 17th- and 18th-century pieces."

Their spacious, airy apartment features a simple palette of white walls with blue-white soft furnishings and sisal flooring to offset the fine antique furniture. On the walls hang an impressive collection of 16th- to 18th-century Italian drawings and European Masters paintings, many housed in 16th- to 19th-century frames, often as valuable and rare as the pictures themselves. "I think we are a mixture of both European and Chinese classical traditions—and a happy one," says Clark.

When Clark opened the Altfield Gallery in Hong Kong in 1982, she was at the forefront of traditional Chinese furniture dealing. Today, there is a second gallery in London's Chelsea Harbour. "When we brought country—that is, not blackwood—furniture onto the market, it simply had not been seen before. It has been the most incredible adventure, travelling and sourcing all over China."

Clark remains excited by the possibilities collecting presents. "The extraordinary thing is that today there are some wonderful pieces coming onto the market from the 16th–18th century that we would not have believed possible even 10 years ago. These pieces work very well in modern homes as they tend to be functional, highly styled and with very beautiful wood grain or lacquer finishes."

In the living room (right), a rare 18th-century child's horse-shoe backed armchair made entirely of bamboo stands next to a 16th-century Ming Kang table covered in woven bamboo and lacquered in red over black. In the foreground is a low table displaying 18th- and 19th-century Tibetan silver bowls. The Tang horse is a fine example in apple green glaze, with its original unglazed saddle.

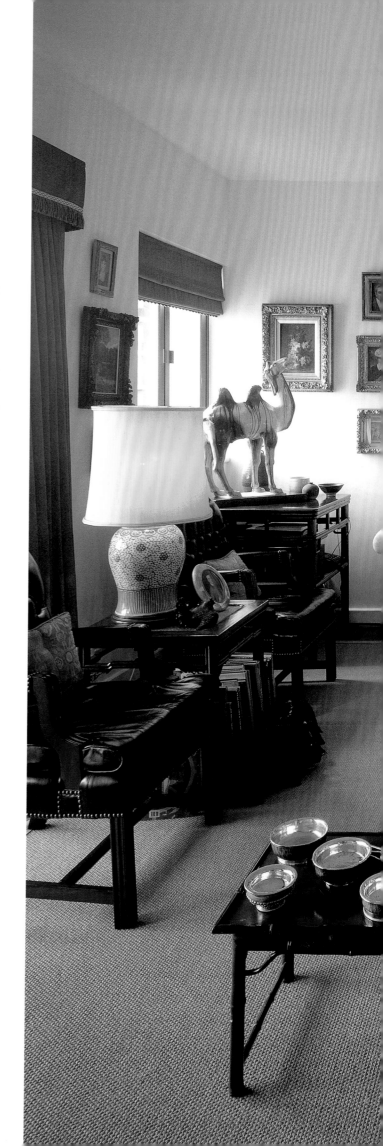

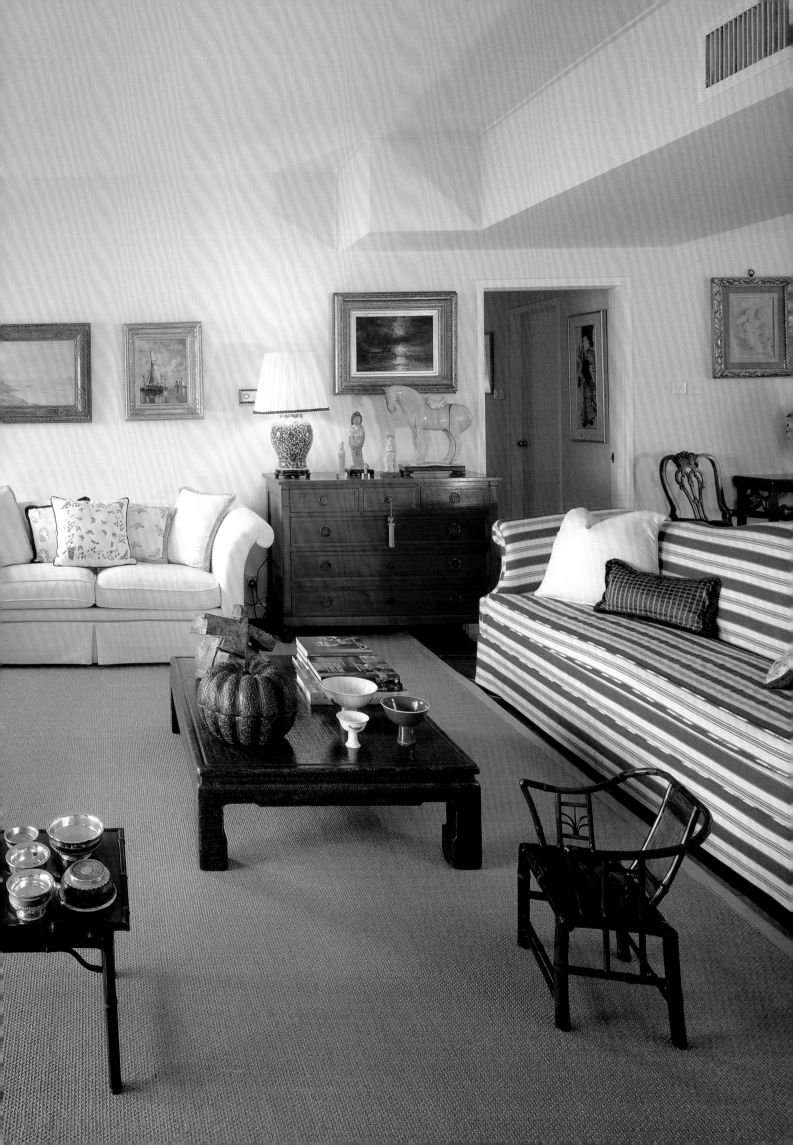

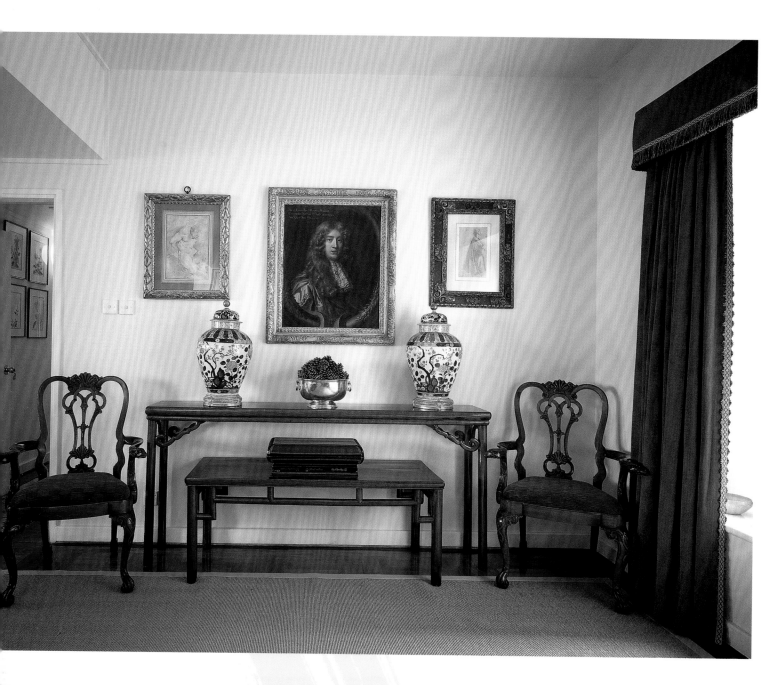

Against the dining room walls (above) stands a pair of mahogany Chippendale chairs. Between them is a slim 18th-century elmwood sidetable from Shanxi province; on top is a pair of baluster vases, decorated in underglaze blue with polychrome enamels in the Chinese Imari style of the 17th century. The portrait is of Viscount Wenman, painted in 1680 by Mary Beale, one of the few female artists of the period.

The bed (left) is covered with a Pierre Frey Chinoiserie design fabric, copied from an 18th-century handpainted silk from China. On the French cherrywood Provence style commode is a group of 18th-century *famille rose* porcelain from China and 'peach bloom' monochrome ceramics from the 18th and 19th centuries.

In the study (right) is a tapered cabinet in *ju mu* (southern elmwood), circa 1800. The rug is from Pao Tao in inner Mongolia, with a repeating peony design, circa 1880. The lamp is made from a 19th-century blue and white underglaze pot with lid.

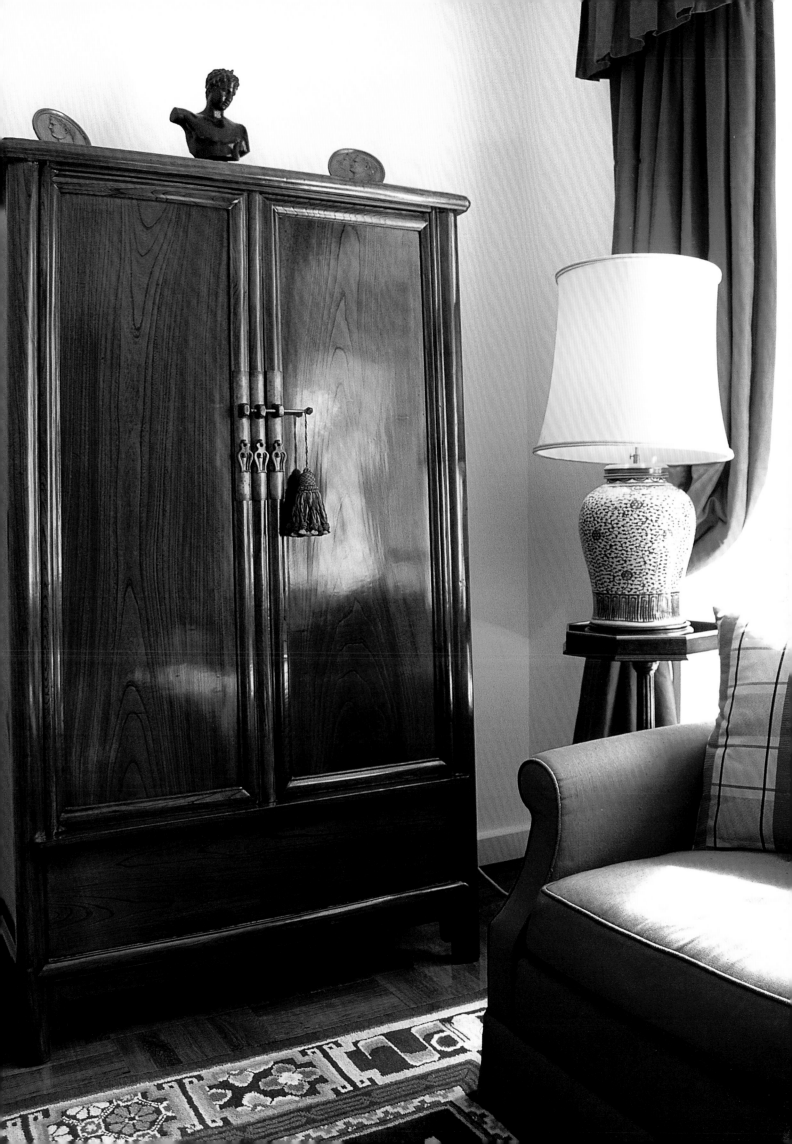

Recreating the Past

The Minneapolis Institute of Arts in the United States has an extensive collection of classic Chinese furniture housed in unique surroundings. In a departure from regular exhibition techniques, the Institute chose to import, reconstruct and furnish a 17th-century Ming reception hall and a late 18th-century Qing library within its galleries. In this way, it offers visitors first-hand views of life in a traditional Chinese home hundreds of years ago.

In today's China, such old structures are increasingly victims of modernization, so to rescue and restore buildings that would otherwise be lost forever was a major incentive for the Institute. To find such structures, the team looked to the Jiangnan region (south of the Yangzi). As Robert Jacobsen, the Institute's Curator of Asian Art notes, Jiangnan was an important area for both bamboo and hardwood furniture in the late Ming and early Qing periods. But there were obstacles: finding structures small enough to fit within the 5.8 m (19 ft) high galleries was a challenge, as was locating buildings whose timber frames still had structural integrity. Eventually, two rooms were found from the region of Suzhou in Jiangsu province and were shipped back to the United States.

The reception hall, from a courtyard-style family home in the East Dongting Hills, retains its original decorative carvings, foundation stones, floor tiles and most of the windows and wooden grills. As the most important room in the house, the reception hall expressed the social status and economic power of the family, as well as its cultural refinement and artistic taste. The carved beams, ornate cloud-and-phoenix panels in the ceiling and diagonal floor pattern point to an aristocratic household, notes Jacobsen.

The library, or study, came from a large Qing dynasty residence in Tangli, in the West Dongting Hills. Scholars would read, write, examine antiquities, converse and find solace there. Nearly all the library's wooden structural elements, carved beams, upper-storey windows, floor and wall tiles and foundation stones are original.

Placing the museum's collection of furnishings in such surroundings clearly reveals the relationship between furniture and architecture of the time. Exposed frames, natural materials, efficient designs: all are apparent in both.

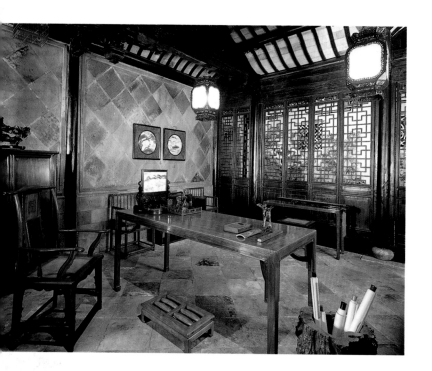

The reception hall (right) would have been used for formal family ceremonies in the traditional upper class home. Here, the carved decorative ceiling, foundation stones and floor tiles appear to be original. As the most important room in a Confucian household, the reception hall contained furniture that defined the social status and wealth of the inhabitants. Conventions dictated the placement of furniture (screens, armchairs and altar tables) as well as paintings and calligraphy. The furniture includes a large folding screen which serves as a backdrop to the seats of honour—a couch bed (*luohan chuang*) and pair of horseshoe armchairs.

The library (left) was the second most important room, and was vital to the educated elite. Here scholars would read, write and converse in a meditative atmosphere. This library is dated to 1797 by a commemorative plaque. When hardwood furniture is placed in its original context, its close relationship to classical architecture (both aesthetic and technical) is clear to see.

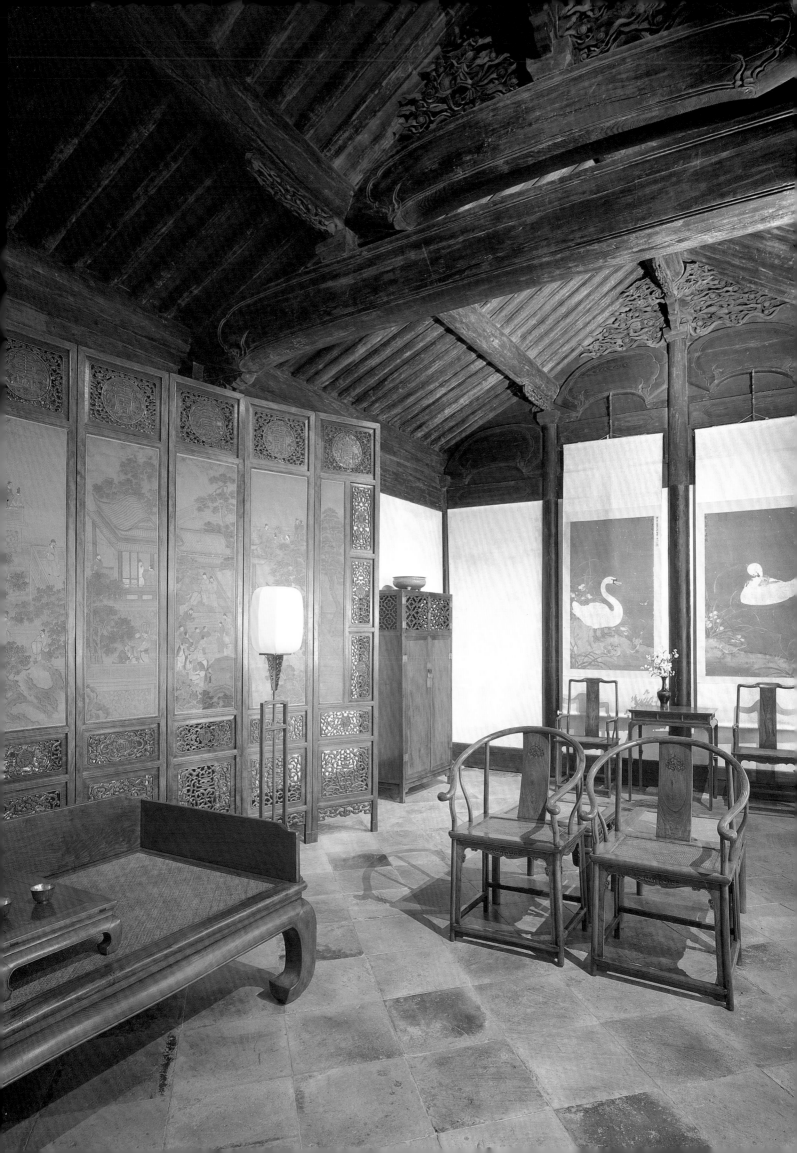

Chinoiserie Old and New

THE NEW AESTHETICS OF OPULENCE

Cinnabar red, imperial yellow, luxurious silks embroidered with dragon, phoenix and floral motifs, decorative ceramics, glossy lacquerware, jades, bronzes, ornate furniture and gemstones: the opulence of Imperial China retains its exotic appeal today. So much so that interpretations of its rich colours, patterns and textures are often found in contemporary interiors.

From China's first great dynasty—the Han (206–220 AD)—to the end of the Qing dynasty in 1911, 2000 years of Imperial rule provided countless opportunities for lavish living. In direct contrast to the Confucian principles of scholarly living, many wealthy city families lived extravagant lives in richly decorated and furnished houses. In the early 1300s, Marco Polo wrote of the "grandeurs and treasures" of Cathay, and since that time the Orient has gripped the imagination of the West, conjuring up images of a land of pagodas and palaces, exotic landscapes and tantalizing riches. Fabrics, ceramics, fragrances and spices all found their way along the Silk Road to Europe and the Americas, and helped to keep such romantic views alive.

The East India trading companies of the 17th and 18th centuries imported Chinese lacquerware, blue and white porcelains, ivories and silks to the West; their popularity encouraged European craftsmen to produce copies of the Chinese originals. Although imitations were faithful to begin with, they were soon abandoned in favour of a purely European interpretation of Orientalism and furniture, tapestries, wallpapers and more sported fanciful motifs of scenery, human figures, pagodas and exotic birds and flowers. This decorative movement was known as Chinoiserie.

In other parts of Asia, such decorative opulence was also embraced, particularly in Malaysia and Singapore, as seen in the lavishly decorated Peranakan town houses owned by the Straits Chinese, descendants of Southern Chinese immigrants. With their handpainted tiles, ornate carvings, beautifully carved bas-reliefs and mother-of-pearl inlaid furniture, the houses offer a unique diffusion of Imperial style.

Peranakan décor featured auspicious motifs to bring good luck; examples include the peony flower, which signified wealth, love and affection, and the phoenix for goodness and benevolence. Indeed, such faith in supernatural powers played an important role in life across all of China and most items in the home would have been decorated with symbols to ward off evil. Some of the most common are bamboo (the symbol of longevity), the dragon (the emblem of Imperial power and representative of the yang or male energy), the fish (said to bring wealth) and the plum blossom (for beauty and long life).

Modern, statement-making interiors often echo such Imperial splendour. Art dealer Pearl Lam's Hong Kong home is the ultimate in colourful extravagance and offers a unique interpretation of 21st-century Chinoiserie. Louise Kou's luxurious apartment blends dashes of colour with silks, ceramics, jade and silver while antiques dealer Amanda Clark takes a refined, classical approach to living with Chinese and European furniture, accented with Chinoiserie style. Robert Ellsworth's apartment, the largest single-floor apartment on Fifth Avenue, is packed with priceless antiques, and in Malaysia and Bali, two Peranakan townhouses and a family temple have been converted into a heritage museum, a restaurant and a hotel respectively.

The Feminine Touch

When Eileen and Jack Bygrave moved back to Hong Kong after two years in Singapore—their third stint living in the territory—they eschewed high rise living in favour of a ground floor apartment complete with balcony, garden and surrounding swimming pool just outside Stanley Village on the south side of Hong Kong island. "We have lots of patio space, are set back from the main road and are yet just five minutes to the beach. We've even had a baby owl visit us on our balcony."

Having moved 23 times in Asia and Europe during her married life and amassing enough possessions to fill two homes and an attic in the UK, Eileen Bygrave knows how to create a relaxed, comfortable home. She furnished the bright airy interior with pieces from Singapore—the altar and coffee tables, the screen-panel doors, the desk—along with others found in Hong Kong, China and Macau.

Touches of sizzling colour—brilliant lemons and limes, shocking pinks and deep purples—offset the antique furniture. In front of French windows leading onto the plant-filled terrace hangs a traditional Chinese birdcage, complete with a wooden parrot. Such a lighthearted decorative approach adds to the relaxed feel of the space. A Victorian chaise longue, which Bygrave imported originally as part of the furnishings for a shoe boutique, is a favourite spot for sipping tea and reading the papers on a Sunday morning.

Bygrave cites the two pieces of calligraphy hanging in the red-walled dining room as favourites. "We decided over 10 years ago that we must go up the Yang Tze Kiang River to see the interior of China before the Three Gorges Dam obliterated the area. When I saw this pair of scrolls I fell in love with the graphic character of the script. Remembering how I used to struggle with Chinese calligraphy at school, I marvelled at the sheer skill and beauty of the brushstrokes."

For the Bygraves, Chinese decorative style fits perfectly with their global lifestyle. "We both feel totally at home with these pieces and we find they fit equally well in Europe too. They can lift a nondescript environment, sit well in a contemporary setting or enrich even a cluttered one."

The laid-back village of Stanley on Hong Kong island's southside provides a welcome respite from the fast pace of city life. Here Eileen Bygrave has created a relaxed home which celebrates decorative style in a contemporary way. Carved woods, sizzling colours and feminine patterns add a personal touch to the light-filled interior. The desk and mirror combination in the living room (right) are particular favourites; the desk was sourced in a Singapore warehouse; the mirror was framed using a wooden carving originally from a Chinese wedding bed found in Shanghai.

A sizzling pink tray from chic Chinese emporium Shanghai Tang livens up the rattan-topped Kang table (left, detail) in the living room.

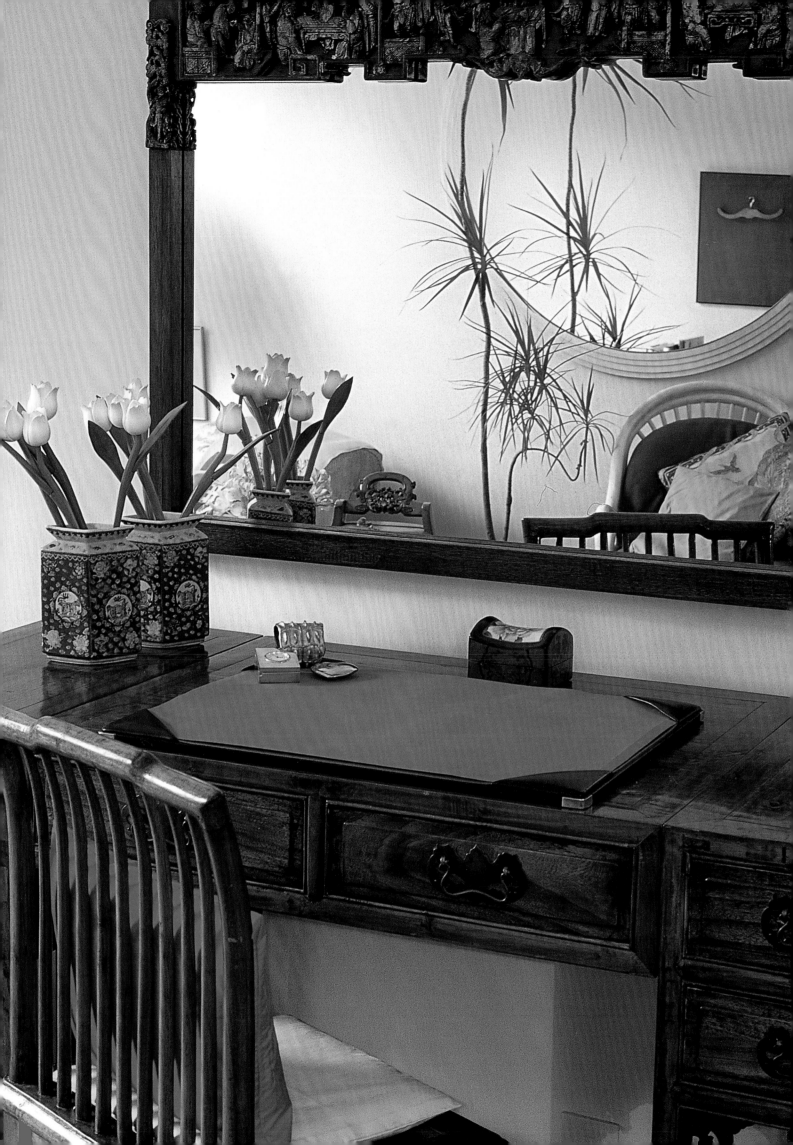

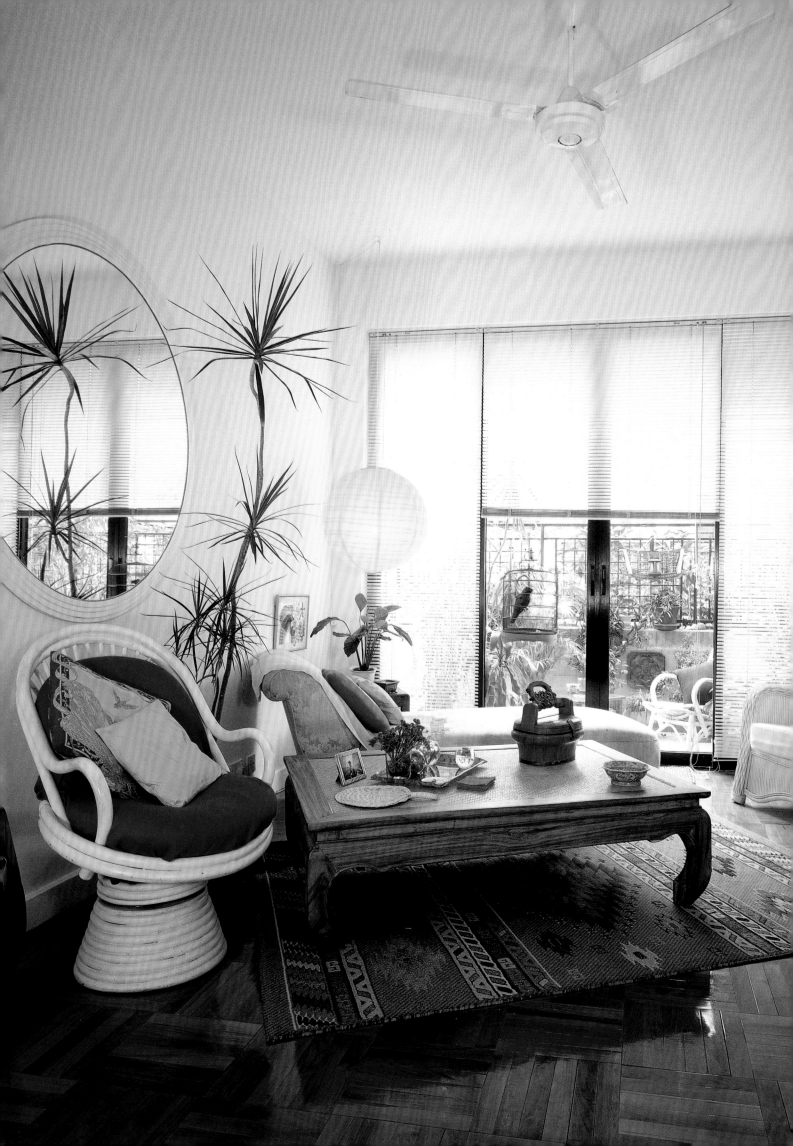

In the dining room (above), a wall has been painted red to provide a striking backdrop for a pair of silk calligraphy scrolls found along the Yang Tze Kiang River. One scroll bears the pre-battle thoughts of Chu Ker Liang, a famous advisor to army generals at the time of the Three Kingdoms. The other scroll reveals his thoughts post-battle. A carved door panel and altar table are against the opposite wall.

Brightly coloured cushions are scattered on the Victorian chaise longue (below), positioned near the French windows looking out onto the plant-filled terrace.

The light and airy living room (left) is a mix of warm woods, wickers and rattans, with dashes of vibrant colour from brilliant lemon, lime, pink and purple silk cushions. The cushions were made in Shenzhen using silks found in Hong Kong's Chinese Arts and Crafts shop. The rattan-topped Kang table functions as a coffee table and a display area for decorative pieces. In front of the French windows hangs a traditional Chinese birdcage—complete with wooden parrot.

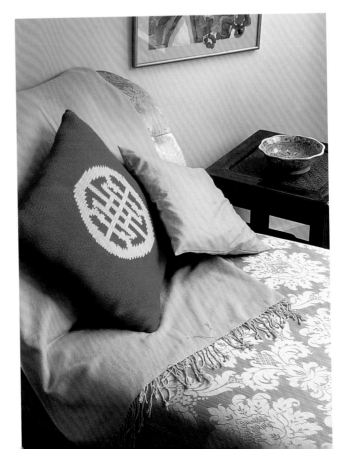

Living with Collectibles

With her Shanghainese ancestry, a childhood spent in Africa and extensive experience in the high-end retail business, it is not surprising that Hong Kong-born and based Louise Kou opts for unexpected and original decor combinations. Taking a modern yet serenely opulent approach to living, Kou draws on her cultural heritage as well as international trends in her 280 sq m (3,000 sq ft) home, which nestles at the base of The Peak.

Devoted to the art of display, she likes to mix and match. "I am a collector. I love to mix different cultures and styles and bring beautiful objects together in harmony," says Kou, who has used shades of cream and palest green as a backdrop to her furnishings and accessories.

Kou turned what was a three-bedroom apartment into a one-bedroom space which benefits from high 3 m (12 ft) ceilings, unusual in Hong Kong. Her interior blends textures such as black cowskin rugs, cream suede upholstery, red silk hangings and floral Chinoiserie textiles ("too delicate to wear but make nice throws"), with an antique Chinese day-bed, Tang ceramics, Tibetan silver, white jade, huge amber, turquoise and coral beads and silver export porcelain.

In a bid to make her home cosy rather than open, Kou created alcoves and a study area with folding doors that can be rolled back if desired. "I like small, intimate corners," she explains. In the bedroom, soothing padded pale green silk walls reflect the greenery outside and add a touch of Zen-like tranquility to the space. "Wherever I am, I collect," Kou says. "Purchasing solely in Hong Kong is limiting. I love ethnic stuff and beautiful things from all over the world."

In the dining room (right) Kou uses ceramics, jade, silver and crystalware to produce an innovative tablesetting. Antique Chinese ceramic sugar bowls become soup containers and pieces of old jade are used for placemats, napkin rings and chopsticks stands. Burmese lacquerware and silver bowls provide a contemporary centrepiece. On the floor is a black cowskin rug; a rich red silk hanging serves as a backdrop to a large Tang dynasty horse with an oversized coral bead collar.

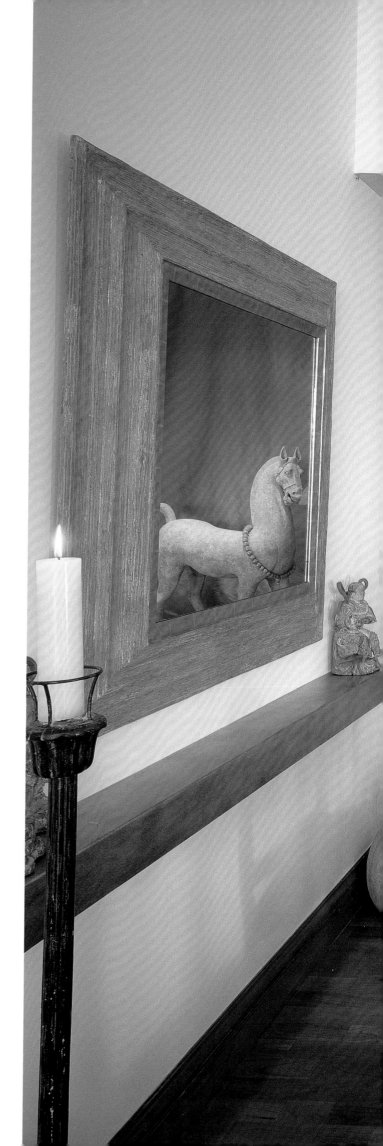

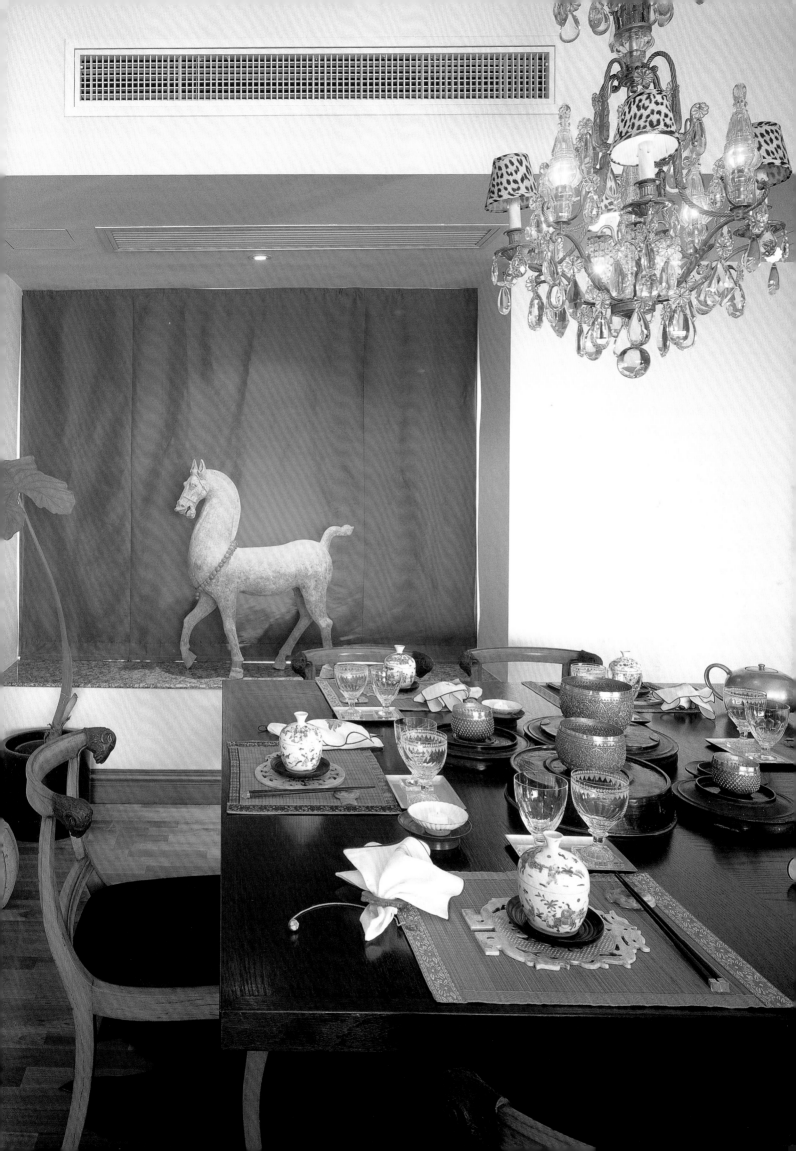

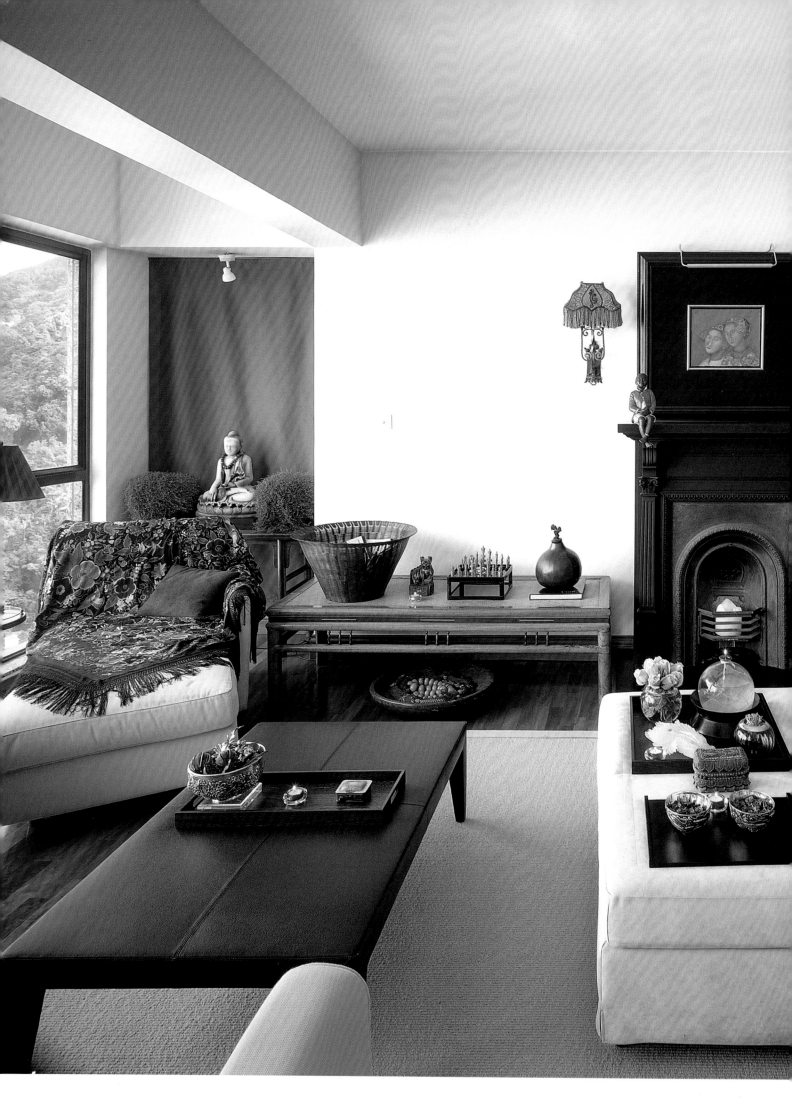

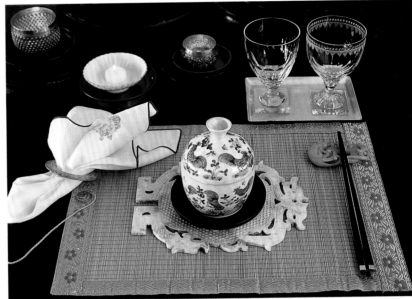

Functional art: antique collectibles are used as modern-day tablesettings (above, detail). "I love to collect things, but also like to use them—one of the best ways is as tablesettings."

The living room (left) blends antique and modern and is testament to Kou's commitment to living with her collectibles. A contemporary cream sofa and chaise longue (draped with a chocolate-coloured Chinoiserie floral throw) are juxtaposed with an antique Chinese day bed. Collections of objects fill the room, including white jade, Tibetan silver, ironwood figures from Bali, Chinoiserie lampshades, amber and turquoise beads.

Delicate carved silver betel nut leaf holders have been collected during travels in Asia (below, detail).

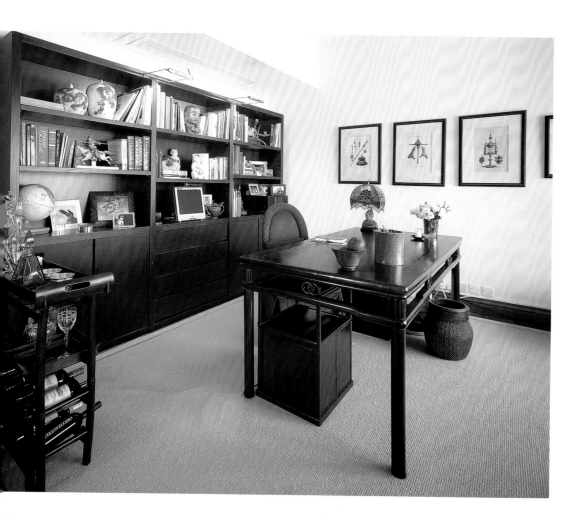

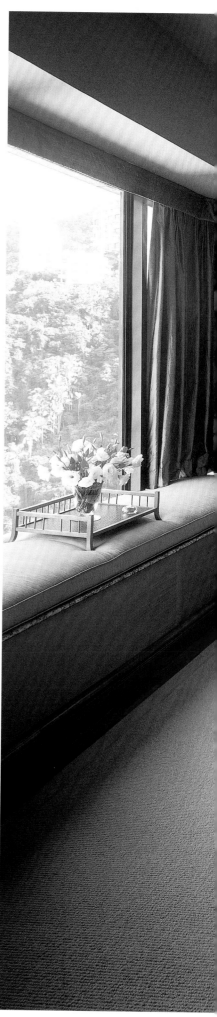

Kou decided to transform her large apartment into a more intimate environment by creating a series of alcoves off the main living room. For the study (above), she installed folding doors that can be rolled back if required. The table was an old calligraphy table which has been reduced in height to function as a desk. The turquoise beaded lamp, made in Europe in the 1930s, is an example of Chinoiserie.

Simple luxury: in the serene bedroom (right), the soothing green padded silk walls and window seat mirror the greenery outside. Slate grey and cream Italian bedlinens, a neutral carpet and raw silk drapes continue the theme of muted elegance.

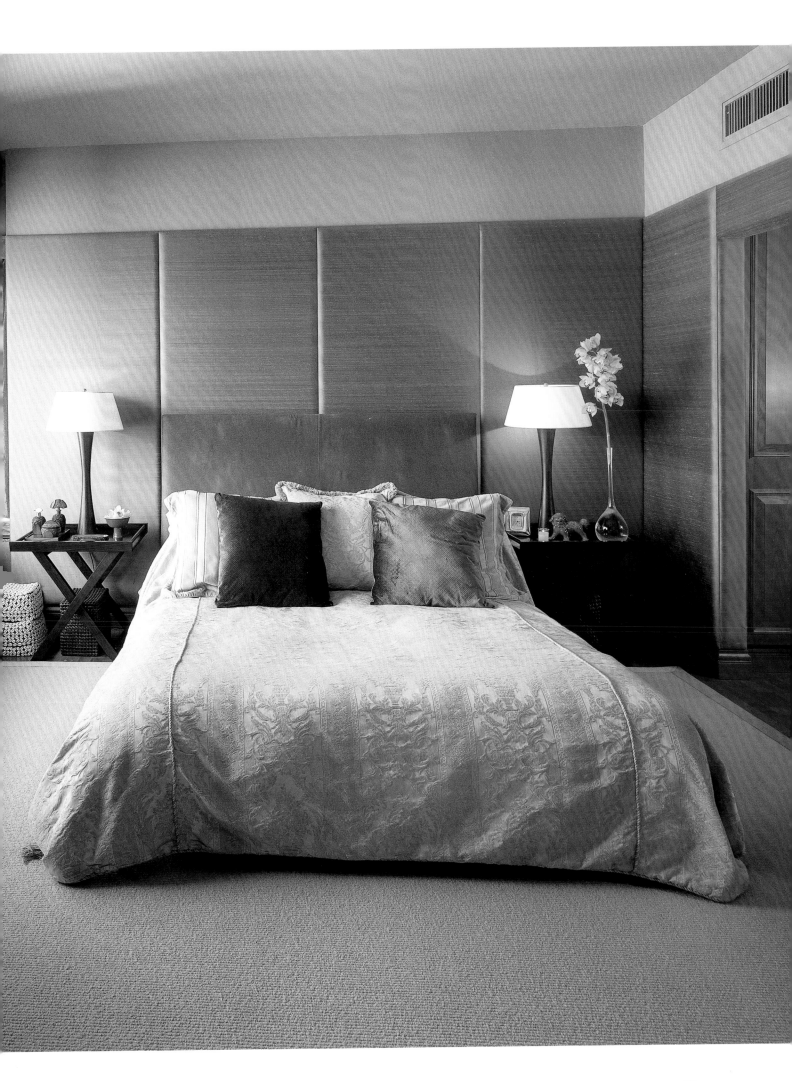

The New Orientalism

The words colourful, extravagant and opulent can hardly begin to describe the palatial home of Contrasts Gallery owner Pearl Lam. In what looks like a modern-day Imperial palace transported to the leafy environs of Jardines Lookout on Hong Kong island, the lower floors of Lam's home are filled with specially commissioned pieces, Chinese antiques and her own inimitable creations.

A few years ago, Lam hosted an exhibition here, "The Oriental Curiosity—21st Century Chinoiserie", in which she asked avant-garde and fashion designers from the West to interpret Orientalism. Mark Brazier Jones, Franck Evennou, Danny Lane and Andre Dubreuil lined up with Azzedine Alaia, Alexander McQueen and Maximiliano Modesti to design exhibits that ranged from the exquisite to the truly bizarre. A selection of the pieces are still in Lam's home today, which remains decorated as it was for the exhibition in an interpretation of John Nash's flamboyant early 19th-century Royal Pavilion in Brighton, England.

Everywhere, there are cascades of semi-precious stones, crystal beads, peacock feathers, fringing and ornate embroidery. From many of the ceilings hang over-the-top chandeliers; walls are painted in vivid blues, purples, yellows, reds and golds. *Trompe l'oeil* work—including Chinese latticework panels and Warholesque murals—makes unmissable visual statements. Lam is the first to admit that her "philosophy is eclecticism", and here fantasy has been allowed to run wild.

In such a maximal environment, Lam displays her quest to explore "a global decorative language" in which East and West, old and new, avant-garde and Baroque, collide in a glorious explosion of decorative art.

Extravagance and opulence define Pearl Lam's theatrical dining room (right). Above the table hangs an 'Emperor' chandelier by Contrasts Gallery; it incorporates lengths of semi-precious stones inspired by a Qing dynasty headpiece. The candelabra in the centre of the table is by Franck Evennou; the tableware is from Thomas Goode and the chairs were designed by Caroline Quartermaine. On the wall behind is a Warhol-esque *trompe l'oeil* by New York artist Elizabeth Thompson.

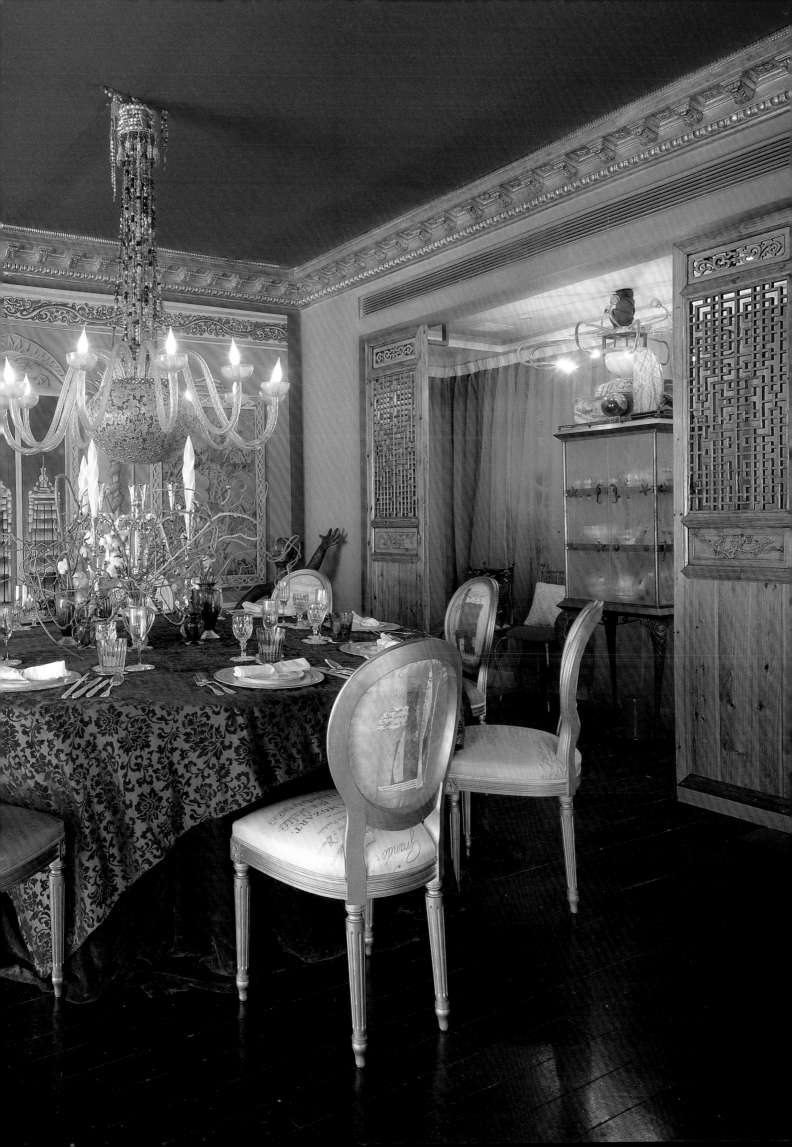

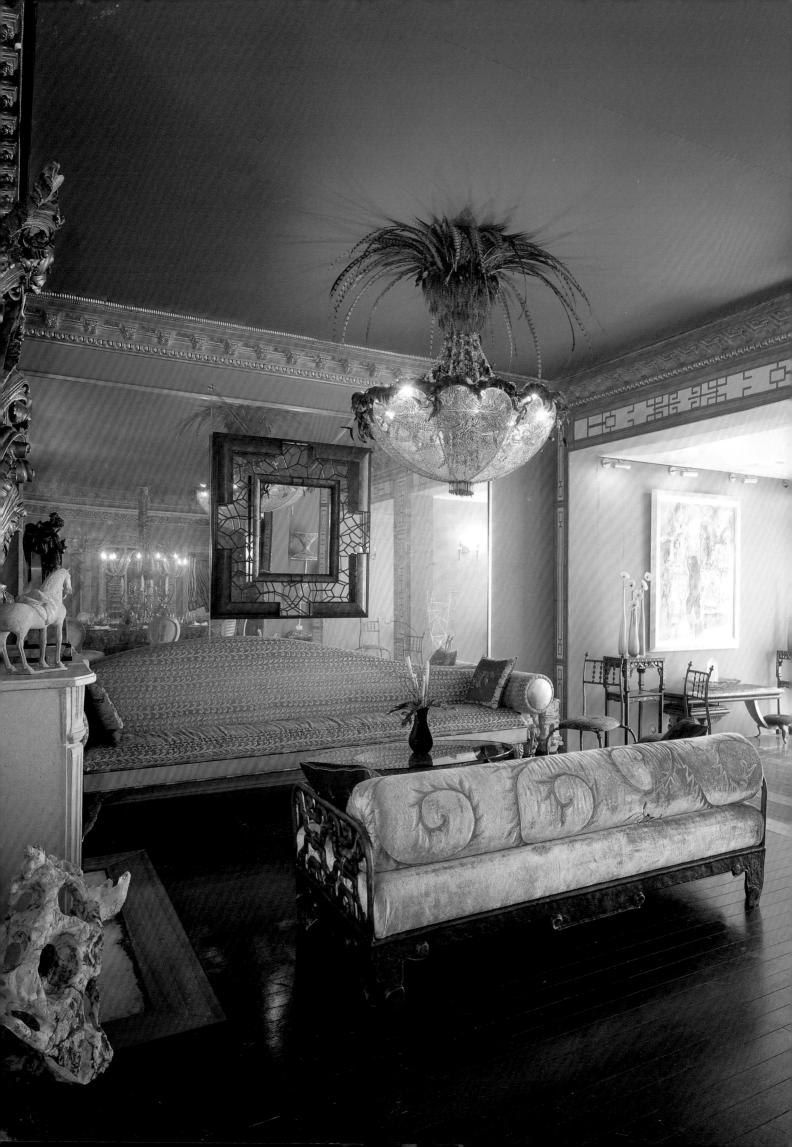

Regal purple, rich red, Imperial yellow and cool turquoise feature in gallery owner Pearl Lam's decadent Hong Kong home. Gold ceiling mouldings, *trompe l'oeil* Chinese latticework panels and furnishings by top Western avant garde and fashion designers redefine Orientalism for the 21st century. Furnishings in the living room (left) include a bronze-framed sofa with cloud-motif ends by Franck Evennou covered with hand-embroidered silk velvet by Maximiliano Modesti and an ornate feather-trimmed 'Coca-cabana' chandelier by Contrasts Gallery which is encrusted with jade and Swarovski crystal beads. On the rear wall hangs a mirror by Andre Dubreuil.

In an alcove off the main living room, a white upholstered Throne Chair by Mark Brazier-Jones contrasts with turquoise walls and sheer purple drapes (above). On either side stand a pair of embroidered and bejewelled 'Corsette' lampshades with nipped-in waists by Contrasts Gallery on bronze stands by Franck Evennou. They were inspired by the Chinese *cheongsam*.

In the Baroque marble and gold entrance hall (above), ornate decorative mirrors and picture frames line the curvaceous purple walls and a show-stopping winding staircase leads to the upper levels. In the centre is another Throne Chair by Mark Brazier-Jones, this one upholstered with an 18th-century Chinese silk shawl with glamorous fringed edges. The shawl was purchased in London.

An easy chair (below) is upholstered with a fringed, hand-embroidered gold silk fabric by Maximiliano Modesti. The fabric design is a contemporary version of the traditional Chinese cloud motif.

Cultures and decorative approaches collide in the palatial living room (right). In the foreground is a Pylon Chair by Tom Dixon; to the right is a claw foot sofa by Mark Brazier-Jones. Standing on the mantelpiece is a pair of Tang horses.

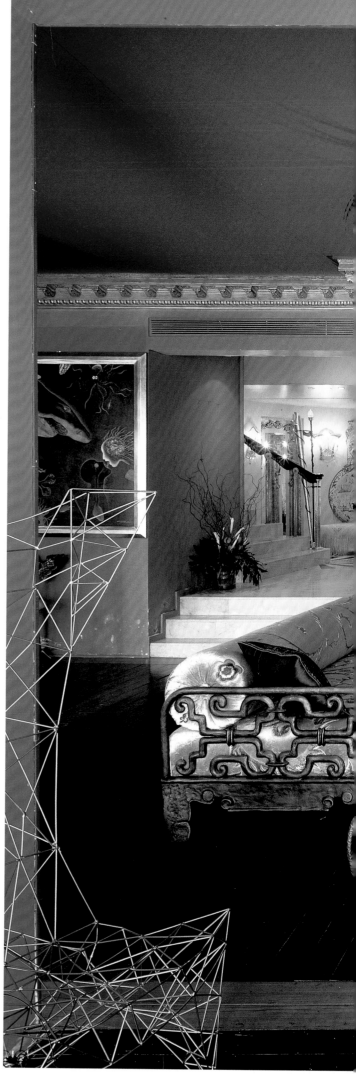

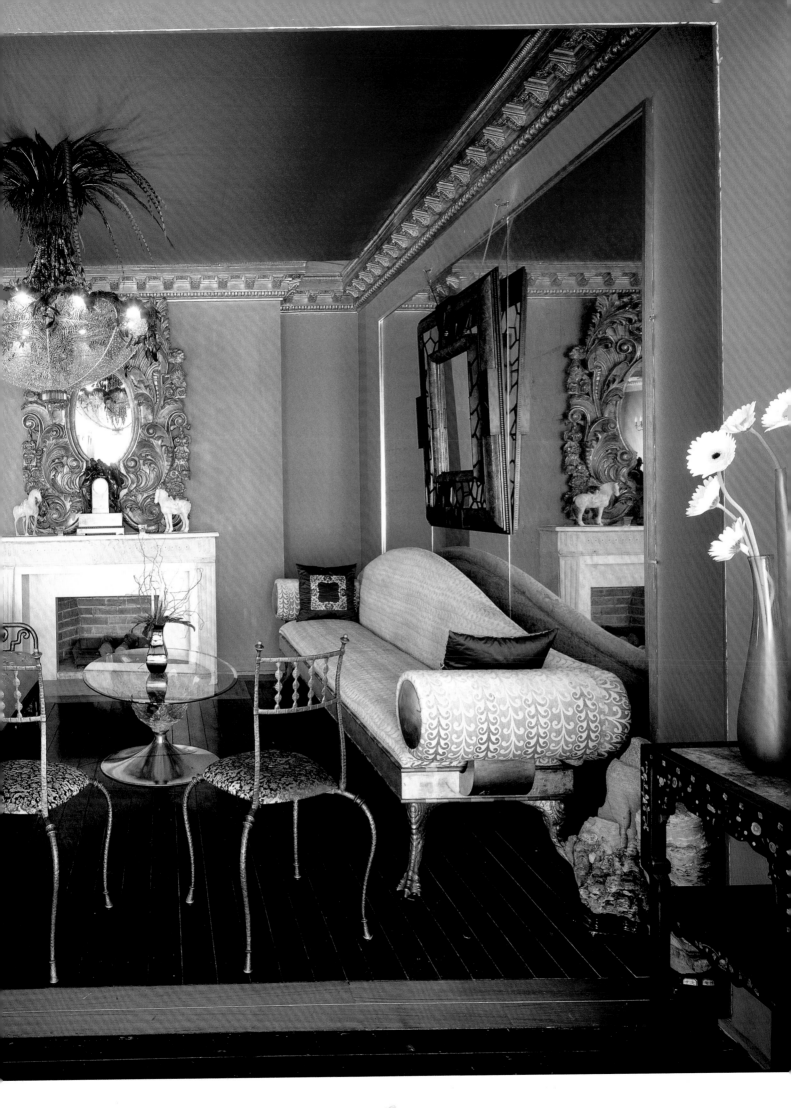

Brilliant Baroque

A gilded domed ceiling, which would be more at home in a Tuscan villa, is not what you would expect to find in a townhouse tucked away in the heart of sleepy Shek-O village on Hong Kong island's south coast. Add to this a huge 1930s wood-framed lantern from Shanghai, which lights up the cool limestone flooring and *trompe l'oeil* walls, and it is obvious that this interior is going to provide some surprises.

Home to top Hong Kong—and international—hairdresser Kim Robinson, the three-storey house has been infused with more than a touch of European opulence. Robinson turned what was a bare shell into a bohemian refuge, accessed by twisting stairwells and furnished with a mix of Western Baroque and Chinoiserie pieces.

The domed entrance hall leads up into an open-plan dining and living room, where windows at both ends allow light to flood in, even on an overcast day. Small-scale grandeur is key: there are Victorian-style pistachio green chaise longues, crystal chandeliers, distressed walls and rich red decorative Chinoiserie fabrics with phoenix and floral motifs strewn casually around. In the corner stands an old painted screen from a Beijing dress shop, spotted *in situ* by Robinson and procured for his home. The double-height ceilinged dining room is more low-key, with high backed chairs in cream fabric and a wooden table dressed with contemporary pale green celadon ware, raffia mats and simple chopsticks. A pair of bamboo and paper lamps perch on top of cabinets. At night they add a soft light, supplemented by the flamboyant silk-fringed chandelier hanging above.

A self-confessed design addict, Robinson admits that he steers well clear of the 'normal'. It's a term that could never be applied to his historical mix of Western and Eastern styles in one of the most modern cities in the world.

Kim Robinson transformed what was a 1970s-built box-like house in Hong Kong's Shek-O village into an historic extravaganza. Distressed walls, pistachio green chaise longues, decorative Chinoiserie fabrics and an old painted screen add a flamboyant touch to the living room (right).

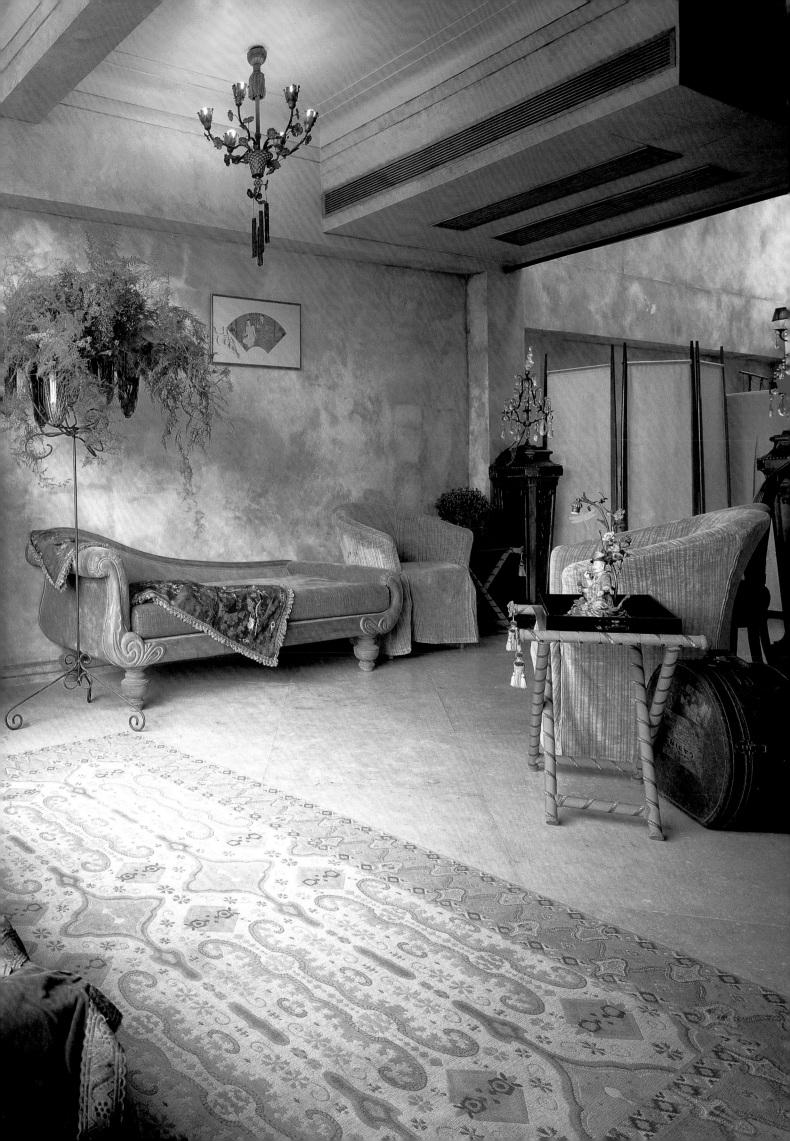

Visitors to Kim Robinson's three-storey Shek-O townhouse are in for some surprises. The entrance way (below), with its gilded domed ceiling, cool limestone flooring, 1930s Shanghai lantern and stained glass doors, sets the scene for an interior which oozes Baroque opulence with flashes of Chinoiserie style.

The first floor (right) is devoted to living and dining. High backed chairs surround a distressed wooden dining table set with celadonware, chopsticks and raffia matting. In the day, natural light fills the room due to double-height windows and a skylight; at night, lighting is provided by a glittering chandelier and a pair of bamboo and rattan lamps. On the wall is a set of three glass and mother-of-pearl Chinese mirrored pictures.

A Touch of Luxe

Chinese influences weigh heavily on a lushly designed restaurant in the heart of London's Soho district. BAM-BOU, which takes up four floors of an old Fitzrovian townhouse in Percy Street, combines simple Vietnamese style with the faded grandeur of French colonialism. The Chinese have long been bound up with the history of Vietnam—they ruled from 200 BC to 938 AD—and even today the ethnic-Chinese (Hoa) constitute the largest single minority group in Vietnam. It comes as no surprise, therefore, to find temples and homes that once belonged to rich mandarins still intact across the country today.

BAM-BOU was conceived by Mogens Tholstrup, managing director for Signature Restaurants, and designed by Andrew Norrey. Authenticity is key: the cuisine is inspired by authentic Vietnamese recipes, jazzed up to appeal to cosmopolitan diners; the furnishings—including paintings, light fittings, teak furniture and bamboo-clad bars—were sourced during a shopping spree in Vietnam. Downstairs, papyrus and ivory tones dominate with leafy plants and contemporary Vietnamese art offering a soothing airy ambience. But upstairs in the private Lotus Rooms it is a different story. A traditional Chinese palette of rich red, dark wood and strong gold dominates in what could be considered a contemporary recreation of the traditional opium den.

Calligraphy, carved latticework window screens, lacquerware and silk lanterns furnish the series of small lounges and bars which make up BAM-BOU restaurant (right). Designer Andrew Norrey has finished the walls in deep and luxurious lacquered crackle glazes to add to the ambience of faded grandeur. In this third-floor lounge are tactile soft furnishings which provide a touch of luxe.

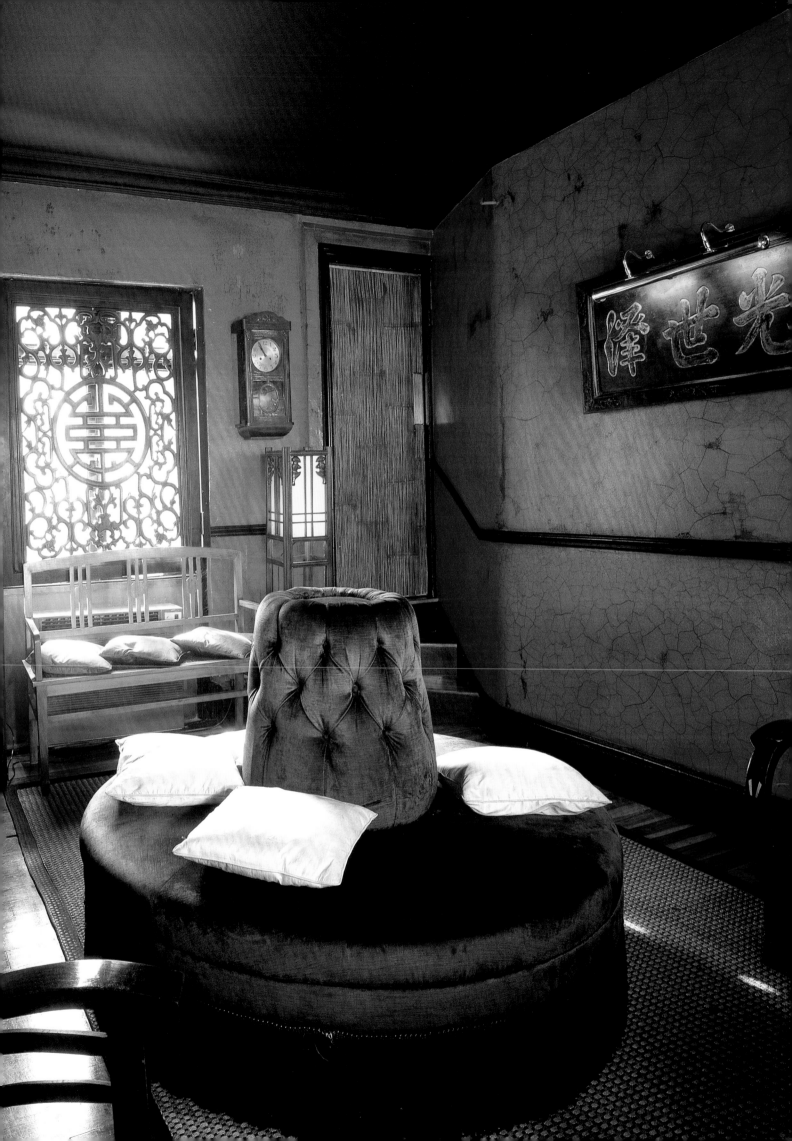

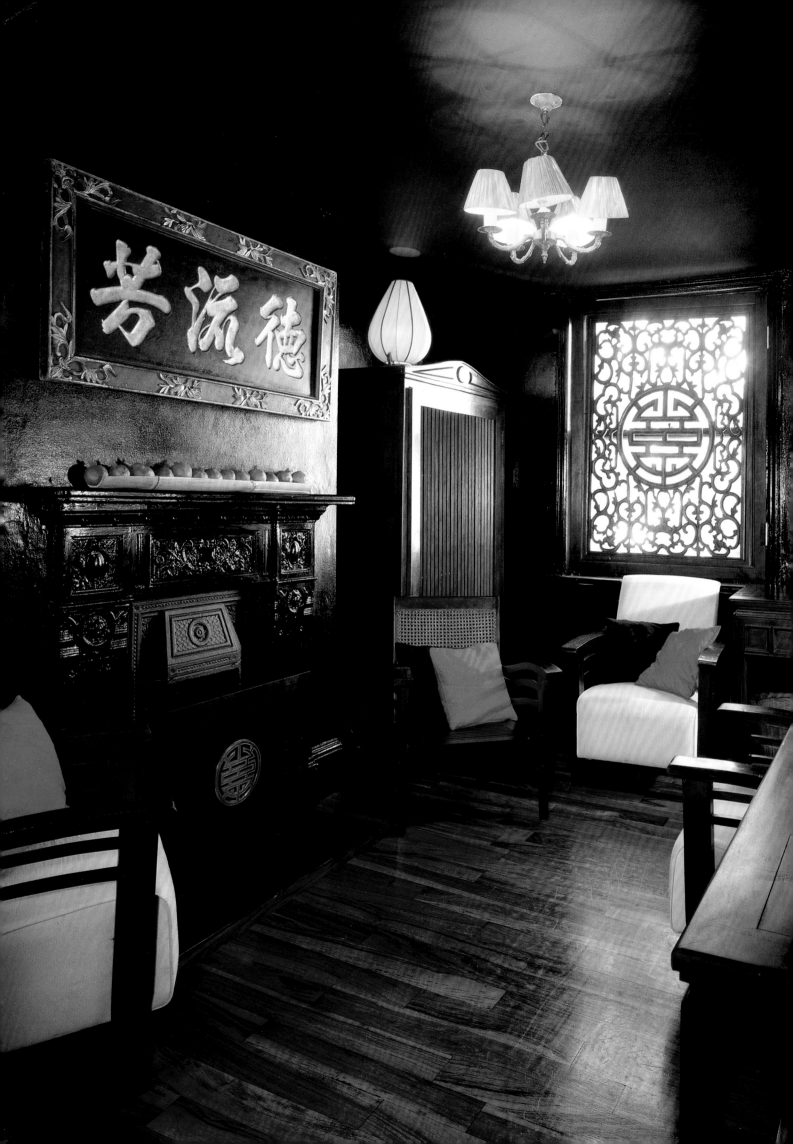

A sanctuary from the hustle and bustle of the busy West End. A series of intimate rooms over four floors (left) feature open fire-places and cosy corners—ideal for dining, drinking and conversation. On the walls hang old photographs and prints sourced in Saigon.

In this corner (above), the decor blends rich chocolate brown woods with soothing shades of ivory and papyrus. The teak wood furniture was shipped over from Vietnam. Cream upholstery adds a modern edge to the armchairs.

Living with Antiques

American architect Alec Stuart has been living in Hong Kong for 10 years and since that time has been collecting antique Chinese furniture, art and Tibetan carpets. His Tin Hau apartment, which he shares with his wife and young child, benefits from high ceilings and a free-flowing sense of space and is testament to the fact that there is nothing old-fashioned about living with antiques.

By painting the walls of his home in vivid lilac, midnight blue and lime green colours; covering the floors with an extensive collection of geometric Tibetan rugs; and throwing in less conventional touches, such as a custom-designed Chesterfield-style sofa in taupe velvet, a voluptuous modern armchair in deep blue and a modern reworking of a traditional day bed in biscuit-coloured suede, he has created a classic yet contemporary home.

Stuart views his design approach as one of modern opulence. "Chinese furniture works well as it has straight lines and is very modern looking," he explains. Original touches include a landscape painting by Mainland artist Jiang Bao Lin and a decidedly contemporary looking collection of antique Tibetan carpets dating from the late 19th-century to the 1930s. Stuart also admits to an "Edwardian sitting-room thing going in" in the living room with its lush fabrics and country-house style floral sofa. With such a mix of patterns and decorative styles, it would be easy to fall prey to decorative chaos but in this apartment the blend is successful. "If the colours match it all works," says Stuart. "That's the most important part of any interior."

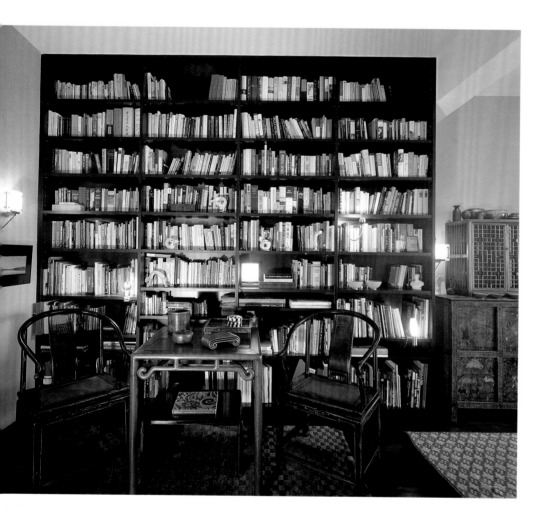

Stuart aims for a lush modern aesthetic within a classical framework. The entrance hall (left) is reminiscent of a Chinese scholar's study with a huge floor to ceiling bookcase housing stacks of books, acrobatic tomb sculptures and other collectibles. Two horseshoe armchairs flank an antique table; to the right is a painted 18th-century Tibetan cabinet.

To ensure the apartment has plenty of light, internal walls have been kept to a minimum. The collection of antique Tibetan rugs, which covers every inch of floor space (right), adds a sense of continuity between the living and dining areas. By keeping colours consistent, Stuart ensures decorative cohesion.

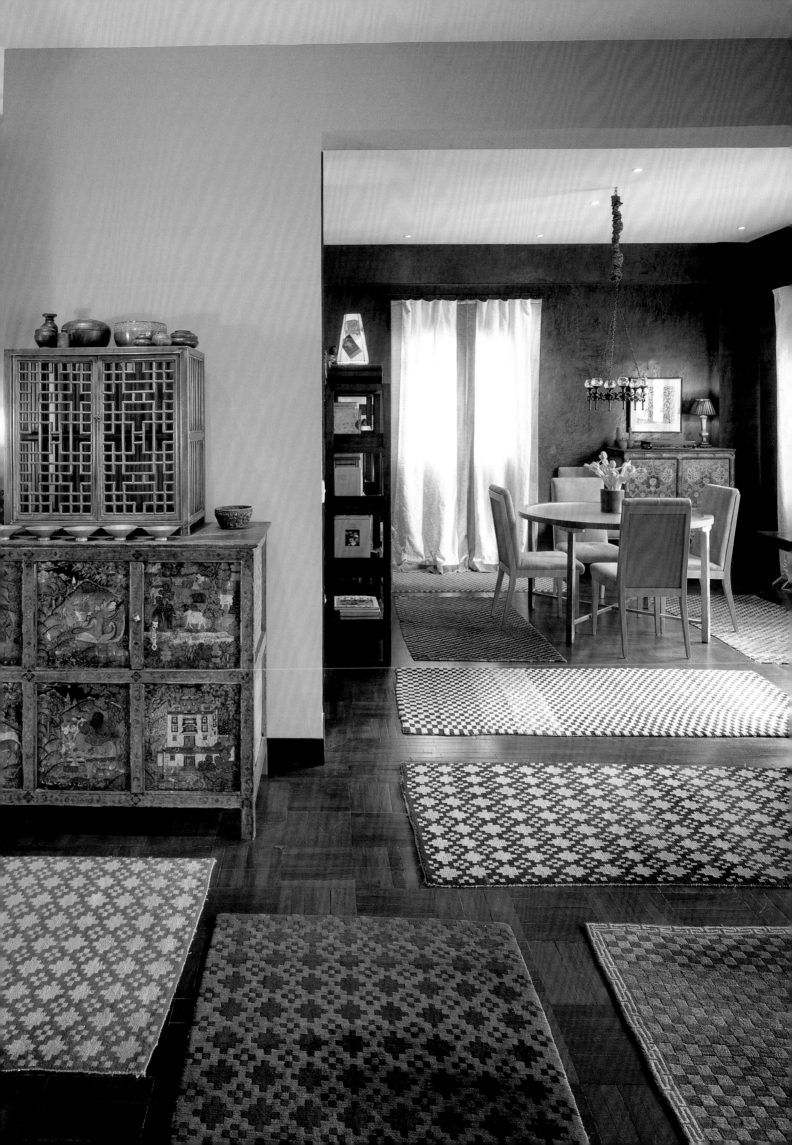

In the open plan living room (right) is a luxurious custom-designed Chesterfield style sofa alongside a deep blue armchair and an Edwardian-style floral sofa. The Chinese coffee table is from Shaanxi province and is made of elmwood. The floor is covered with part of Stuart's extensive collection of antique Tibetan rugs dating from the late 19th to the early 20th century.

The lime green walls in the study (above) perfectly offset a biscuit coloured suede day bed, a modern interpretation of a traditional Chinese design. Asian textiles have been used to good effect: Cambodian silk covers vibrant green bolsters and a Tibetan door cover from Lhasa has been turned into a window blind. Built-in drawers under the day bed provide extra storage space.

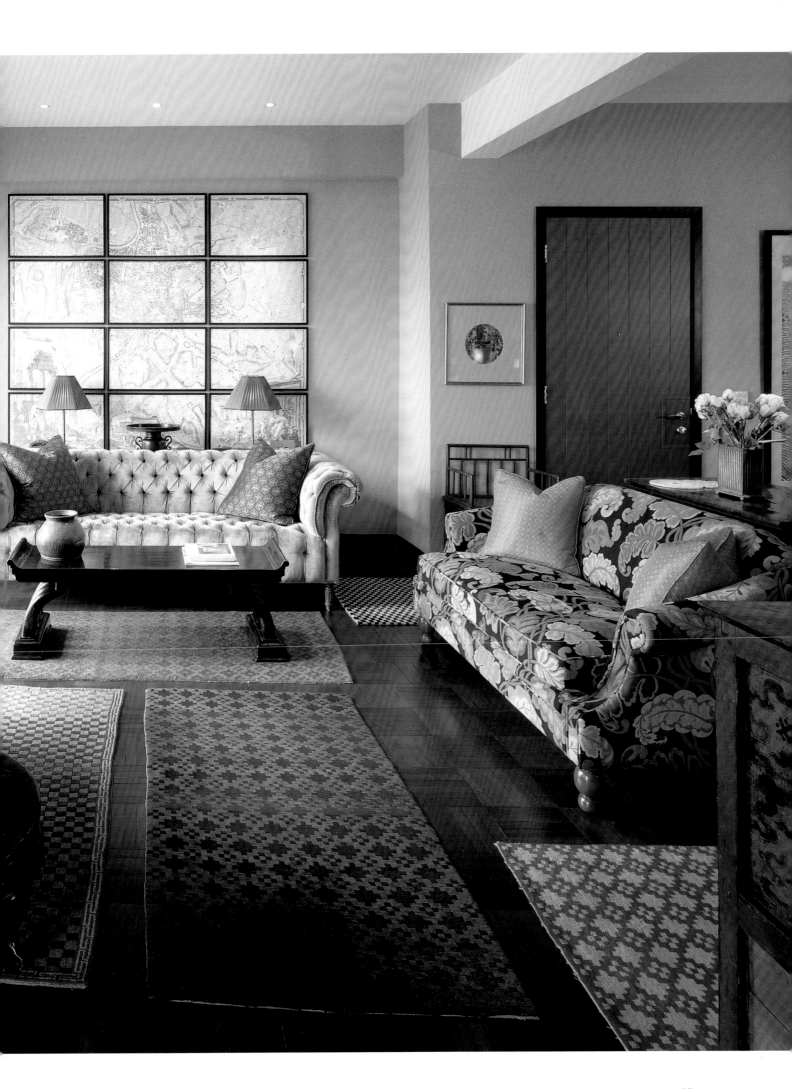

In the master bedroom (above) is a Ming-style reproduction cabinet from Beijing and a petite chair from Shaanxi province. The bamboo blind has been backed with an ethnic batik from Yunnan province. "I like to put Chinese and Asian objects together in a Western manner," explains Stuart.

The dining room (right) leads off the living room and mixes antique and modern pieces. Against a backdrop of midnight blue Venetian plaster walls is a painted Tibetan chest, a pair of dark wood bookcases topped with scroll end stands and Stuart's own design dining table comprising a stainless steel frame with a walnut veneer rim and frosted glass top. The high-backed chairs are made of cherrywood and suede.

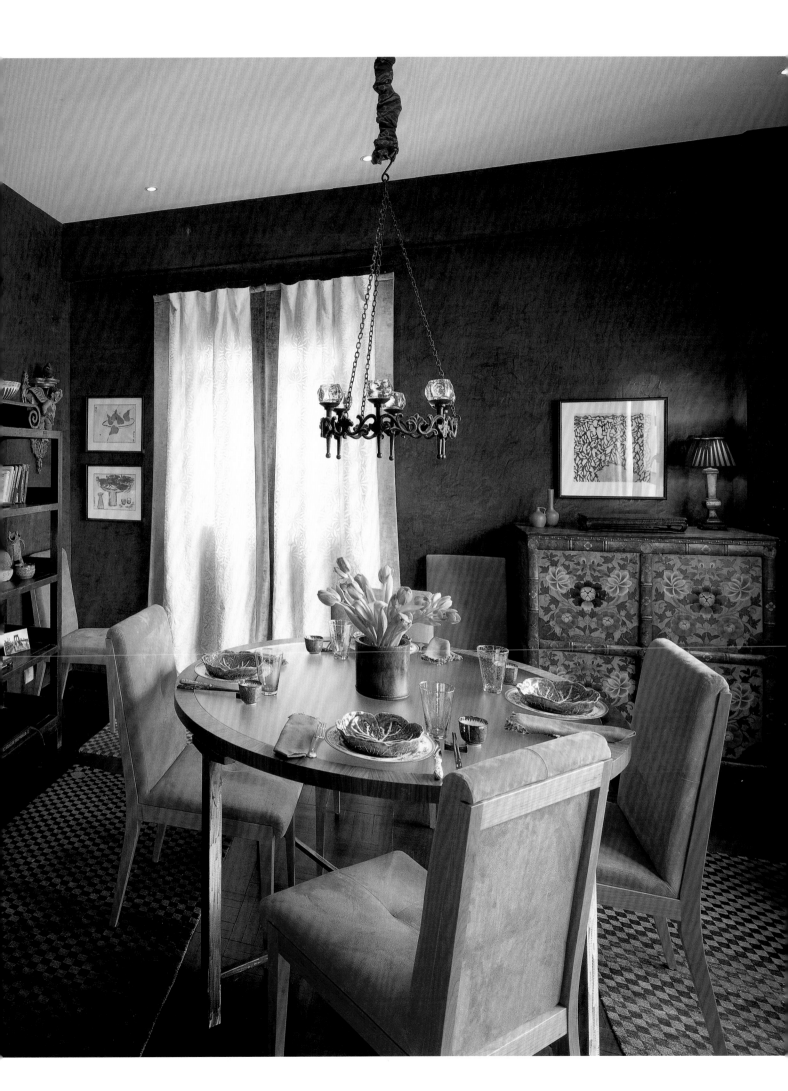

A Fascination with Oriental Art

American artists Brad Davis and Janis Provisor left the New York art scene in the early 1990s to spend a year in the East. "We packed our watercolours and went to China for an adventure," explains Provisor. Both had long been fascinated by Asian art, especially calligraphy and landscape painting, and this led to the desire to integrate their artistic sensibilities into a high end craft. Today they design (using watercolours) and produce (in a workshop in Hangzhou province) a luxurious range of wild Dandong silk carpets inspired by Chinese calligraphy, woodgrains and nature-related motifs under the label Fort Street Studio.

Their Hong Kong apartment, located on the hills overlooking Happy Valley, offers a very personal interpretation of Chinese style. They have brought their artistic sensibilities into play by cleverly mixing cultures (Chinese, Asian, European and American) with textures (fake furs, feathers, velvets) and vivid colour contrasts (pinks, greens, reds). Inside, one of their carpets, a shimmering pale pink and green creation, defines the living room. In the dining room the paint effect table is in Tibetan colours of burgundy and mustard yellow. "Everything here we bought whilst in the region. We like to mix modern with Asian. We try to find things that are somewhat eccentric," says Provisor.

The artists, whose work hangs in New York's Metropolitan Museum of Art and the Museum of Modern Art, have brought a unique decorative vision to bear in their home. Colours, textures, styles and eras come together effortlessly, enhanced by collections of Chinese, Italian and German glassware, calligraphy brushes, tiny teapots and ceramic bowls brimming with jade and stones. And, as befits their profession, the walls are covered with Chinese landscape paintings, calligraphy scrolls and their own watercolours.

Covering the living room floor (right) is a shimmering pale pink and green carpet entitled 'Amorphous'. Against the wall is a huge 18th-century opium bed. For added comfort, the bed has been covered with luxurious silk and velvet cushions; a glamorous throw made of gold brocade from Hangzhou and leopardprint fabric is draped over one end.

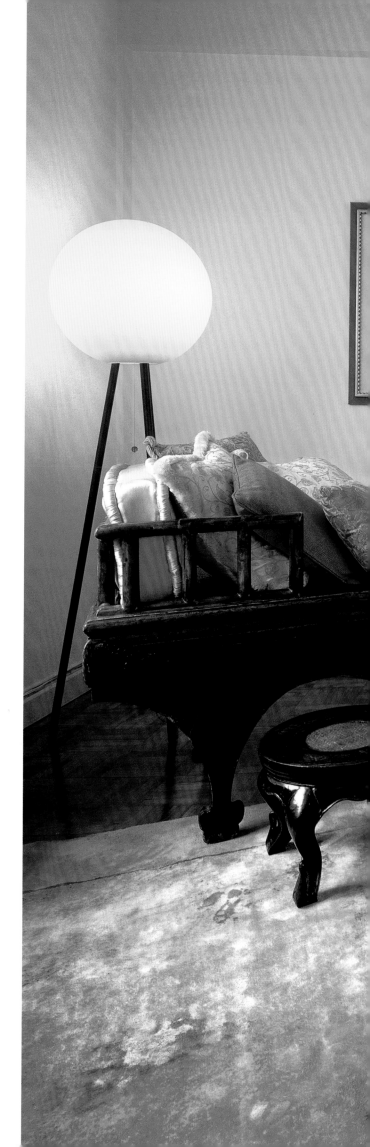

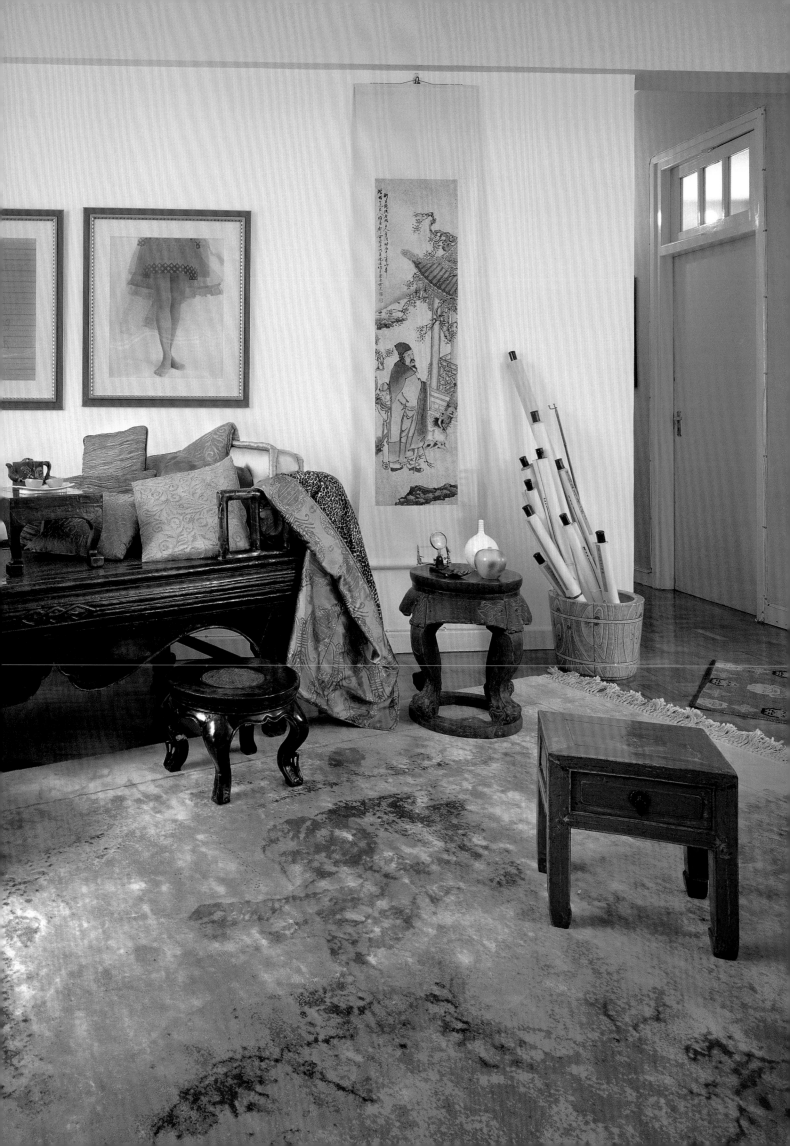

In the living room of Brad Davis and Janis Provisor's apartment (right), a sheepskin throw is draped over a pistachio green sofa; a 1940s chair is covered with leopard-skin print fabric and an Isamu Noguchi lamp stands in the corner. Hanging above the brick fireplace is a watercolour by Janis Provisor; on the mantlepiece is a collection of Italian glassware from the 1950s alongside antique Chinese jars and vases. On the wall hangs a pair of calligraphy scrolls.

The dining room table (left, above) has been double lacquered and scraped to look like a painted surface. The pale green upholstered chairs are by Gio Ponti; the tableware is Fort Street Studio's own design. On the altar table is a collection of coloured glassware from Germany alongside Western-style Chinese ceramics. "We try to find things that are eccentric and European-based; things that are Chinese but don't necessarily look Chinese." Above the altar table is 'Daddy's Girl', a painting by Janis Provisor.

A fake fur bedspread and Chinese brocade pillows add a touch of glamour to the master bedroom (left, below). The wardrobes are covered with gold leaf flecked Chinese painting paper and door handles have been replaced with carved jade pulls. A pair of cabinets from Shaanxi province flank a Chinese scroll painting that has more than a hint of Japanese style about it. On top of a cabinet is a theatre hat from Suzhou. In the hallway is a series of illustrations by Hong Kong artist Wilson Shieh.

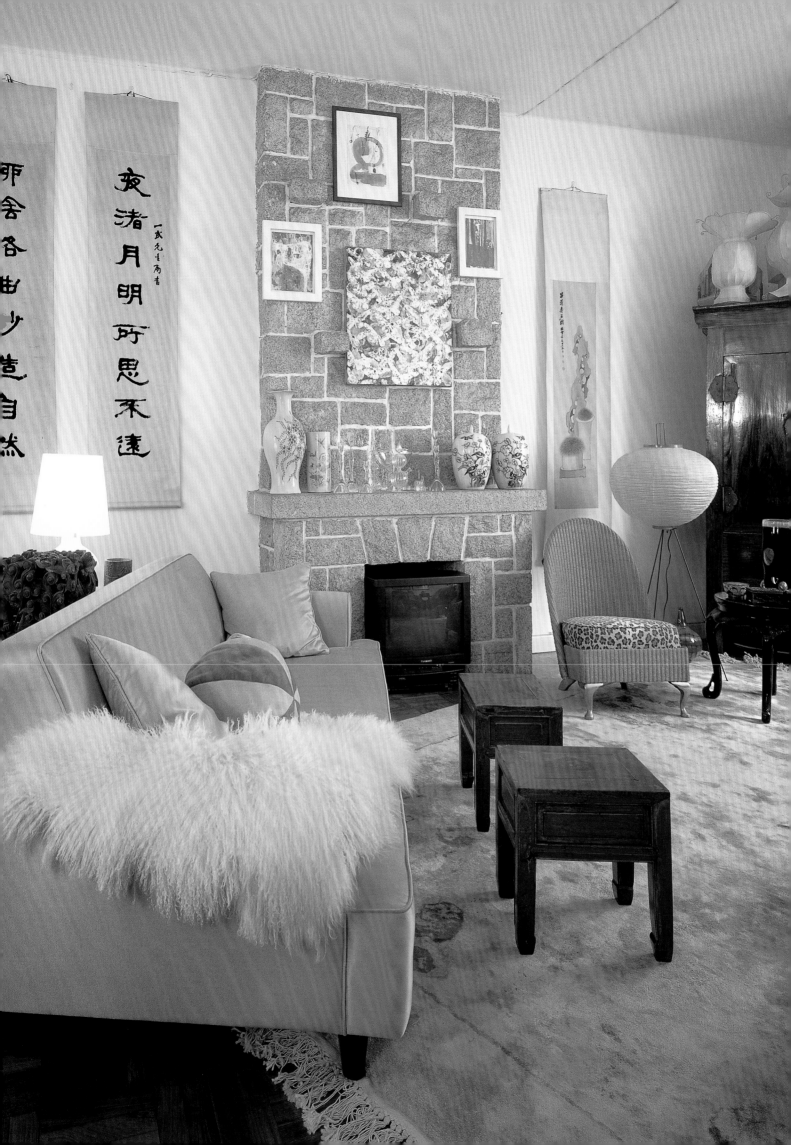

Straits Ornate

The Straits Chinese or Peranakans (which means 'born here') of Malaysia and Singapore can trace their descendents from Southern China back centuries. Peranakan men (*babas*) and women (*nyonyas*) created a wealthy and influential community with its own unique culture and customs.

Peranakan architecture is exemplified in both townhouses and shophouses, and some of the finest examples can be seen in Malacca, on the West coast of Malaysia (see overleaf). Some date from the Dutch era; others, including some of the most decorative, were built during the 19th-century rubber boom. Typical Peranakan townhouses were long and narrow with high ceilings and stuccoed ornamentation, built around a central open courtyard. Typical features included handpainted tiles, carved front doors, Corinthian columns and opulent bas-reliefs of bats, phoenixes, flowers and dragons. In the late 19th century, the houses became more ornate and, to traditional Chinese features such as rounded roof gables and painted scrolls, European features were added. In the early 20th century, European classical style won through, with craftsmen adapting Renaissance and Baroque elements in plaster columns and pilasters.

Other Straits Chinese buildings are mainly religious or clan houses. In Bali, Javanese lawyer-turned hotelier Anhar Setjadibrata rebuilt an original 18th-century Chinese family temple in the grounds of his luxurious Hotel Tugu (see right). An avid art and antiquities collector, Setjadibrata spotted the temple in Surabaya (the capital of East Java) and, on realizing it was about to be demolished, hired a team of workers to dismantle and faithfully rebuild it down to the last detail in Bali. Against a classic Chinese palette of red and black, there are altars to Balinese and Chinese deities, vintage photographs, antique silk textiles and traditional Chinese wood furniture. "The temple reminds me of my childhood," Setjadibrata says. "From an aesthetic point of view, I think traditional Chinese décor is always beautiful and it would be foolish to let it disappear."

An 18th-century Straits Chinese temple in the grounds of the Hotel Tugu in Bali (right). Owner Setjadibrata is on a mission to preserve manifestations of cultural heritage in Indonesia.

On Jalan Hang Jebat (Jonkers Street), a high-profile residential area in Malacca for Straits Chinese families, many beautiful townhouses remain. One has been converted into Jonkers Restaurant (this page), complete with marble-topped tables and original décor. In keeping with classic Straits shophouses, it has a narrow street frontage and an interior courtyard (right). The courtyard acted as a source of light and ventilation and also helped in the collection of rainwater which feng shui dictates brings good luck to the household. Such an open air space would also have served as the focus of informal family life. Today, the courtyard leads into the restaurant with its marble-topped tables and original décor.

Turquoise and gold louvred painted shutters (below) in the Portuguese manner cover the tall slim windows. (Malacca fell to Portuguese rule in 1511 and remained so for 130 years.) The shutters reduce the sun's glare yet allow air into the rooms.

Ornamental glazed tiles imported from Europe were favoured decorative devices (left). Bright flowers were a common motif.

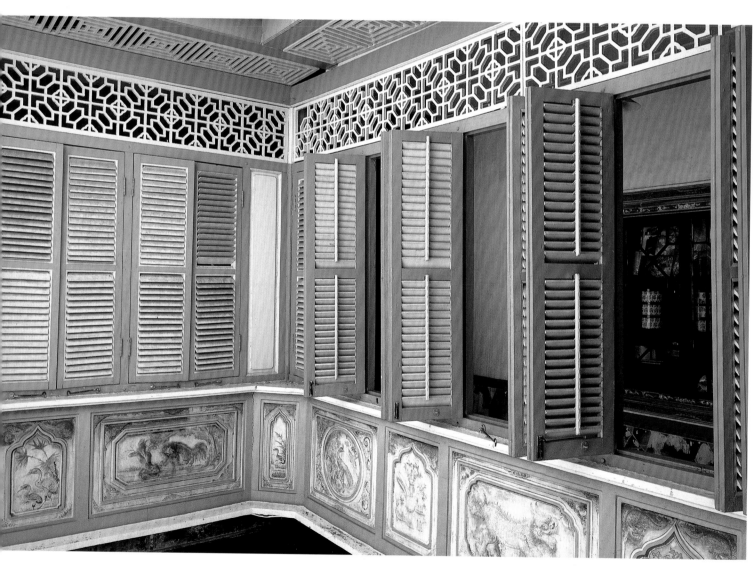

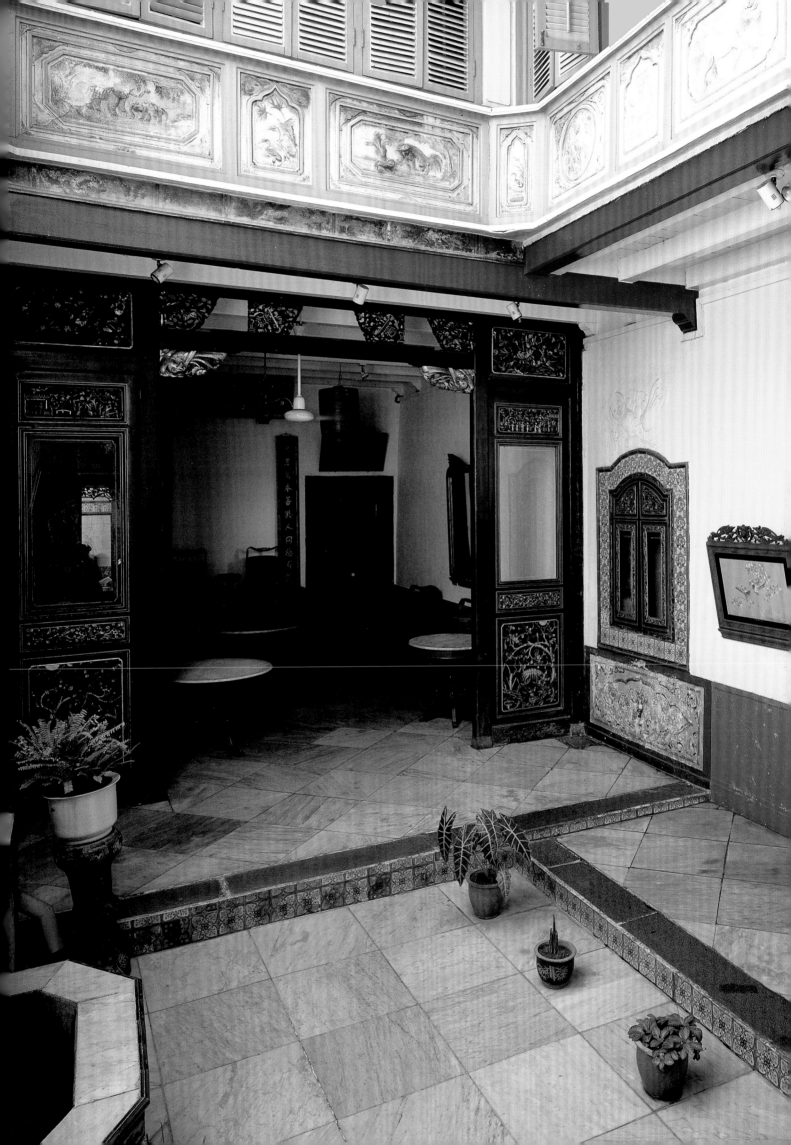

A flamboyant townhouse, built in 1896, once owned by millionaire Chan Cheng Siew, has been converted into the Baba and Nyonya Heritage Museum (below). The double-frontage house is furnished with opulent, original pieces, including Chinese blackwood furniture inlaid with mother-of-pearl and gilded wooden screens which would have reflected the family's status and wealth. High ceilings, decorative carved latticework, colourful ceramic tiles and some Regency style furniture hint at the integration of European style. The museum today gives a glimpse of what life may have been like in a Straits Chinese household in the early 20th century.

Tiles imported from Europe (left) line the staircase and lower part of the walls.

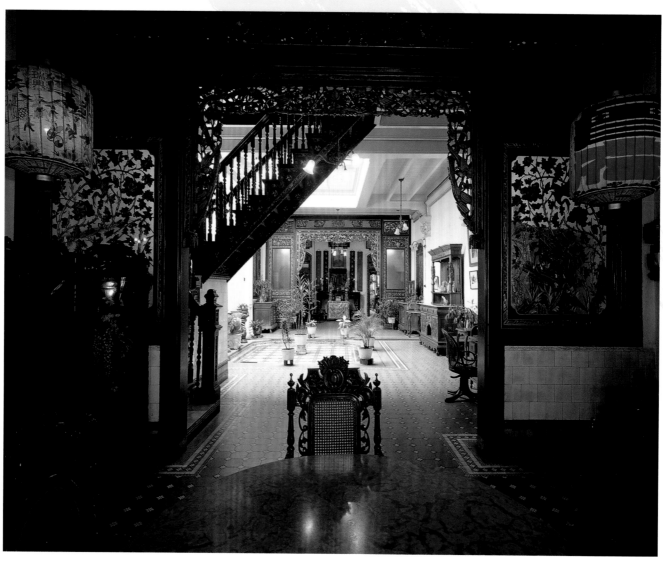

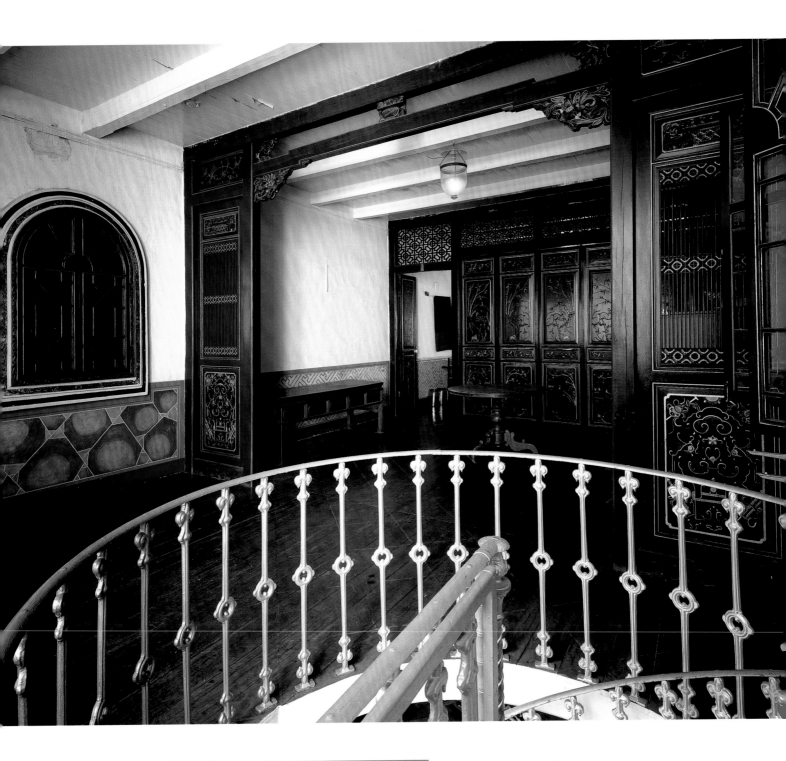

In what is now Jonkers Restaurant, a wrought-iron spiral staircase leads to the upper floor of the Peranakan house (above). The interior features high ceilings and carved wooden panels, intricately decorated with gilt.

Glazed pots with accompanying stands featuring Chinese motifs are in the courtyard of the Chan house (left).

The New Shanghai Style

DECADENT ART DECO TO RETRO ROMANTIC

To the outsider, Shanghai evokes a kind of romantic glamour, stemming from its heyday in the early 20th century. Back then it was known as the Paris of the East; synonymous with decadence, extravagance and corruption; a bustling frontier town populated with gamblers, gangsters, singsong girls and opium traders. Even today, traces of its grandeur and glitter can be seen in its architecture and attitude.

Shanghai lies on the coast of the East China Sea at the mouth of the famous Yangtze River. It became a treaty port in 1843, ending centuries of isolation and opening the floodgates for a wave of international settlers. Living areas known as foreign concessions were carved out by the British, French and Americans and were governed by their own rules of law. The melting pot that was Shanghai was also home to huge numbers of Chinese refugees who fled to the city to escape the mid-century countryside rebellions.

By 1930 Shanghai had become a cosmopolitan metropolis with the various styles of architecture of different cultures competing for space. In her book, *A Last Look, Western Architecture in Old Shanghai*, Tess Johnson notes that there is no city in the world today with such a variety of architectural offerings. On its famous river embankment known as The Bund, there is Western architecture on a grand scale; in the French Concession, magnificent Tudor-style mansions once owned by wealthy *taipans* (foreign businessmen) are now homes to multiple families; there are low-rise Chinese style buildings such as *shikumen* (stone gate) houses; and gleaming skyscrapers are springing up across the city.

The late 1920s was the great period of art deco apartment building in Shanghai. Art deco style is characterized by strong horizontal and vertical elements and decorations reduced to abstract, geometrical shapes. New construction techniques meant that towering edifices with such distinctive styling changed the face of the skyline; many are still standing today, including the famous Peace Hotel, the Park Hotel, Grosvenor House and the Paramount Theatre. This building boom came to an abrupt halt with the onset of the Second World War and, with the establishment of the People's Republic of China in 1949, Shanghai's doors closed to the West. But now wedged firmly open once again, the city and its inhabitants are embracing the 21st century with vigour.

Today's Shanghai is a city of colossal change where modern skyscrapers take the place of crumbling *fin-de-siècle* architecture; taxis, cars and buses scream along streets where bicycles used to rule; and the lure of all that is shiny and new runs roughshod over traditional crafts and techniques. Unfortunately, architectural heritage is fast disappearing, as countless steel and glass monoliths rise up in the city's race to become a world-class metropolis in as short a time as possible.

Many of those who have made their home in China's most fashionable city have an entrepreneurial outlook and a thirst for success that would not have been out of place a century ago. In terms of design, creative influences blend the rich, dramatic influences of the art deco age and of China's rich cultural heritage with a streamlined modernity that is definitely of the moment.

Many of the homes featured in this chapter have drawn on Shanghai's diverse heritage to create styles that range from retro modern to divinely decadent to quasi-romantic. These outlooks are cross-cultural; a blend of Western and Oriental influences that reveal a refreshing approach to interior design in 21st-century Shanghai.

A Slice of Nostalgia

Shanghai's dining scene is undergoing a transformation, with numerous stylish restaurants and bars springing up across the city. One example is Face. Housed in a 1936-built red brick and stone period mansion in the gardens of Rui Jin Guest House in the French Concession, Face offers diners a slice of history, nostalgia and romance to accompany their cuisine.

A villa type hotel set in expansive grounds containing a small lake, three gardens and four villas in different European styles, the Rui Jin Guest House complex has many stories to tell. Its villas have acted as homes for a British businessman (who ran a dog racing track nearby) and a Japanese millionaire; they have been headquarters for the Guo Min Dang, have hosted Madame Song Mei Ling and housed the East China Bureau of the Communist Party after Liberation in 1949.

Face is in Can Ying Lou (No 4 building) on the north side of the gardens. The villa has been divided into three areas: a downstairs bar filled with Chinese antiques, Lan Na Thai restaurant upstairs and Hazara Indian restaurant in a luxurious tent outside. With sister venues already operating in Jakarta, Indonesia, Singapore and Mongolia, Face has proved a big hit with the hip Shanghai set.

The structure of the house was left intact by the owners of the restaurant yet was brought up to date with bright orange and yellow walls, comfortable red and blue armchairs, wood shutters and floaty white drapes. The Chinese furniture in the bar was sourced in Shanghai markets and makes a dramatic contrast to the contemporary colour scheme. None of the furniture has been polished or over-finished so as to give the place a lived-in feel and to retain the ambience of a bygone era.

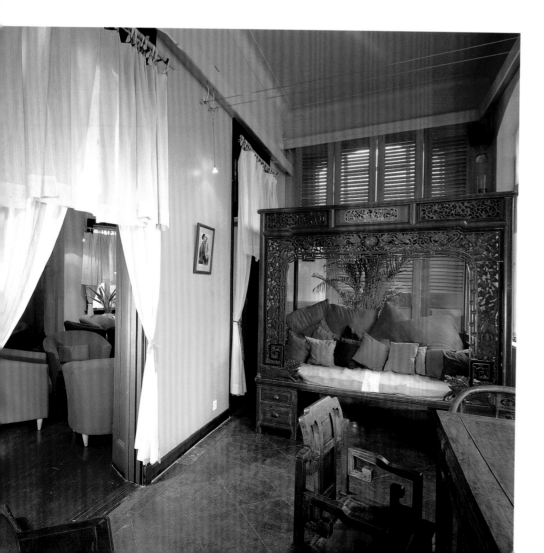

Face Shanghai's current owners wanted to recreate a secluded, nostalgic environment for drinking and dining in modern-day Shanghai. The red brick and stone mansion set in acres of gardens in the heart of the city comprises a Chinese-furniture filled lower bar area which has been decorated with warm orange and red walls to offset the slightly distressed wooden furniture. A huge bar dominates the room (right); drinkers can either perch here or relax in curvaceous red and blue modern armchairs nearby.

A long slim room, leading off the main bar, has a traditional carved Chinese bed (left) at one end which is stacked high with colourful cushions. The management says this bed is extremely popular with drinkers and is often reserved ahead of time. Once installed, people never seem to want to leave.

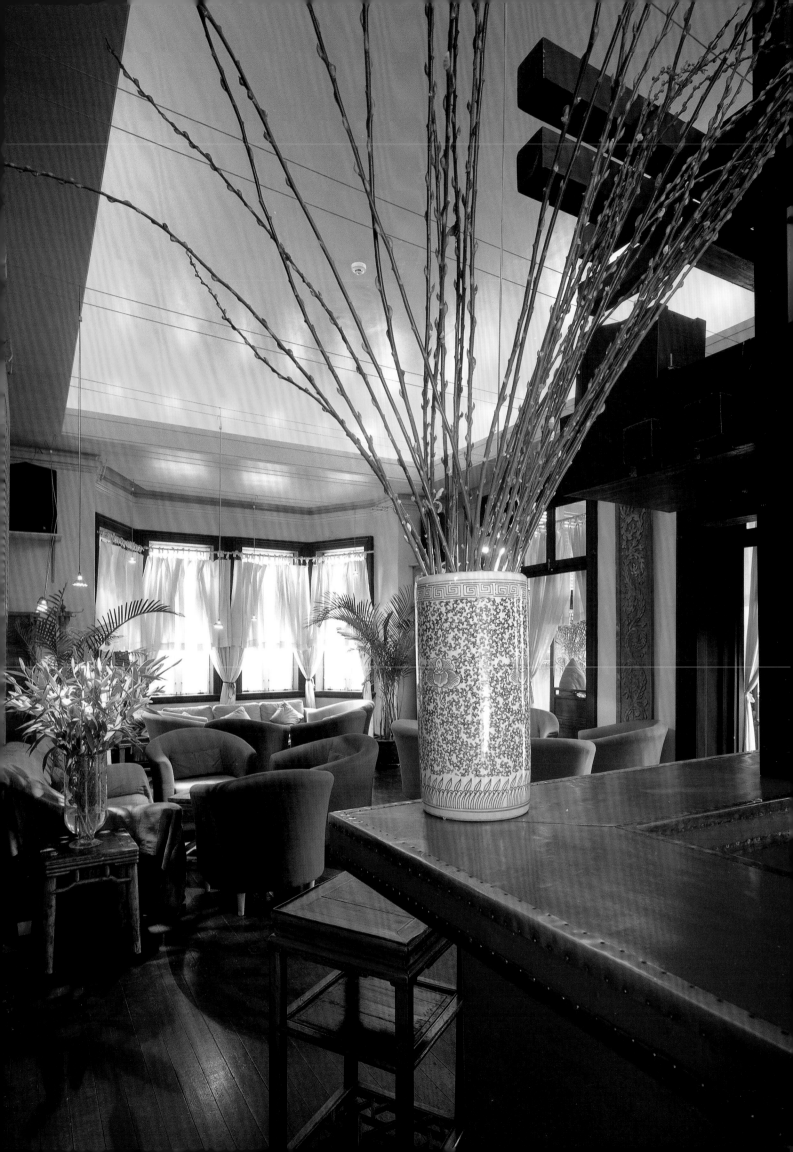

Retro Modern

In the heart of downtown Shanghai stands the famous Grosvenor House apartment building that today lies within the Jin Jiang Hotel complex, a green swathe of gardens and buildings that effectively protects residents from the hustle and bustle of the streets outside. It is in this prestigious complex that advertising director Melvin Chua has set up home, creating an ultra modern living space within art deco surrounds. Chua, who recently moved to the city, is representative of the new breed of Shanghai dwellers: cosmopolitan urbanites who are adding a creative buzz to life in the modern Chinese city. His spacious interior is filled with a clever mix of streamlined furniture, antique Chinese pieces and colourful, modern Chinese art. Chua commissioned interior designer Robert Chan (formerly London-based, now living in Shanghai) of Nube to help him create the sophisticated space.

Keeping doors and interior walls to a minimum allows each room to flow effortlessly into the next and enhances the sense of space. Clean lines and luxurious textures are key, evident in the custom-made modern cream sofas, leather armchairs and the Ming-style furniture sourced from Shanghai's famous flea markets. The retro-inspired, somewhat sombre palette of brown, white and cream is lifted by vibrant Chinese artworks by prominent Shanghai and Beijing artists.

In the study-cum-relaxation area (right), positioned to the right of the entrance hall, a bold red artwork by Shanghai artist Shen Fan adds colour and energy to the space. An oversized, L-shaped cream sofa designed by Robert Chan is perfect for lounging around on. A yokeback Chinese chair is positioned behind a wooden desk in the corner of the room: this kind of chair was traditionally called an 'official's hat chair' in reference to the ends of the rail (which appear like the wings of an official's cap).

A gold coloured teapot and teacup (above) give the ancient Chinese art of lacquering a modern, glamorous edge.

The Grosvenor House apartments—constructed in the 1930s—remain one of the best-preserved examples of Western-style art deco design in Shanghai. Residents enjoy an almost unrivalled sense of space, with towering ceilings, well-maintained original features and easy access to the heart of the city. Chua's dining room (right)—often used for entertaining—features a huge, wooden table which can comfortably seat 10 people. High-backed dining chairs in midnight blue covers and gold lacquer place settings (below, detail) set the scene for chic urban entertaining. A trio of blue and white Chinese porcelain vases has been turned into oversized candleholders; on the opposite wall hangs Chua's collection of black and white photographs by top international fashion photographers. By keeping the inner doors open, views extend to the rear of the living room, ensuring a free-flowing feel and enhancing the sense of space.

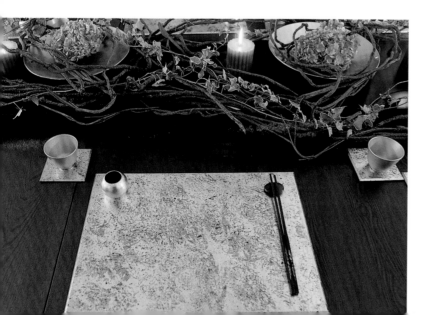

Minimal, understated and luxurious: Melvin Chua's spacious living room (right) features clean-lined contemporary furniture that offsets the polished dark wood floors and original art deco detailing of the apartment complex. Echoing the original 1930s palette, the beige walls with signature brown trim provide the perfect backdrop for the mix of cultures and styles. A Ming-style sloping stile cabinet found in a Shanghai market fits neatly into an alcove; to the left hangs a contemporary painting by Beijing artist Gu Zhen Hua entitled 'Yellow Frog', 1996. A pair of matching '50s-style leather armchairs adds to the retro feel.

On the living room table is a set of four square ceramic candleholders housed in a dark wood tray (above, detail).

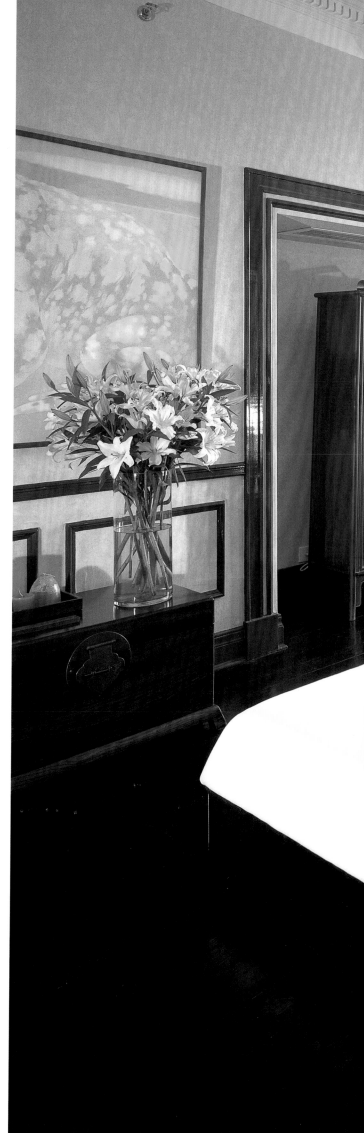

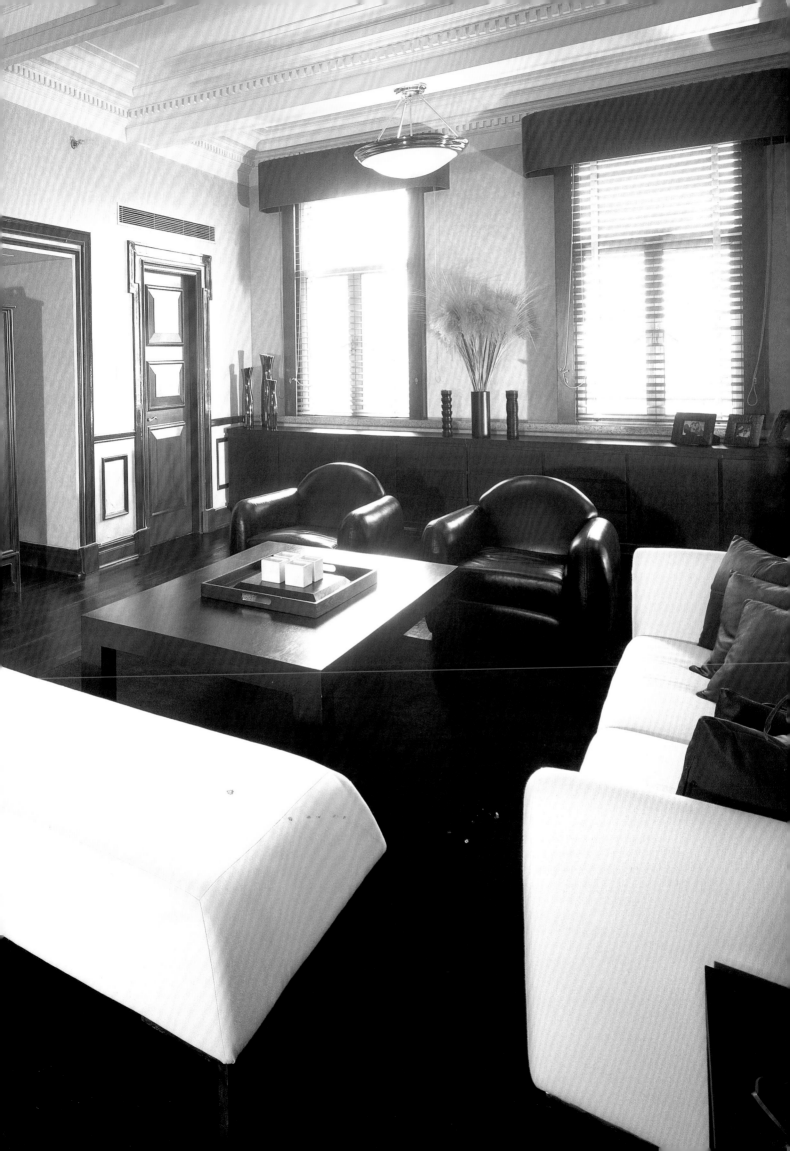

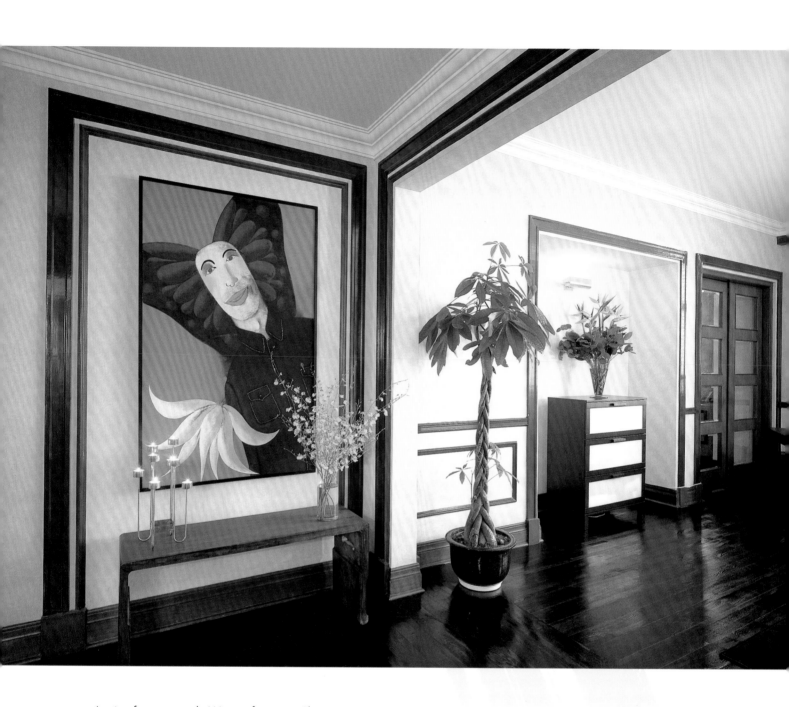

A mix of custom-made Western-furniture, Chinese antiques and vibrant contemporary Chinese artworks produce Shanghai chic with an international edge. Shanghai's art scene is still in its infancy and Chua has selected work by prominent Chinese artists that, at present, are making more of an impact on the global scene than at home in China. In the entrance hall (above) hangs a dramatic work by Shen Fan, untitled, 1995.

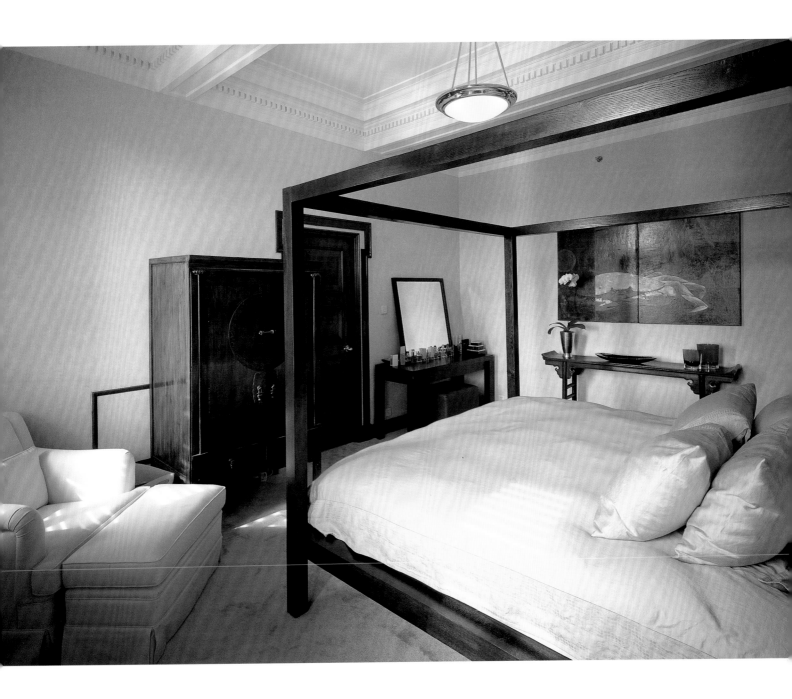

High ceilings in the master bedroom (above) allow space for
an oversized four-poster bed which is a modern interpretation
of a traditional Chinese canopy bed. It is dressed in luxurious
pale yellow linens which effectively contrast with the dark
wood structure. Above a classic altar table hangs an artwork
by Gu Zhen Hua called 'Crab and Helicopter', 1997. From
the ceiling hangs an art deco light fitting.

A Touch of Romance

Businessman Max Chang has a relaxed approach to interior design. Born in Taiwan but now based in Shanghai, Chang travels extensively across China and makes the most of opportunities to source décor items from different regions. The result is a sophisticated interior that is fresh and interesting to the eye.

Chang's penthouse apartment is located in The Gascogne, completed in 1934 on what was once Avenue Joffre. With renaming, the luxury apartment house became known as Huai Hai Apartments and the street as Huai Hai Zhong Lu—now a busy shopper's paradise offering everything from top fashion labels to high street brands to designer copies. What makes Chang's home unique is its huge terrace offering panoramic views over the city—it's a perfect location for summer parties and for watching the ever-developing face of new Shanghai take shape.

The rooms within the white-walled interior are linked by a series of archways and sliding doors. Decorative textiles, scarlet 1930s-style Chinese lamps, calligraphy panels and flea market-sourced antique furniture are offset by modern, clean-lined sofas and dining chairs which add a dash of contemporary style to the interior. "You cannot do everything Chinese, it's too heavy," explains Chang. "I prefer to mix Western and Chinese elements." In choosing pieces for his home, Chang went for appearance rather than historical value: "I don't think about whether things are antique or not, I buy them because they look nice."

At the rear of the study area (right) are two archways leading into the living and dining rooms; two patterned curtains are draped between the archways and another orange and gold textile covers the top of a Tibetan chest painted with flowers. On the floor is an oil lamp which would have once been used in a family temple. To avoid bad feng shui, Chang disguised what would have been the third of three doors by painting it red and installing a carved window panel with a cracked ice design. If needed, the door still opens and functions as the side entrance to the dining room.

White walls, a striped cream sofa and beige carpeting form the backdrop to a collection of Chinese antiques in the living room (above). With a nod to practicality, Chang added a glass top to an old wooden trunk engraved with country scenes. Against the wall stands a pair of Qing dynasty wood and brass doors from Shanxi province; near the sliding doors to the dining room is a 1930s cabinet which demonstrates the mix of Western and Chinese elements characteristic of the time. The glass in the bottom section is original.

The study area (above) contains a low-level, custom-made sofa dressed in white fabric. On top is a compact wooden table in the style of those once used on traditional opium beds. The calligraphy panels were picked up in a street market in Chengdu; a pair of red silk and wood 1930s art deco lamps placed on a pair of painted chests enhances the opium den theme. Symmetry and order define this tableau.

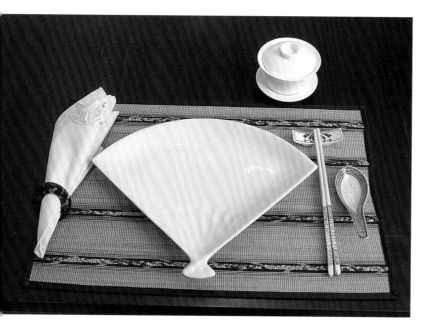

A custom-made dining table and chairs add a contemporary touch to the dining room (right). An ugly bank of windows has been covered with Japanese style sliding screens, which let the light through. Beneath the windows is a bamboo cabinet and on top an original art deco gramophone from Shanghai. Two Beijing silk table runners add a decorative touch to the dark wood dining table. In the foreground is a latticework cabinet used for storing tableware.

Chang keeps things simple when entertaining (above, detail). He dresses the table with bamboo place mats, white ceramic fan-shaped underplates and classic blue and white chopsticks. Jasmine tea is served from white china cups.

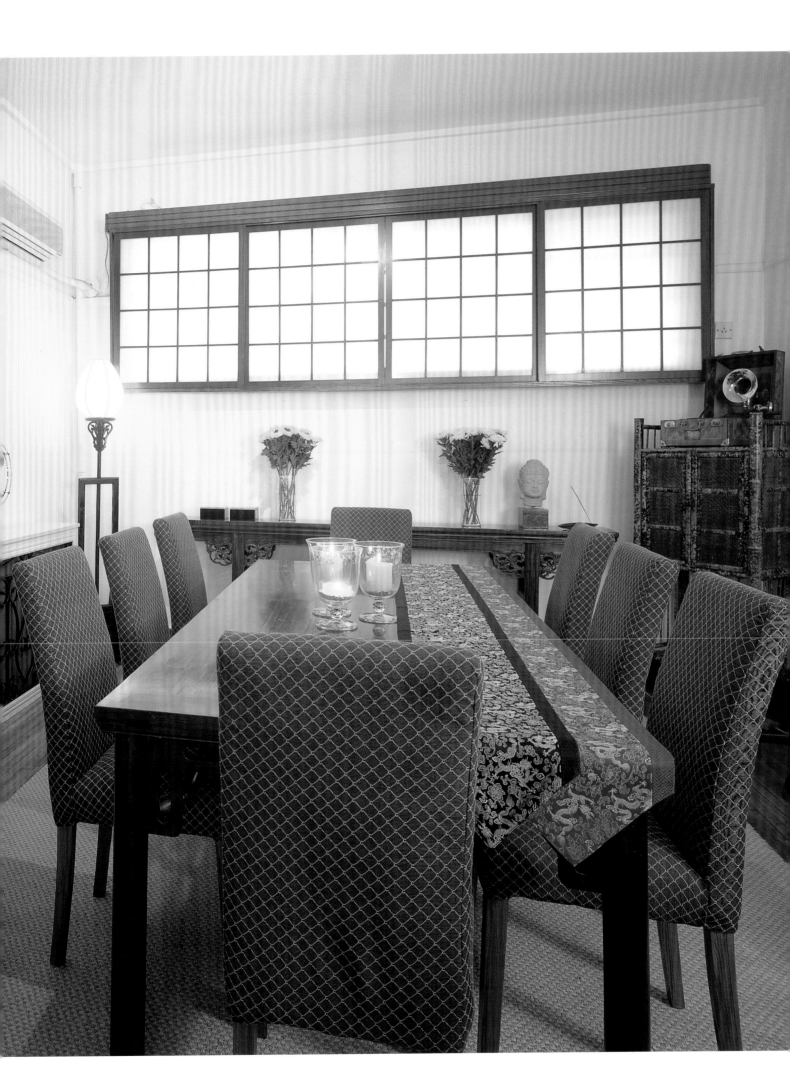

Art Deco Decadence

"I wanted to live in an old Shanghai house, so I replicated 1930s art deco Shanghai style as I perceived it using old photographs and pictures as references," explains David Orenstein, gesturing around his warm-toned home. "This is what I thought it may have been like."

A Harvard graduate, Orenstein moved from the United States in 1998 to study in Shanghai; he eventually became so fascinated with the city that he decided to stay. His 190 sq m (2,044 sq ft) apartment in King Albert Apartments in the French Concession district harks back to another era. With its taupe, mustard and plum walls, antique furniture and custom-made pieces, Orenstein's home is his personal interpretation of Shanghai style. Combining traditional Chinese style and art deco pieces, Orenstein says: "I did it all with a sense of humour ... and on a budget too."

The King Albert Apartments comprise 16, four-storey art deco apartment houses linked by winding, tree-lined paths. Today, many have fallen into disrepair but a few, like Orenstein's, have been renovated (the interiors at least) and function as homes to folk who prefer to incorporate a touch of history to their Shanghai living experience. Orenstein lives on the top floor of his block and to help him accomplish his vision, he called on interior designer Kenneth Grant Jenkins of The Design Association Inc. The result is a contemporary home that exudes a sophisticated aura of the past. Painted walls with white or brown trim offset the dark wood furniture; living room sofas and chairs are custom-made along art deco lines and on the walls hang Orenstein's black and white family portraits and a stunning 1930s clock he found in an antique warehouse.

David Orenstein's bedroom (right) features mustard and plum walls which help reduce the effect of the high ceilings and produce a cosier space. Here, the wall trims and doors have been painted a dark glossy brown in an effort to emulate the original colours. Lightly restored carved wood panels have been incorporated into the design of the bed; the side panels are from the Republican period (1911–1945), the headboard and footboard feature Qing dynasty panels. The dressing table is 1930s Shanghai. Orenstein's apartment is one of few in the King Albert Apartment complex that has been renovated.

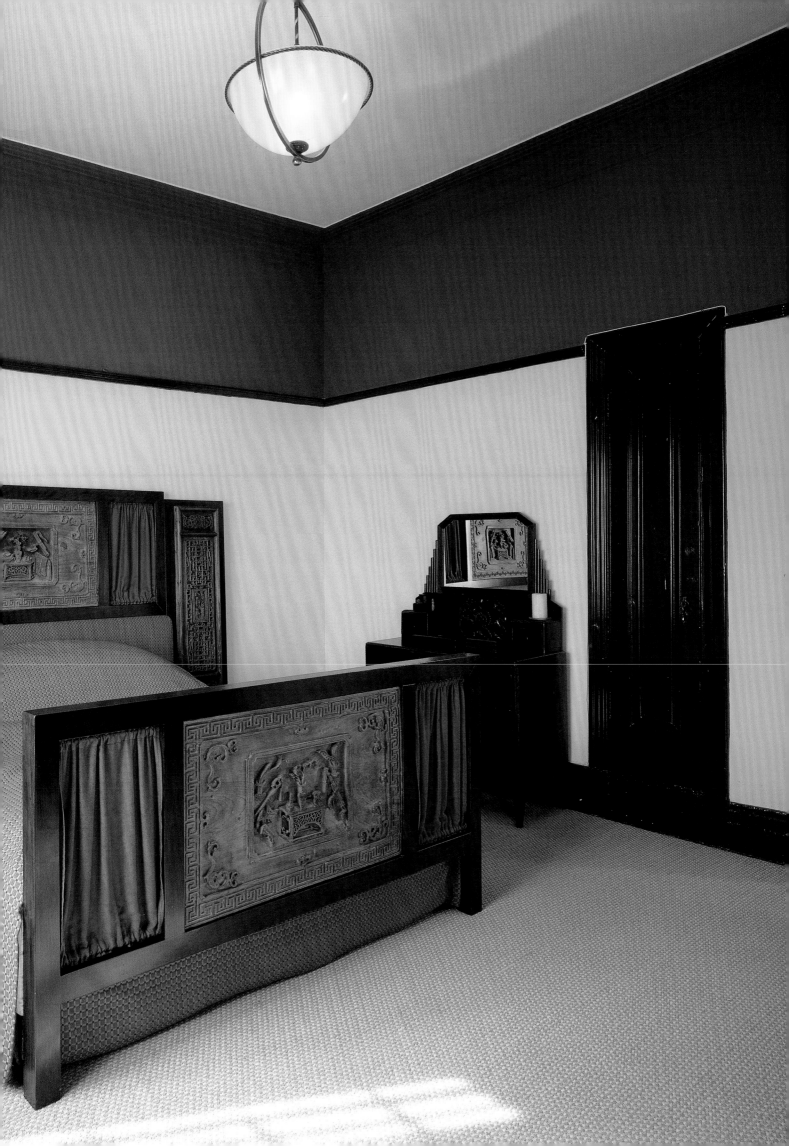

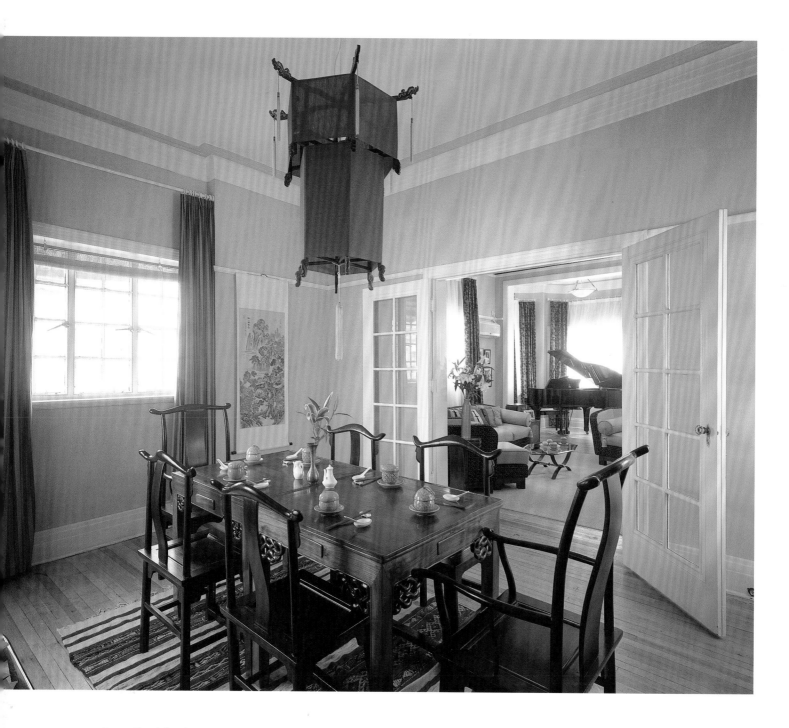

The walls of the dining room (above) are painted a warm mustard colour to offset the burgundy drapes and a restored wooden Qing dynasty lampshade is covered with Xian silk. Six yokeback armchairs—all balanced forms and artistic lines—are placed around the dining table set with traditional Korean celadon ware.

Taking inspiration from old photographs and pictures, Orenstein created a rich interior which resonates with the influences of 1930s Shanghai. Two large custom-design sofas and an armchair define the living room (right); on the wall hang old black and white Orenstein family photographs and a 1930s calendar clock with a swinging pendulum that once belonged to the Chung Hwa Book Company. The scatter cushions are made with Thai silk; on the iron and glass coffee table is a set of traditional Korean celadon ware.

Longtang Life

The spirit of old Shanghai is alive and well in a small side street off Xing Guo Lu in the French Concession. Furniture dealer Jean-Philippe Weber lives in a traditional *longtang* (lane) house, built during the 1930s and originally the home of a high-ranking French officer. He has a garden filled with banana trees which is the perfect place to relax in while one listens to the sounds of the city outside.

But would-be tenants who wish to experience a slice of Shanghai's architectural heritage often have a hard task ahead as many *longtang* properties have fallen into dis-repair. Neglected and left to function as run-down homes for multiple families, houses such as these are only now being recognized for their value. In Weber's case, his 16-roomed house with its unassuming grey frontage had stood empty for more than 15 years. He took responsibility for the renovations and aimed to preserve the beauty of the original art deco design. This he achieved by retaining the leaded glass windows, the marble foyer (all it needed was a good clean), the rich, chestnut coloured wooden floors on the upper level and the original brick walls in the study, which still bear the seal of the manufacturer.

The light-filled house brims with antique furniture and accessories in different styles, woods and grains, sourced from across China. There are Qing dynasty lacquer cabinets, Shaanxi ancestor tables and doctors' desks, Tibetan carpets, official's hat chairs from Beijing, lacquer trunks, Qing hatboxes, calligraphy scrolls and much more, filling each room to overflowing. This is not just to fulfill a personal passion: the house also functions as a showroom for Weber's antique furniture business, Hong Merchant, and buyers from all over the world come to browse and enjoy the quality of the collection.

In Weber's main downstairs living room (right), curved leaded glass windows look out onto the garden. Own design art deco style furniture 'Titanic' steamer leather and teak chairs and a triangular nest of tables (foreground) are displayed. From the ceiling hangs an antique Tibetan lamp and on the floor is a tiger print Tibetan rug.

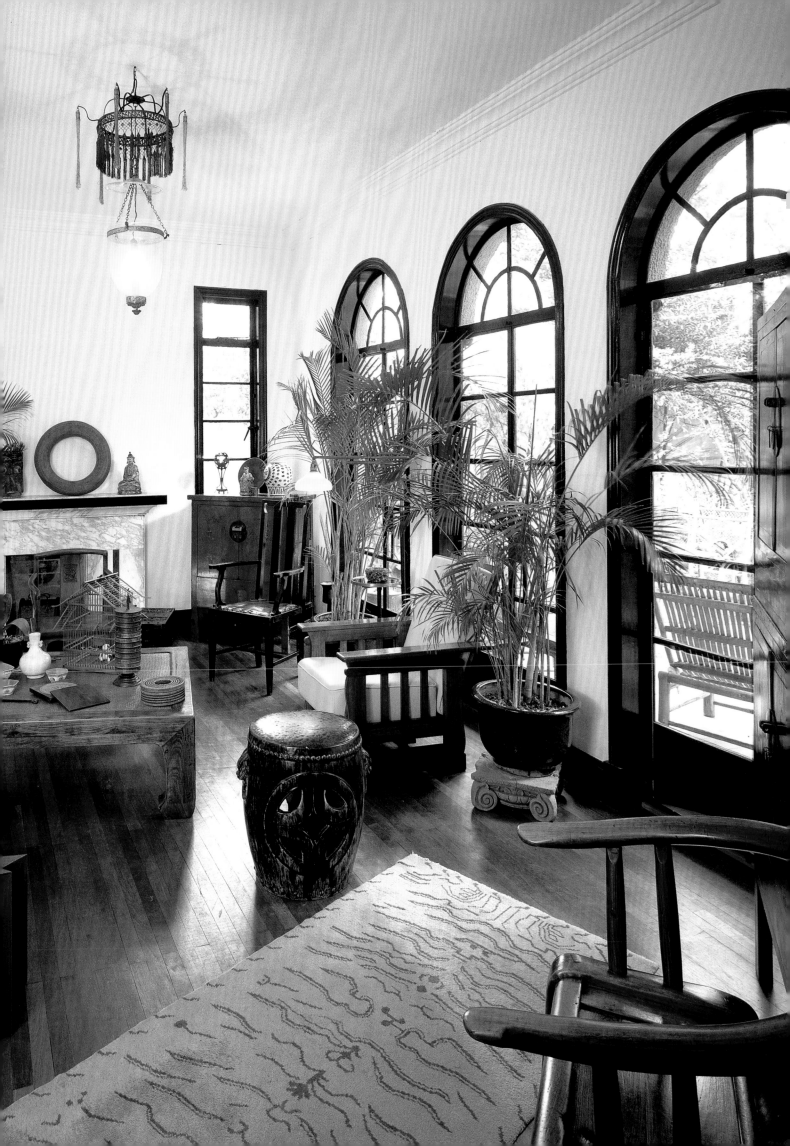

Weber buys pieces not just for their age but for their visual appeal. "We try not to restore them too much," he says, preferring to enjoy the inherent beauty of the pieces. A 19th-century ancestor portrait hangs above a 19th-century doctor's travelling desk (right) which can be folded up for ease of transportation. It is coupled with an official's hat chair, 19th century.

At the top of the stairs (left, below) is an early 19th-century ancestor table from Shaanxi province. Hanging above is a painting by Pang Yong Jie, the Shangdong artist whose dramatic fat lady portraits are based on perceptions of beauty during the Tang period (618–907 AD). On the floor is an antique document box which lawyers would have used to carry papers whilst travelling from province to province.

Weber stocks a wide selection of scholar's objects, including this travelling pouch (left, detail above), which houses calligraphy brushes and chopsticks.

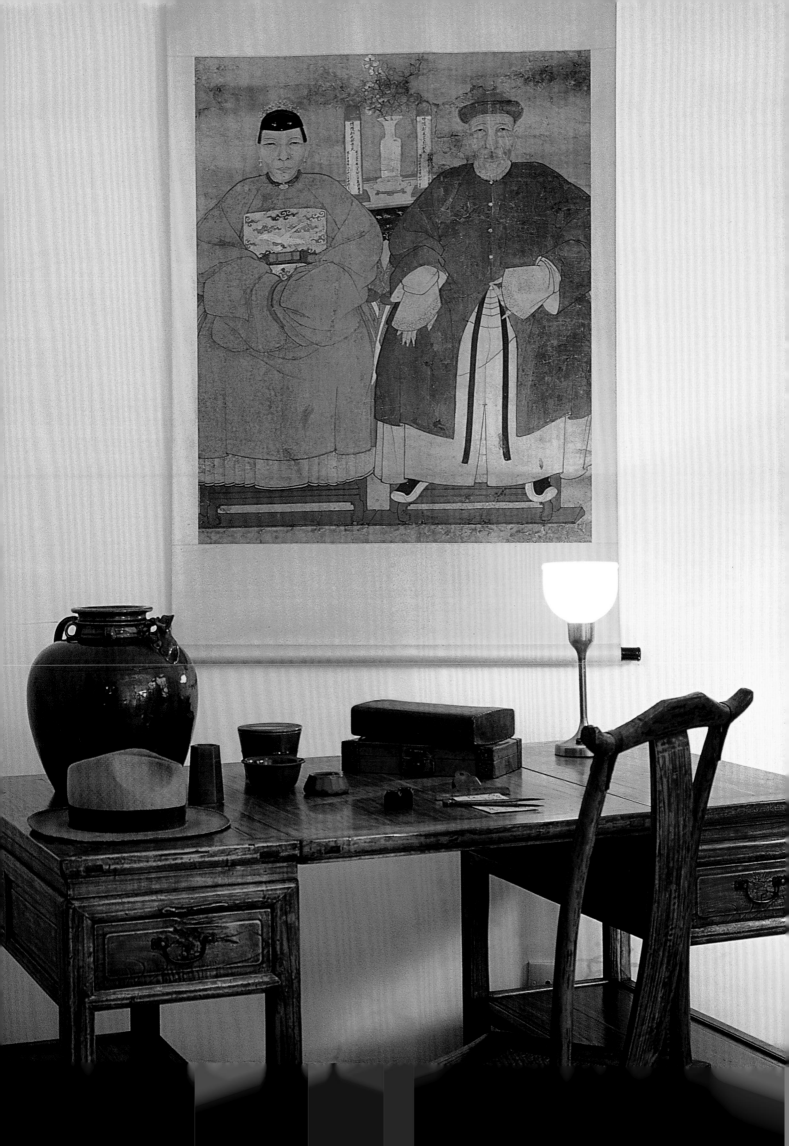

Shanghai Chic

The China Club may only have been around for a decade or so, but it is now a quintessential part of Hong Kong life. A private members' club located on the top three floors of the old Bank of China building in the Central district, it is the brainchild of one of the city's leading public figures, David Tang. The ebullient Tang—well known in business, culture, the arts and high society—has provided Hong Kong's entrepreneurial elite with a place to do business and relax afterwards amid stylish surroundings which ooze tradition and history. The interiors evoke the glory days of old Shanghai, generously borrowing items from different eras and cultures. Meticulously replicated, the Club has an air of charm and nostalgia with oak and mahogany panelled walls, sweeping staircase, latticed silk panelling and gently whirring ceiling fans.

The main dining room is said to serve some of the best dim sum in Hong Kong. Its high ceilings, art deco chandeliers, Qing chairs (over 140 and no two are the same) and red leather banquettes are modelled on the concept of the traditional Chinese teahouse. A curved staircase lined with modern Chinese artwork accesses the upper levels. The Club's impressive collection was compiled with Johnson Chang of Hanart TZ Gallery, an authority on contemporary Chinese painting and includes everything from premier work by established artists such as Yu Youhan to sculptures by Taiwanese artist Ju Ming to kitsch Revolutionary porcelain figures and old Mao posters.

Upstairs, Hong Kong's movers and shakers can enjoy a pre- or post-dinner drink in the Long March Bar, complete with somewhat shabby (but comfortable) velvet armchairs draped with lacy antimacassars. For an after-dinner cigar, the 15th-floor library, with its huge collection of over 5,000 books on China and the Chinese, has a sweeping balcony with splendid views over Hong Kong.

Tang has expanded his China Club concept into Beijing and Singapore. In the former, the club is located in a well-preserved, courtyard-style royal palace built in the 16th century for a prince descended from Emperor Kang Xi of the Qing dynasty. The Singapore venture is housed in a rooftop space at the top of one of the city's new skyscrapers. Together with his Shanghai Tang department stores in Hong Kong, Singapore and New York—which sell contemporary Chinese Chinoiserie such as Mao-style suits in sizzling colours and Cultural Revolution T-shirts—Tang aims to bring his particular brand of Chinese style to a global audience.

The main dining room on the 13th floor (right) hums with activity every lunch and dinner time. Inspired by the traditional Chinese tea house, the high-ceilinged space with its art deco chandeliers and old Shanghai electric fans harks back to another era as the modern-day clientele—from businesspeople to *tai tais*—partake of Chinese cuisine. The walls are half panelled in oak and mahogany and are filled with a fine selection of contemporary paintings by Chinese, Taiwanese and Hong Kong artists. Qing dynasty chairs feature shocking pink and lime green silk padded covers.

In the Long March Bar, a collection of kitsch Revolutionary porcelain figures wave their Little Red Books and pay homage to Chairman Mao (left, detail).

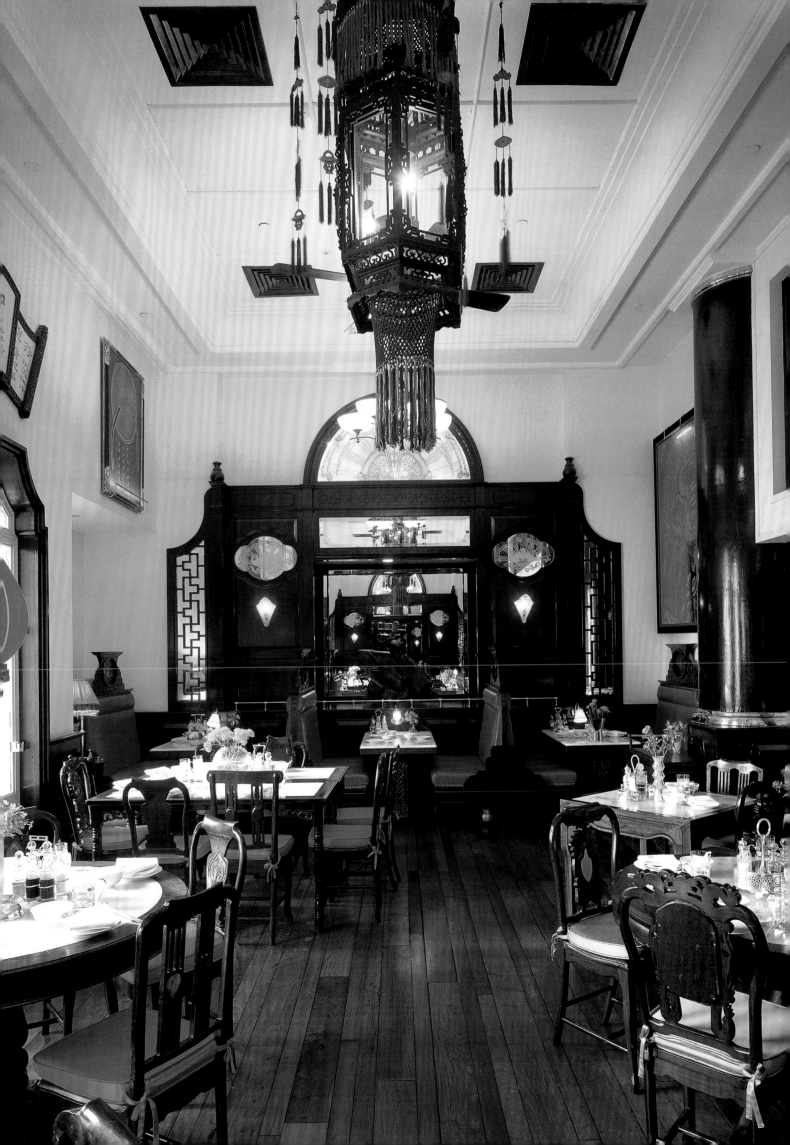

The China Club is a slice of Chinese tradition and history in a modern metropolis. Designed using motifs that were widely used in the 1930s and '40s, it celebrates the Shanghai chic of days gone by. Upstairs, members and their guests pass through stained glass doors into the Long March Bar (right), which is filled with green and burgundy velvet chairs, lacy antimacassars and revolutionary artwork. Today, the cushions are a bit tatty and the chairs have seen better days, but that is all part of the appeal. Revolutionary scenes are also etched onto the mirrored wall at the end of the bar. In the evenings, the room is softly lit by a mix of art deco metal lamps and freestanding corner lamps with yellow-fringed lampshades.

The 14th floor was designed for banquets and private parties. Art deco style (above, detail) comes through in this geometric lamp and coloured glass pillar cladding found in one of the function rooms.

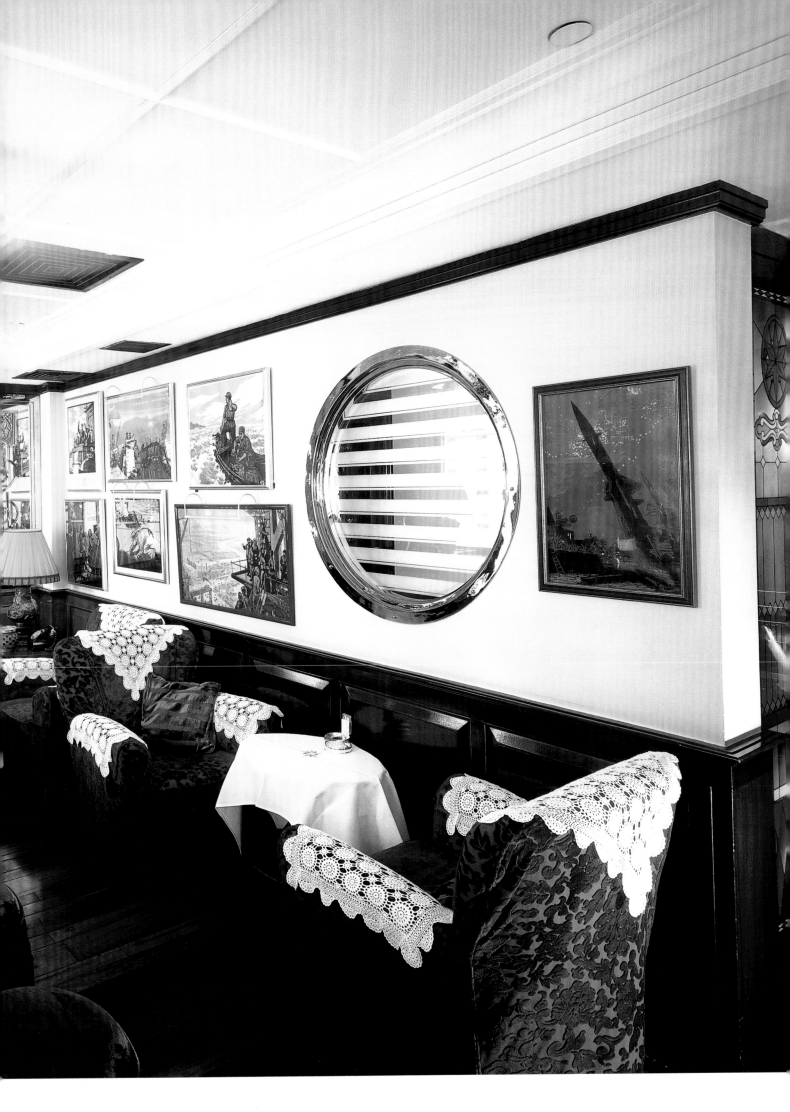

At either end—and along one side—of the China Club's dining room are rows of cosy seating booths featuring padded red leather seats with carved headpieces and inset stained glass panels (left).

The décor exhibits tongue-in-cheek humour: marking the area where the shoeshine man works is a pair of shiny, black oversized leather shoes (bottom, left). On top of a wooden coatstand hangs a green PLA cap .

On stepping out of the private elevator, China Club guests are transported back in time (right). This alcove on the righthand side of the entrance lobby is clad with carved wood panelling and contains an original fireplace. Completing the scene is a free-standing brass fan and an old telephone.

The New Jazz Age

One block south of Shanghai's busy Huai Hai Zhong Lu is a new development that aims to change the face of the city. Xintiandi (literally meaning "new earth and sky") is an impressive 30,000 sq m (322,800 sq ft) site featuring dining, retail, entertainment, commercial and residential facilities. While many of the existing buildings on the site have been razed and replaced with shiny new complexes, a portion of Shanghai's architectural heritage has been retained with the restoration of some *shikumen* (stone gate) houses which are being turned into shops and restaurants.

A typical *shikumen* house was built along a narrow lane (*longtang*) and featured a stone gate framing a black wooden front door that led into a small enclosed courtyard. Built from the middle of the turbulent 19th century onwards in the city's foreign concessions, these houses provided safe refuge for residents. At one point, they accounted for 60 percent of the total residential space in Shanghai. As many *shikumen* houses were built by foreign developers, their unique architecture has become a symbol of East meeting West.

Xin Ji Shi restaurant, owned by the effervescent Adam Chu who is as passionate about jazz and photography as he is about cuisine, is housed in a 1925-built house. Chu is a firm believer in the value of restoring Shanghai's heritage and his restaurant cleverly blends the historical with the contemporary. The original paved courtyard entranceway, wood latticework, tile flooring and stairway have been retained to create an old-world feel, yet an angled modern glass and metal extension attached to the restaurant's exterior wall adds a totally modern note. Interestingly, both work together well, giving diners at Xin Ji Shi a choice of old or new Shanghai style.

Adam Chu believes it is important to preserve Shanghai's traditional architecture. His restaurant, called Xin Ji Shi—located in the new Xintiandi development off Shanghai's Huai Hai Zhong Lu—is in a restored 1925-built *shikumen* (stone gate) house. In a corner of the ground-floor dining room, Chu has created an informal café area (right) complete with retro-style black vinyl banquet seating and original carved wooden window shutters. Their intricate designs indicate that the house was once owned by a wealthy family.

The diamond and floral floor tiles (left, detail) are original 1920s. Chu was determined to retain some of them on the ground floor of the restaurant.

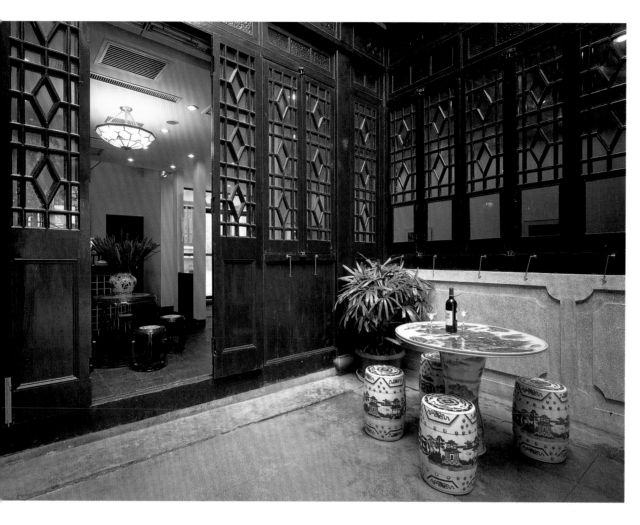

Attached to the ground floor dining room is a modern, light-filled conservatory area (right) with a glass and metal framework. The walls are covered with pale plaster tiles; white fabric is draped from the ceiling. On the walls hang black and white photographs of 21st-century Shanghai, taken by the restaurant's owner, Adam Chu.

The ground floor dining room, accessed through an enclosed courtyard (above), features original wooden doorways and window shutters. Chu has painted the walls a vibrant green to offset the traditional Chinese furniture inside. In the courtyard is a set of blue and white Chinese garden furniture with distinctive hexagonal drum seating.

To promote good feng shui, a blue and white ceramic urn filled with goldfish (left, detail) stands in the corner of the conservatory.

China Modern

THE SEARCH FOR SIMPLICITY

Simple, functional, beautiful: the global passion for pared-down style has its roots in Oriental design. Fluid shapes, streamlined room, attention to the art of detailing, all reveal a sense of balance, order and harmony that is at the heart of Eastern ideals.

Interior designers the world over have long looked eastwards for inspiration, and the profusion of Thai and Japanese-inspired decorative elements in hotels, restaurants and homes from London to Sydney to New York is testament to its wide-ranging appeal. Now Chinese decorative style, at last being recognized for its relevance to modern living, offers a host of ideas for 21st-century living.

In the past, Chinese style was usually associated with ornate carvings, complex patterns and an eye-scorching palette of rich reds and glitzy golds. What is often overlooked is the fact that there is an age-old classicism inherent in Chinese design that appeals to the modern minimalist in all of us.

This stems in part from the philosophy-cum-religion called Taoism, advocated by the Chinese scholar Lao-Tse (604–531 BC) who stressed the importance of simplicity and harmony in daily living. It arose in the pared-down style of Ming dynasty décor (1368–1644) which is totally in tune with modern aesthetics; and it is revealed in the global popularity of the ancient Chinese practise of feng shui, whereby people focus on the placement of objects in their homes to achieve greater balance in their lives.

More and more busy city dwellers—both in China and the West—are embracing classical serenity at home. The appeal of a relaxing sanctuary to retreat to at the end of a stress-filled day has never been greater. A calming decorative approach, one that incorporates balanced lines, natural materials and neutral colours is key. The look may be minimal, retro, provincial or eclectic, but the most successful interpretations use Chinese accents in fresh and interesting ways.

Interior designers in Hong Kong—a highly populated city dominated by skyscraper living and compact living spaces—are developing their own brand of China chic. Whereas once it was believed that emulating Western style was the key to sophisticated living, now, more than ever before, it is cool to be Chinese. A new breed of globally aware creatives is drawing on its cultural roots to produce a new vocabulary of design which blends Chinese accents with a minimal design ethos. Furnishing ideas, such as low level seating currently enjoying a revival, are present in Chinese history (low platforms were the earliest type of raised seating furniture to appear). Multifunctional furniture, ideal for living in small spaces, was already popular in 16th-century China when day beds were used for sitting on in the day and for sleeping on at night. These ideas and more have been emulated by modern furniture designers whose understated collections provide a touch of tranquil Oriental style to the modern home.

This chapter features a variety of contemporary interiors that demonstrate the successful application of Chinese elements in a minimally designed framework. These include Carol Lu's elegant Hong Kong apartment where Ming blends beautifully with a quasi-industrial palette and Johnny Li's collection of pared-down furniture inspired by traditional Chinese architecture. In his Peak home, John Chan prefers to mix classic European and Chinese elements while Caroline Ma demonstates her unique brand of Oriental fusion. Subtle, harmonious and balanced, they reveal a restrained elegance which has enduring appeal.

Stylish
Minimalism

Kowloon is the busy hotel, shop and restaurant-packed peninsula facing Hong Kong Island. Located in the heart of the cacophony, a few minutes walk from the traffic-filled Jordan Road, is a serene apartment overlooking the green lawns of the Kowloon Cricket Club. From the spacious living room, you can hear the gentle thud of balls against bats as all-white-garbed players enjoy an afternoon game, a scene strangely out of place amid the crowded city streets.

The 1960s-built apartment, owned by a Hong Kong businessman and designed by Ed Ng and Dan Lee from AB Concept, is an exercise in luxurious minimalism. "Simple and functional are probably the key words to describe the space," explains the businessman owner. "My previous apartment was rather ornate (gilt-edged, curved frames, damask, inlaid woods) and after living there for eight years I got tired of that style and wanted a complete change. I wanted something minimalist but still warm and inviting."

Filled with elegant warm wood furniture by French designer Christian Liaigre, the 242 sq m (2,600 sq ft) space, comprising living and dining room, two bedrooms and study area, may not be overtly Chinese in style but it undoubtedly has an air of Asian calm and orderliness. It's a hip Hong Kong home, perfect for parties. Whether hosting a bash for a hundred (a Christmas dessert and champagne party drew more guests than expected) or an intimate dinner for eight around the square dining table, the space can easily be adapted to suit entertaining needs.

Asian in its simplicity, the dining area (right) has a square *wenge* wood table and chairs by Christian Liaigre. The table setting includes black raffia place mats and table runners and a centerpiece of cabbage flowers. The curved wall works to break up the straight-lined space. "It was one of the architectural features we loved about the building," says the owner. "We liked it so much we decided to highlight it by installing a back-lit curved bench around the wall."

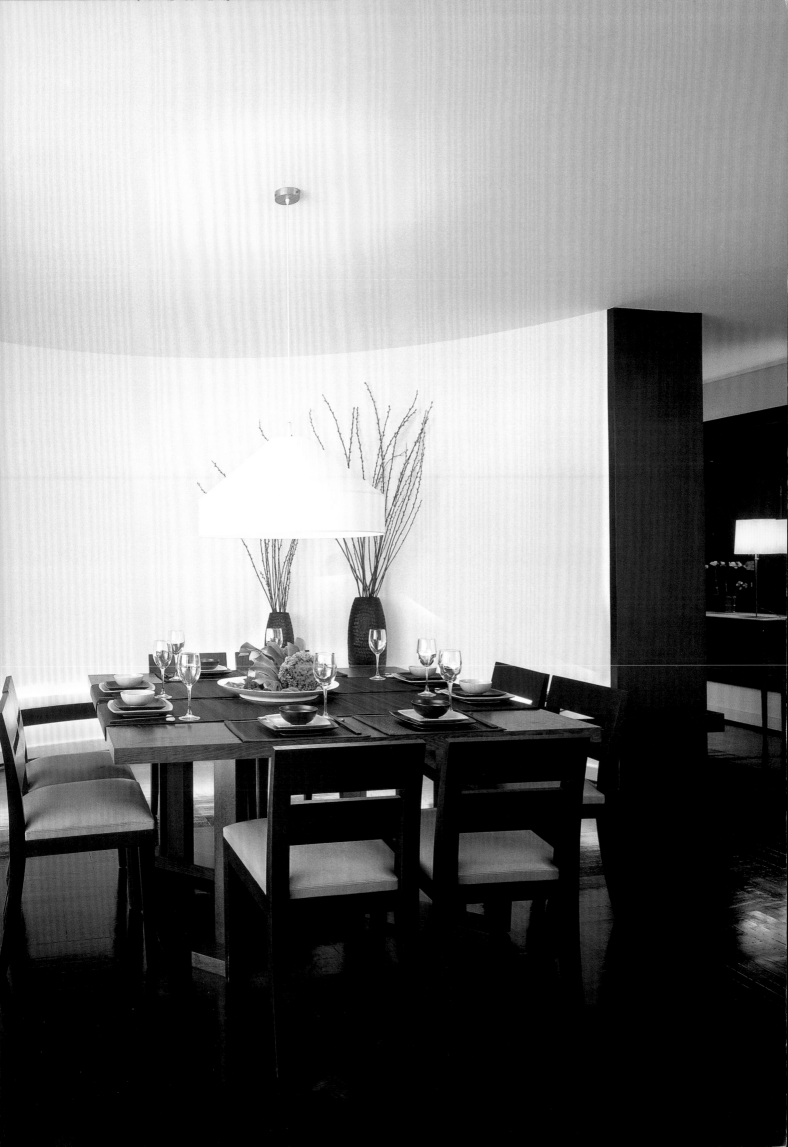

Two rooms were merged to enlarge the master bedroom and turn it into an entertainment and relaxation centre as well as a place to sleep in (opposite, top). The flat-screen TV faces the bed and is mounted on a specially designed stand which incorporates an internal hydraulic lift so it can be raised up at the flick of a switch. This enables easy viewing whilst one is reclining on the bed. The stand also acts as a room divider. Built-in white cupboards run along one wall while windows run along the length of the other. A modern interpretation of a Chinese day bed made of wood, leather and steel is placed at the rear of the room near the entrance to the bathroom.

The ensuite bathroom (opposite, below) has been built for two: above a pair of large ceramic basins, a small TV screen has been inset into the mirror. In this way, access to the latest news and videos is on tap any time of the day. The bathroom leads to the study which is furnished with more traditional Chinese furniture.

Colours have been kept low-key in the open-plan living room (above) which extends off the dining area. Arranged with architectural precision is a stone coloured leather sofa, a pale lilac armchair and ottoman and a wooden 'Tribal' bench (a favourite piece), all by Christian Liaigre. The French designer's furniture was chosen because it looks elegant and suited the style of the 1960s-built apartment block.

East West Fusion

Caroline Ma's brand of East West fusion is far removed from any claims of cliché. The Canadian-born, Cornell-educated architect who was raised in Hong Kong takes a global approach to design. In her view, Hong Kong folk are a living blend of Eastern tranquility and Western vibrancy. "We are equally influenced by China and the Western world. It is already our way of living. We even talk using half English and half Chinese. So why shouldn't interior architecture be the same way?"

Ma's philosophy is revealed in the recent re-design she undertook for clients in a modern house located high on The Peak, Hong Kong's premier residential site. Reached via twisting tree-lined streets that rise higher and higher above the city centre, this light-filled, two-and-a-half storey residence is a harmonious, free-flowing space of grand proportions. Taking inspiration from Chinese architecture and motifs, Ma decided to install a bold, modern moongate (a favourite feature in historical Chinese gardens) in the living room. The warm cherrywood arc, which surrounds the French windows, is lit on three sides and works to define the double-height space. It is the focal point of the room.

"I wanted to introduce some traditional Chinese elements," Ma explains, stating that she also loves the contrast the feature provides against the modern cream furniture, the Philippe Starck lighting and the sleek marble flooring. "The moongate provides an optical illusion, giving the windows an enhanced sense of height."

The lower-floor bedroom (right) neatly juxtaposes the antique and the modern. Next to the entranceway, a pair of latticework Qing dynasty screens has been used as cupboard doors and provides an effective contrast to the ultra-modern bed and furnishings. In the bedroom itself, the bed on wheels is both practical and flexible; by its side is a yellow 'Mama' chair and a navy 'Tato' stool from Baleri. Says Ma: "I didn't consciously choose this style. I let my clients' ways of living generate my design. Today, people travel so much that no one can say that they are not influenced by other parts of the world. Seeking a balance is the key."

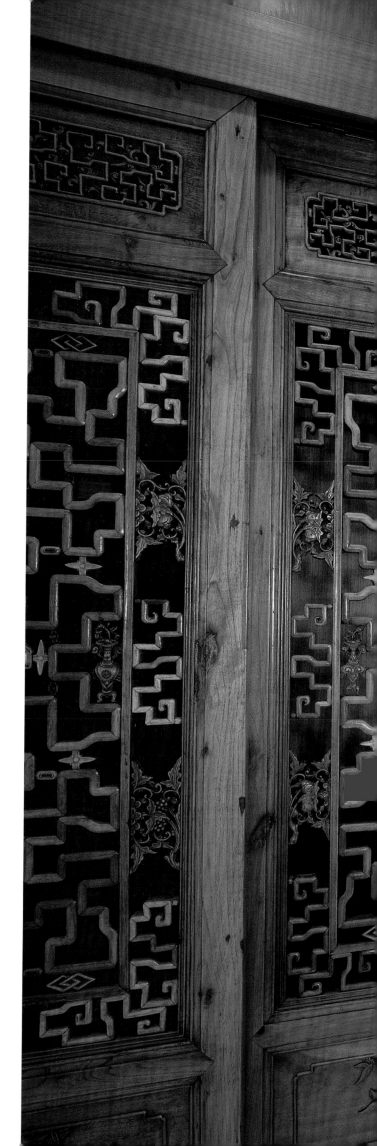

Hong Kong-based architect Caroline Ma's interpretation of Oriental fusion is definitely not run-of-the-mill. A huge cherrywood moongate dominates the living room (right). "Moongates have an East West connotation but I think they also fit well with the retro 1950s movement which is happening right now," explains Ma. Light floods in through the warm wooden arc which effectively defines the living room's double-height space. It also frames impressive views across Hong Kong. Ma's interesting mix of straight lines and curves adds visual interest to the pared-down space.

Entering through the front door (above), visitors are greeted by the soothing sounds of running water: Ma installed a granite waterfall between the hallway and the kitchen to disguise some leftover space. The waterfall also provides good feng shui as water in the house is seen as a way of activating wealth. The walls are clad with reconstituted granite, which contains little bits of crushed sea shells. A skylight above ensures maximum light.

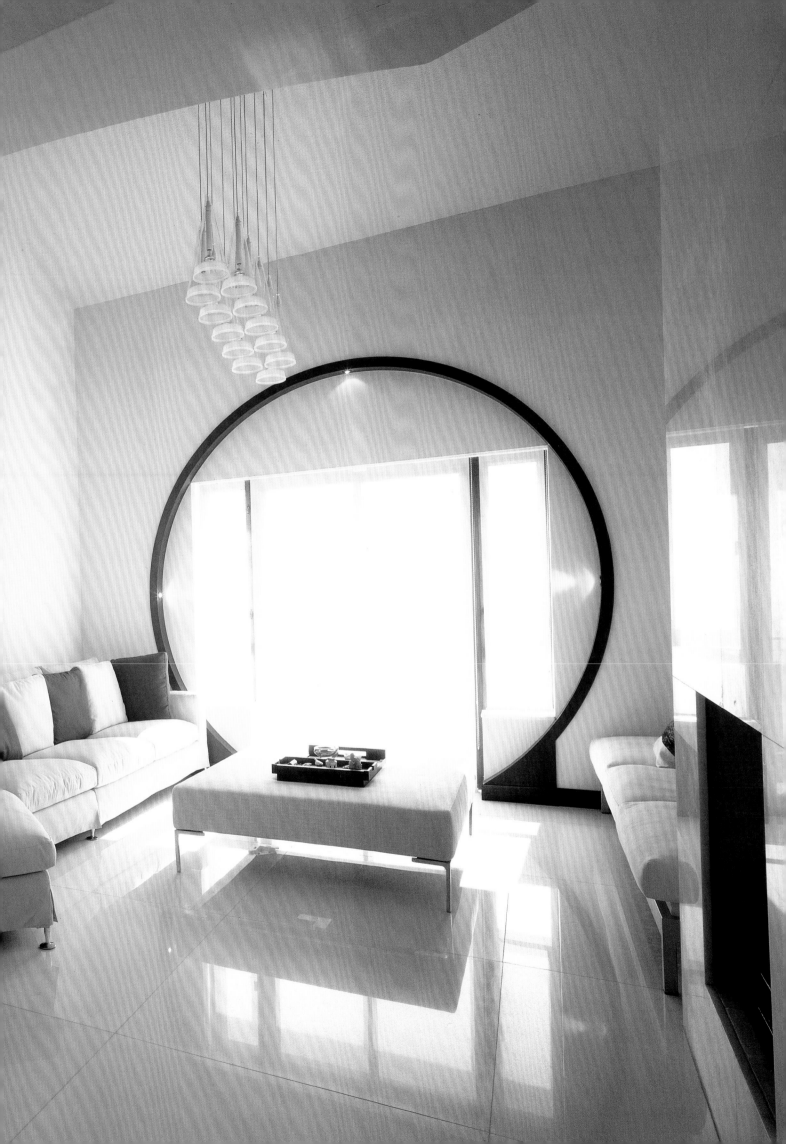

Ming Modernism

Ming meets modernism in Carol Lu's streamlined, airy apartment. The architecturally simplified space in a prestigious apartment complex a short car ride away from Hong Kong's busy business district may mix Ming furniture with contemporary furnishings and modern Chinese art, but it is also very much a family home.

Lu, a former art gallery owner who also studied architecture, admits to being crazy about Chinese furniture. She used her design eye to create a practical, movable and flexible space that is both functional and aesthetically pleasing. Textured materials form a quasi-industrial back-drop to the space: a concrete floor in the entranceway (both durable and childproof), recycled pine wood flooring in the living and dining rooms, lime plaster walls, a touch of oak, and lots of opaque and clear glass panels. "I wanted to use humble finishes," explains Lu. "And with three children, the apartment had to be practical too."

She installed sliding panels in place of walls to divide up the 344 sq m (3,700 sq ft) space, allowing different family activities to take place concurrently. "I also wanted to be able to open everything up so I don't feel boxed in. These allow me to change the interior as I wish."

Lu's impressive collection of predominantly Ming furniture has been carefully selected. The *huanghuali* (yellow flower pearwood) altar tables, cabinets, stools and rose chairs provide an interesting contrast to the modern textures and the contemporary Chinese art which hangs from gallery style fittings (again, so they can be moved around at will). The paintings include work by mainland artist Ding Yi, Taiwan artist Ho Huai Shuo and Paris-based Zao Wuki; styles range from pictorial to abstract to humorous. Taking centrestage in the dining room is a floor-to-ceiling blackboard wall, which gives the children of the household a chance to demonstrate their own artistic tendencies.

The personal touch continues with some eye-catching accessories. An old barber's stool from a Shanghai flea market stands beneath a Ju Ming sculpture; a circular, red lacquer birdcage from Hong Kong's antique street, Hollywood Road, sits on a Trigram table; and a collection of cute miniature *zitan* (purple sandalwood) Chinese chairs (made with the exactly the same construction techniques as their grown-up siblings) adorn an altar table. As with everything here, the children and the adults get equal billing.

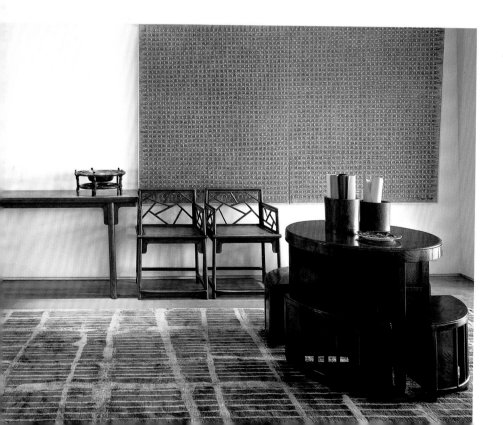

Carol Lu elegantly installed classic, clean-lined Ming furniture within a quasi-industrial palette in her light and airy Hong Kong apartment. In the entranceway (right), the concrete floor is tactile, durable and childproof. A sliding oak door seals off the space that features a burgundy back wall, a spindleback chair and a huge atmospheric canvas by Paris-based artist Zao Wuki.

On the wall in one half of the living room (left) hangs a large artwork from Mainland Chinese artist Ding Yi's 'Cross Series'. Covering the living room floor is a carpet entitled 'Red Stripe' designed by artists Brad Davis and Janis Provisor of Fort Street Studio; the design was inspired by traditional Chinese motifs. A circular maplewood table from 1930s Shanghai features curved pullout chairs; Lu calls it her 'mooncake' table.

Textures take pride of place in this open, free flowing space. In the living room (right), recycled pine wood flooring and terrafina lime plaster walls provide the backdrop for groupings of *huanghuali* wood furniture (a 100-year-old trigram table, a pair of Ming stools, which function as a coffee table, and a pair of low-backed chairs called Rose chairs) plus comfortable contemporary navy blue and white sofas. To the left, an opaque glass partition takes the place of a wall and seals off the entrance hall; inset is a clear glass panel which the children enjoy peeking through when guests come over. Against the far wall, a sloping stile wood-hinged Ming cabinet, a painting table and a pair of Rose chairs with signature cracked ice pattern (which echoes window design in Ming architecture) have been placed with architectural precision.

The antique barber's chair (below) was found in a flea market in Shanghai. It not only functions as a stool but also as a storage unit (with pull-out drawers) and a post-haircut money holder (there is a coin slot in the top).

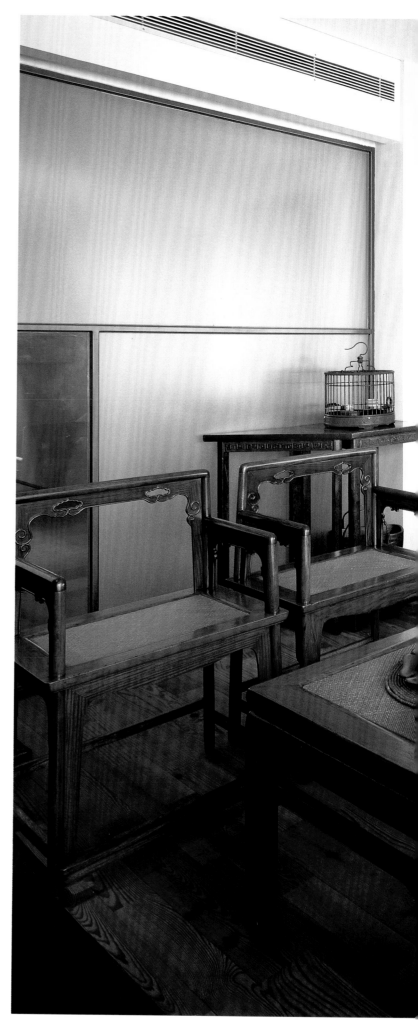

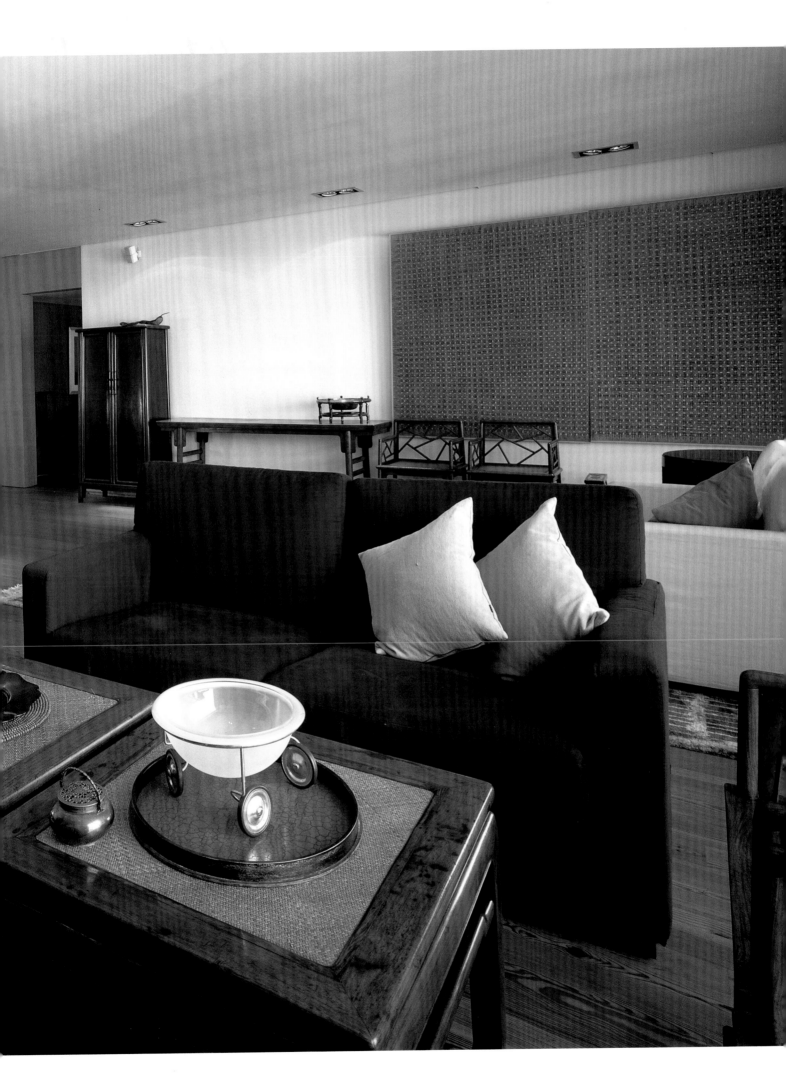

Sliding panels are key to the apartment's flexibility. To the rear of the dining room is a relaxed and informal family eating area (above), complete with large pine table, rice measuring baskets and crayons. The large, humorous painting is by Ding Yang Yong. The opaque glass door can be opened or closed, allowing different family activities to take place simultaneously.

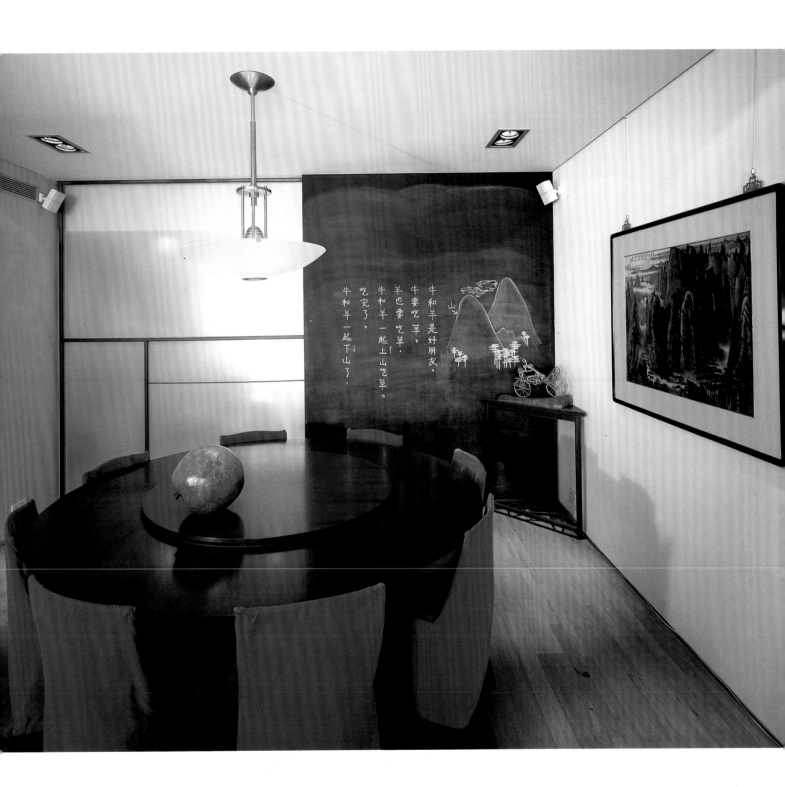

In the dining room (above) a large Charles Rennie Macintosh dining table features a revolving 'Lazy Susan' for serving Chinese meals; it slots neatly into the table when it is not required. On the table is a giant bronze sculpture by New York-based artist Ming Fay. A floor-to-ceiling blackboard wall is primarily for the kids—one day it might contain a good behaviour chart, another time it functions as a storyboard.

Spacious Serenity

The south-facing Peak home of John Chan, one of Hong Kong's established interior designers, is a thoughtful combination of furnishings and understated tones designed to soothe and relax. His design ethos was simple: "I wanted to create a background environment that would complement any mixture of furniture and art pieces."

Located at the end of a quiet lane, where the only sounds are birdsong and the subdued whir of luxury automobiles, the 1970s-built house (which is old in Hong Kong terms) comprises 437 sq m (4,700 sq ft) on four levels. To add more natural daylight into the space, Chan opened up the second floor slab directly over the living area to create a double-height ceiling dissected by a walkway. He also added skylights over the stairwell, the TV room and one of the bathrooms to let in more light.

The furnishings are a classic blend of European and Chinese, featuring clean-lined Ming pieces that work to complement the modern structure and more decorative Qing pieces that contrast with it. This mix, Chan believes, adds a unique cultural perspective to the space. The overall effect is casual, private and very bright. Chan, who spends his professional life designing public spaces including numerous hotels, clubhouses and restaurants, wanted to create a "free and easy" space at home. With the living room doors flung wide, and panoramic views outside, this serene space is a world away from the mayhem of city life far below.

Chan has blended his furnishings with panache: in the double-height living room (right), a pair of 200-year-old calligraphy panels from Anhui province hang above an antique European piano; a limited edition Ju Ming sculpture (bronze with patina highlights) called 'Chung Kwai' is positioned near the contemporary goosedown sofa and chairs. Sisal flooring defines the seating area.

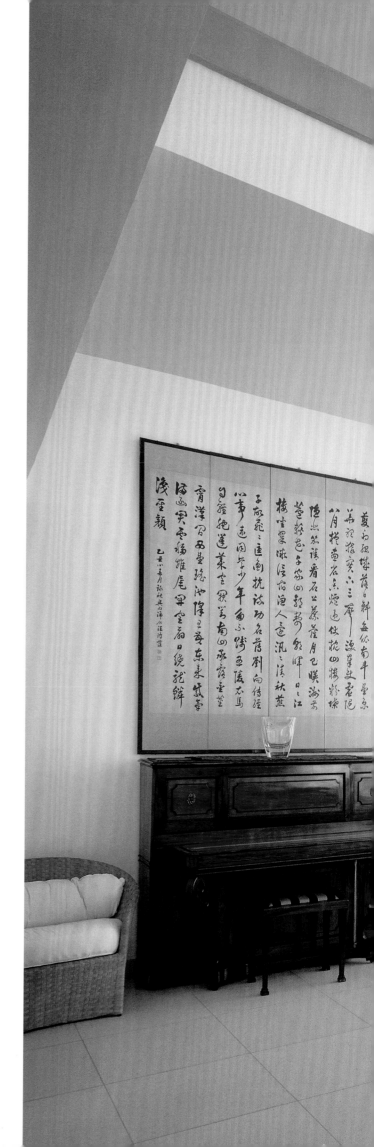

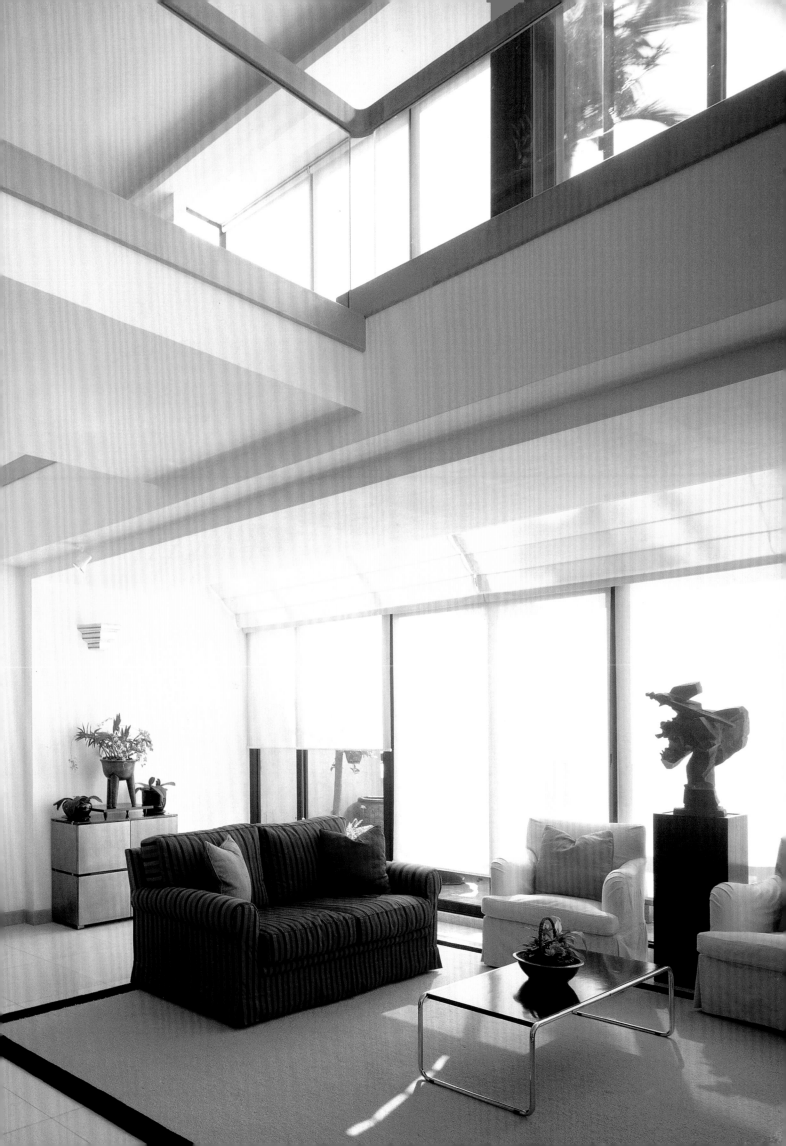

In the hallway (above), a *zitan* wood and ivory birdcage built in the 1970s hangs from a *zitan* wood hatstand from 1920s Shanghai. Good looking hatstands are hard to find, says Chan—he purchased this one for its looks and functionality. Positioned alongside is a bench seat made of *zitan* wood and marble. It is a family heirloom.

Chan contrasts simple, architectural designs with Chinese elements, whether they be the clean lines of the Ming dynasty or the more decorative elements of the Qing dynasty. "When the two are mixed, a certain degree of taste and a touch of culture is achieved," he says. In the dining room (right), which leads off the living room, two *jichi mu* (chicken wing wood) altar tables have been placed under a pair of glamorous silver leaf framed mirrors. On the wall are marble and wood panels from the late Qing dynasty. "In those days it was popular to use exotic stone slabs with characteristic veins in furniture and sometimes, as here, in decorative panels."

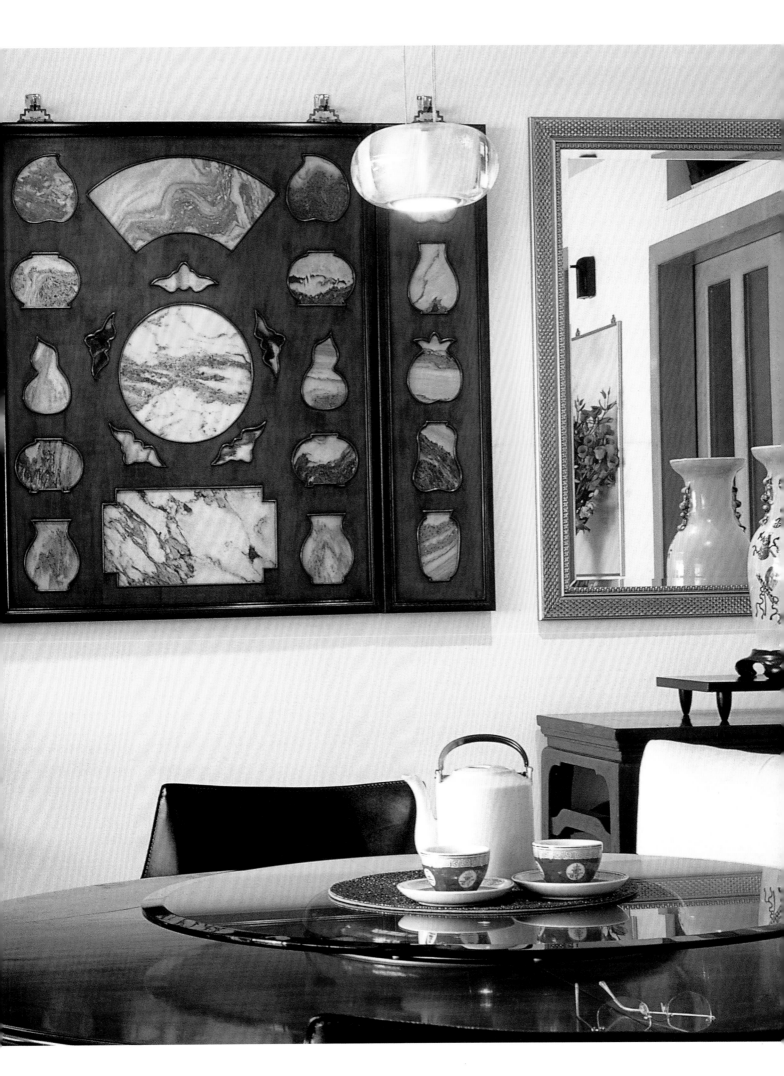

A Zen Sanctuary

The serene London home of interior designer Kelly Hoppen is testament to her self-confessed love of creating sanctuary-like environments that feel good first and look good second. Acknowledging that she draws influence from a subtle Oriental aesthetic, this neutral interior is based on textures rather than colours. To add visual interest to a room, she says, the key is to mix unexpected materials: towelling and silk, chenille and suede, stones, velvets and lots of dark woods.

Although East meets West is an all-too-often used phrase these days, Hoppen's calm cool design aesthetic was one of the first to be labelled thus. She describes her core values: "The defining elements of great design are luxury, balance, light and a sense of being at one with the natural and organic world." Her ordered interior, with its balanced lines and streamlined placement of furniture, adheres to the principles of the Chinese art of feng shui. Such harmonious living produces an efficient flow of energy (chi), allowing it to work for you rather than against you.

Nature, too, is brought inside at every opportunity, with accessories such as single stemmed lilies in clear glass tubes placed in narrow, rectangular display niches and a series of large shallow Perspex trays in which float single white roses.

The influence may be Oriental in feel, but the furniture is modern—pared-down shapes using lots of dark *wenge* wood (from the central African tree *Millettia laurentii*). The oversized dining table comfortably seats 12 and is the centrepoint for dinner parties where Hoppen shows off her flair for creating innovative table settings. In the bedroom is an Oriental version of a traditional dressing table in *wenge* wood; the darkness of the wood provides an effective contrast to the serene, neutral space which, she claims, is perfect for thought and sleep.

Moving into the bathroom, the designer has played upon the Asian penchant for luxurious bathing. A large calligraphy scroll hangs on the wall, a pale wood wash-basin is home to stacks of fluffy white towels and spot lighting adds a subtle glow. Beneath grid windows, a traditional bathtub is balanced on two blocks of *wenge* wood to give the impression of a floating bath with shimmering lights beneath. A sanctuary for the senses, indeed.

"It's all about balance and harmony," says Hoppen concerning her subtle Eastern aesthetic. "I make spaces that work for people." Her functional dining room (right) includes nature as much as possible in the decorative scheme. Narrow, rectangular display niches provide the perfect location for single stemmed lilies in slim, clear glass vases.

A soft, light, monochrome palette runs through the interior. A calming decorative approach is key in the living room (left) with its balanced lines, natural textures—and no clutter at all. Hoppen is a keen advocate of the Chinese art of feng shui and believes that such spatial discipline allows for positive living vibes. In the foreground, a huge low-level *wenge* wood coffee table holds three shallow Perspex trays. A white rose floats in each. On the wall and propped against the wall are black and white photographs collected by the designer.

Preferring texture to colour, Hoppen likes to create a sense of informal luxury by using contrasting materials: dark wood, suede, velvet, silk and chenille. In the bedroom (above), the bed is dressed with piles of cushions and sumptuous bed linens in neutral tones; by the window is an Oriental version of a traditional dressing table made of *wenge* wood (detail on left).

Ordered interiors promote relaxation and a sense of well-being. And nowhere is this more so than in the bathroom (opposite) which plays on the Eastern love of bathing. In front of the grid windows are a set of five wood plant holders—three of which are topped with leafy fronds. A traditional bathtub, ideal for soaking in, has been balanced on two blocks of *wenge* wood and lit from beneath to give it the impression of floating in space.

Contemporary Flair

Contemporary with a Chinese twist, this clean-lined apartment in the heart of Hong Kong's busy Mid-Levels residential district is a superb example of traditional motifs used in a totally modern manner. When designing this compact 74 sq m (800 sq ft) space, architect Johnny Li of Nail Assemblage went back to his cultural roots to formulate a new language of design. Instead of opting for the traditional rosewood furniture look, or placing clean-lined antiques in a contemporary interior, Li chose to focus on the elements that define Chinese style and apply them to a modern design.

Li took inspiration from the layout of historical Chinese buildings. "Traditionally, Chinese architecture used a frame system of openings to suggest more space beyond," he explains. He interpreted this by fitting dining room windows with latticed walnut screens (backed by bamboo blinds and a row of plants) to evoke the impression of an Imperial garden outside. In the wood-clad entranceway he hung a huge, door-sized photograph of traditional Chinese moongates and down the corridor, used a rich purple curtain to disguise a door at the end. This device adds depth to the hallway and hints at a private zone beyond.

By custom-making all the furniture, Li was able to reinterpret Chinese ideas in a contemporary fashion and ensure that every piece fitted the compact space perfectly. He took the decorative Chinese symbol meaning 'cloud' and integrated its spiralling shape into a coffee table-cum-stool, bedside tables and bed legs. His cherrywood and velvet dining table and six-sided stools were inspired by traditional hexagonal Chinese garden furniture, and the decadent red acetate-fringed lampshades hanging in the bedroom are reminiscent of an opium den. On the same theme, an impressive modern adaptation of a Chinese opium bed with footstool appears to 'float' in the study.

Offsetting the pared-down design and neutral colour scheme are modern materials and bright accents. Instead of traditional Chinese blackwood, gilt, lacquer and silk, Li opted for cherrywood, stained maple, stainless steel and Perspex. Colours are those normally associated with Oriental style, such as turquoise, purple and red. "I designed simplified traditional shapes using new materials. It was a creative experience as well as an educational one. It was also an exercise in learning about my roots."

The fact that traditional Chinese courtyard dwellings used a system of openings to suggest more space beyond proved inspirational for this hallway (right) which leads into the living and dining areas. In a nod to Chinese gardens, architect Johnny Li enlarged a photograph of the old moongates in the grounds of Hong Kong's Repulse Bay hotel to poster size and positioned it over a door leading to a storeroom. The dining room windows have been fitted with latticed walnut screens with plants behind. The hexagonal cherrywood dining table and velvet-topped stools are based on traditional garden furniture designs; above hangs a pink Perspex lantern.

At the end of the corridor (left), Li hung a rich, shimmering purple curtain to disguise the door leading to the spare room beyond. This helps suggest there is more space than meets the eye, a valuable design tool for Hong Kong living. A slatted dual tone wood box is an interesting way to disguise an ugly air conditioner. The painting is by Lee Chi Cheung, a well-known Chinese watercolourist from Hong Kong.

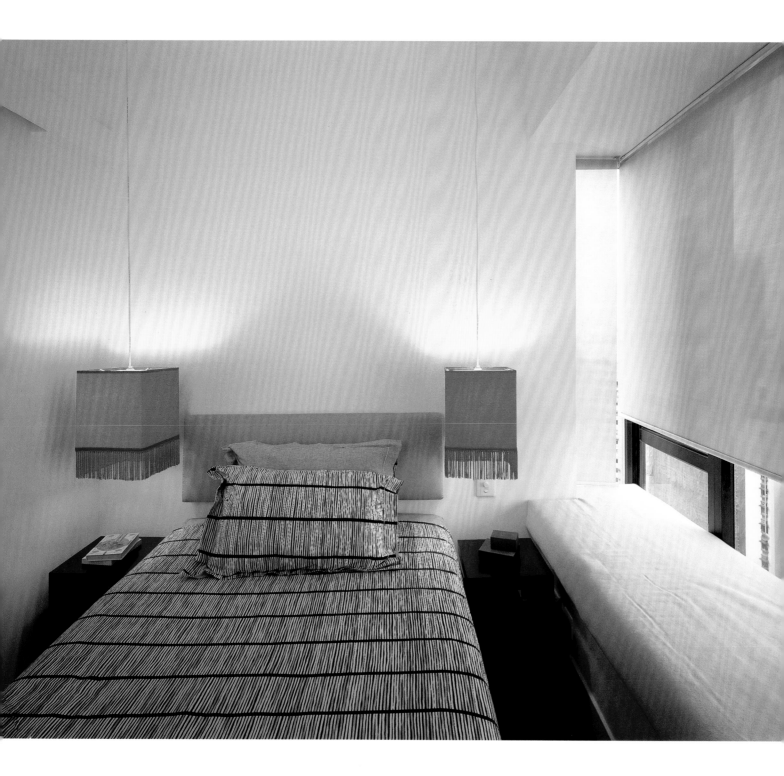

Reflecting on his cultural roots, Li came up with a new take on traditional Chinese style by focusing on its inherent decorative elements and adding a 1950s retro twist. In the living room (opposite, top), a modern cream sofa was custom-made to fit. Lining the wide windowsill with futon-base material and adding some cushions provided additional seating. Li also designed a stained maplewood coffee table-cum-stool based on the Chinese symbol for 'cloud'. The walls in the entrance hall have been clad with wood to provide shelving for the owner's collection of books.

In the bedroom (above), the red-fringed acetate lampshades are more decadent opium den than 21st-century style. Roller blinds fit flush to the window to provide privacy without sacrificing space. The bedside tables and the bedlegs (not pictured) incorporate the spiralling cloud motif.

In the study (right), a modern adaptation of a Chinese opium bed is fastened to the walls at either end of the small room. Lit from beneath, it seems to float in space. In this room, contrasting textures are key: the wood veneer bed, the stainless steel and maplewood side table (again a modern interpretation of a traditional design) and an antique dark wood cabinet. Overhead is a modern anglepoise lamp, ideal when extra light is needed for reading or for working on a laptop computer. To make such activities easier, a clear Perspex bed tray has been placed on top of the bright turquoise futon cover (a colour often associated with Chinese style).

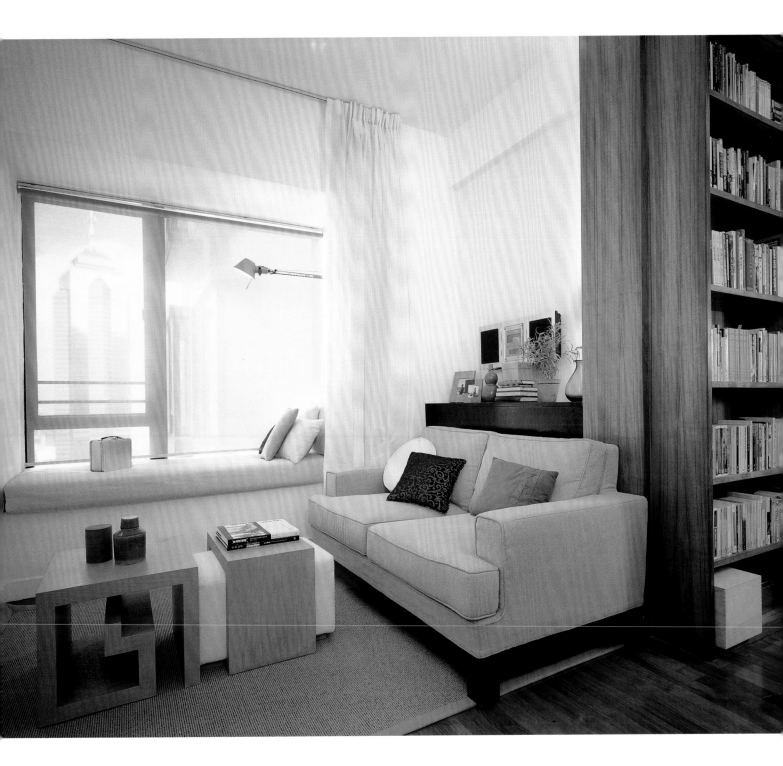

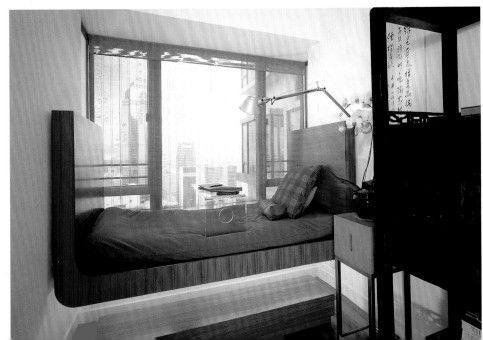

Space and Light

On Dean Street, in the centre of London's bustling Soho district, stands a 1960s-built former synagogue. Today, worshipping takes a different form here as the concrete-framed building has recently been converted into an innovative new complex to house the Soho Theatre Company. In a new take on urban recycling, the architects behind the project—husband and wife team Paxton Locher—have turned the seven-storey structure into a multifunctional building with residential apartments on top, hospitality outlets below and a theatre sandwiched in the middle.

The project was completed in alliance with the Arts Council and a Lottery Grant that paid for the theatre, restaurant and bar on the first four floors. The top three floors were developed by Vinestone Limited and comprise four duplexes of 163 sq m (1,750 sq ft) and one single floor penthouse of 232 sq m (2,500 sq ft). "All the apartments feature large outdoor spaces and patios," explains Gee Thomson of Vinestone. Two have double-height terraces carved into the façade overlooking the street; another two face away from the street with sloping retractable glass roofs.

In one such duplex, what is essentially an ultra-modern interior has been filled with a collection of classic Chinese furniture from London's Beagle Gallery. With its huge glass windows and open-plan layout, the cool, almost-clinical space is tempered by the warm wood antiques. Contrast is the secret to decorative success here. Fresh and modern, the architecturally minimal interior has been furnished with both natural and quasi-industrial elements—including crisp white linens, warm wooden floors and an open metal stairway joining the two levels. The open plan space is large and free-flowing, with walls kept to a minimum to allow light to flood in.

Urban recycling in action (right): In this duplex an open staircase leads to a mezzanine level study above; a kitchen and terrace are positioned to the left. Four Qing dynasty chairs—two 18th-century elmwood chairs with stone insets and two 19th-century elmwood chairs, all from northern China—are arranged around a 19th-century day bed with a cane top.

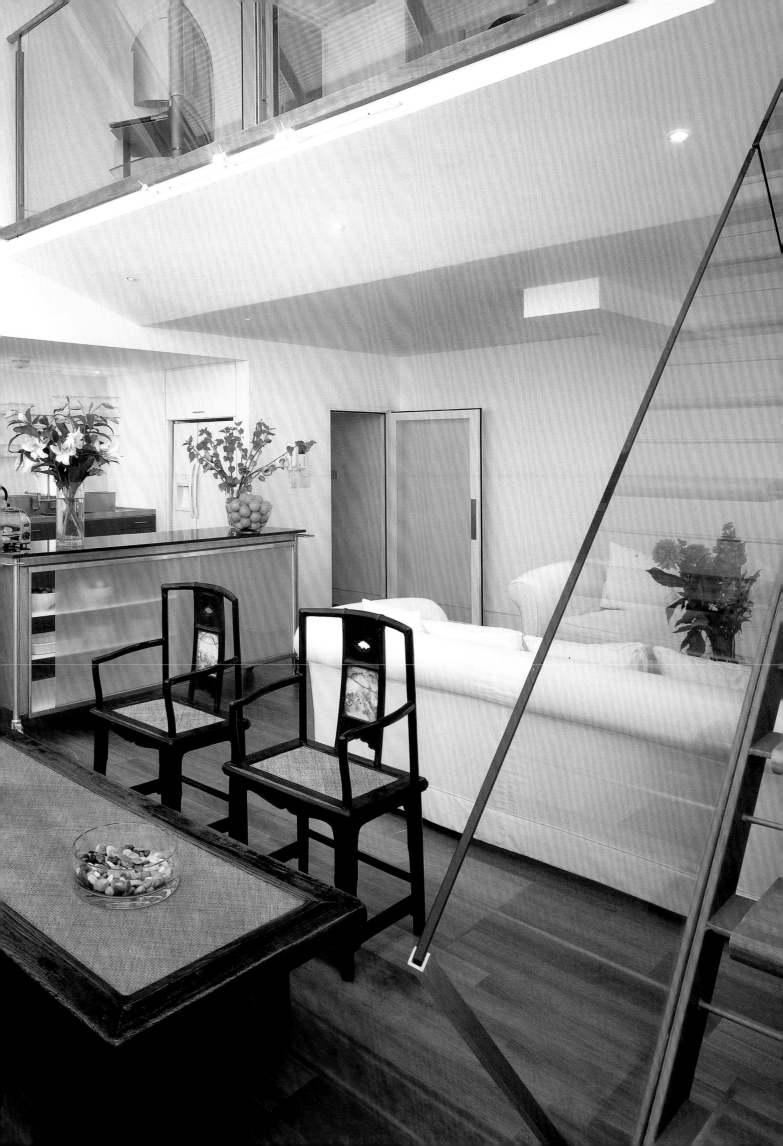

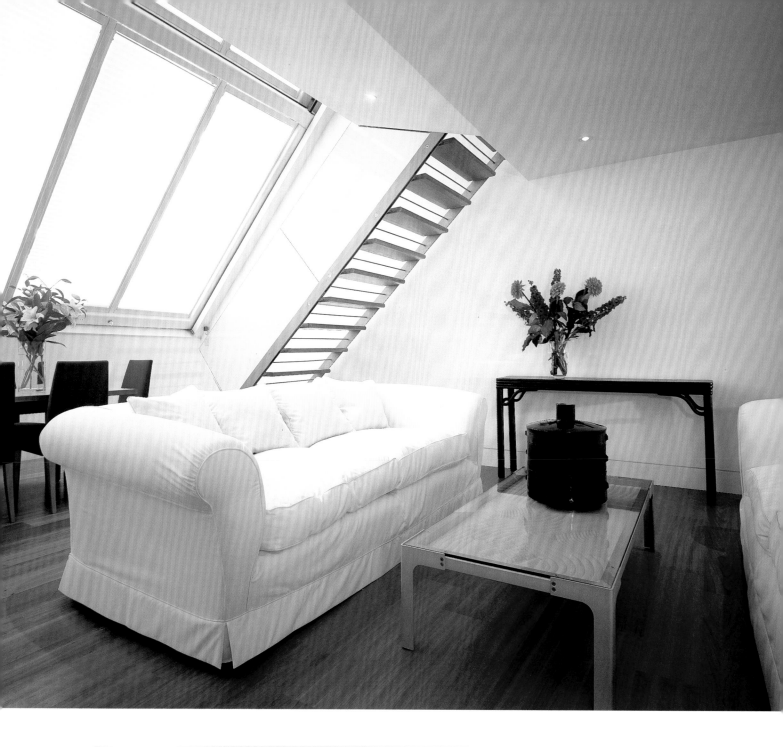

The open-plan living room (above) has been furnished with a mix of Chinese antiques and modern pieces and features huge sloping windows which let in lots of light. Two large, comfortable white sofas flank a modern metal and glass coffee table. On top is a 19th-century leather and black lacquer hatbox. Against the wall is an elmwood altar table from northern China, also from the 19th century. All the antiques are from Beagle Gallery.

Looking from the office into the dining area beyond (left): The open plan proportions of the space enable clear views from one room into another. Concrete columns add visual interest without creating a closed-in feel. An 18th-century southern elmwood cupboard from Suzhou and a 19th-century elmwood chair from northern China make an interesting contrast to the contemporary dining table and chairs.

The bedroom (above) is an exercise in architectural minimalism with its crisp white linens, warm wood floors and antique furniture and accessories. Next to the bed is a Ming dynasty, 16th-century copper hand warmer; on the other side of the room is an 18th-century elmwood armchair.

Tucked away under the eaves: the mezzanine level study area (right) is quiet and peaceful and benefits from lots of light. Underneath the sloping windows is an antique trunk and hatbox; floor-to-ceiling built-in cupboards provide lots of storage and help keep the clean-lined space neat.

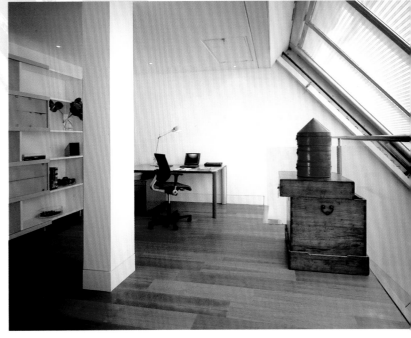

Modern Classics

"I like simple Chinese pieces, not decorative ones," says interior designer Debra Little, with reference to the furniture and accessories that fill her compact Hong Kong apartment, situated on the fringes of the busy Lan Kwai Fong restaurant and bar area in the centre of the city.

Comprising a long slim living area with bedrooms leading off to the left, the parquet floored, white walled space features a monochrome mix of streamlined Ming-style Chinese furniture from Macau (the former Portuguese territory, an hour's boat ride away), modern classics (such as four 1950s-designed Eames chairs) and a collection of tonal Asian and Chinese artworks which cover one wall. All have been arranged with formal precision to make the most of the limited space. "My pieces have evolved as I have collected them over time. I also travel a lot with work and source items that way," she explains.

Natural materials and textures are key: an oversized, low level marble topped table, a cream cotton sofa and lots of wooden objects add warmth to an interior that embraces neutral tones rather than colour. Dotted around are various accessories sourced from Hong Kong flea markets: boxes, candle stands, calligraphy brushes, chops (printing block symbols), assorted scholar's objects and a collection of works by Hong Kong sculptor Lee Man Sang. It is a serene, contemporary and comfortable space—and not a hint of clutter in sight.

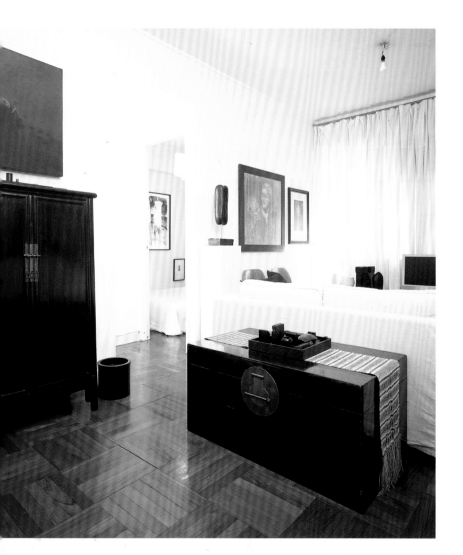

A dark wood Chinese chest from Macau nestles snugly against the back of the white cotton sofa in interior designer Debra Little's living room (left). Natural shades and materials work together in this long, slim space; visual interest comes from textures such as the marble table top and collection of tonal artworks from Hong Kong, Vietnam and Czechoslovakia which run the length of one wall. Two 1950s Eames chairs rest against the rear wall.

Looking through the understated living room and into the bedroom (right). Plain white curtains secure the interior from neighbouring eyes whilst allowing light to filter through. The clean-lined Ming-style tapered cabinet was purchased on a trip to Macau; the trunk is made from camphor wood and has a lovely smell inside, perfect for linen storage. Many of the wooden Chinese accessories were found in Hong Kong's Cat Street, which is lined with stores and stalls selling all sorts of flea market finds.

A Cosmopolitan Mix

The city-state of Singapore is a cosmopolitan melting pot of cultures and styles. So too is this urban apartment, home to an Asian-American couple, perched high on a hill near the centre of the city. Built in the 1960s, this high-rise apartment block has the generous proportions and clean architectural lines prevalent at the time. The dark stained teak floors and contrasting white walls give a streamlined, retro feel to the space. The interior benefits from lots of light: it floods in from the balcony through the original wood-framed glass doors to illuminate the living and dining areas and bounces off the oversized mirror that covers an entire wall in the living room.

The occupants are frequent travellers and have lived in Hong Kong and New York as well as in Singapore, so have blended a little of each lifestyle to create a modern, relaxed home. The refurbished living room chairs are local interpretations of art deco style and originally graced the Bank of China offices in Singapore. A collection of wall and floor lamps from the United States, includes steel and surgical floor and ceiling lamps from the Bronx, Los Angeles and New York flea markets and warehouses. Tiger motif Mongolian woollen floor rugs, some nearly a century old, reflect the star sign (Leo) of one of the occupants.

The apartment also boasts an impressive number of ceramic Mao Zedong figurines and busts. The all-white collection began over a decade ago, prompted by a find in a Hong Kong flea market. The owner admits that he collects reproductions of the communist leader for purely bourgeois considerations and at last count they numbered 172 pieces. However, more than half are in storage or have been given away.

The teak-floored, white walled living room (right) looks extra spacious due to an oversized mirror which covers an entire wall. The mirror was found in an old coffee shop in Singapore and restored. The art deco chairs are local interpretations of the international art deco movement and were originally used in the Bank of China offices in Singapore. The lights (both ceiling and floor) were sourced from flea markets and warehouses in the United States.

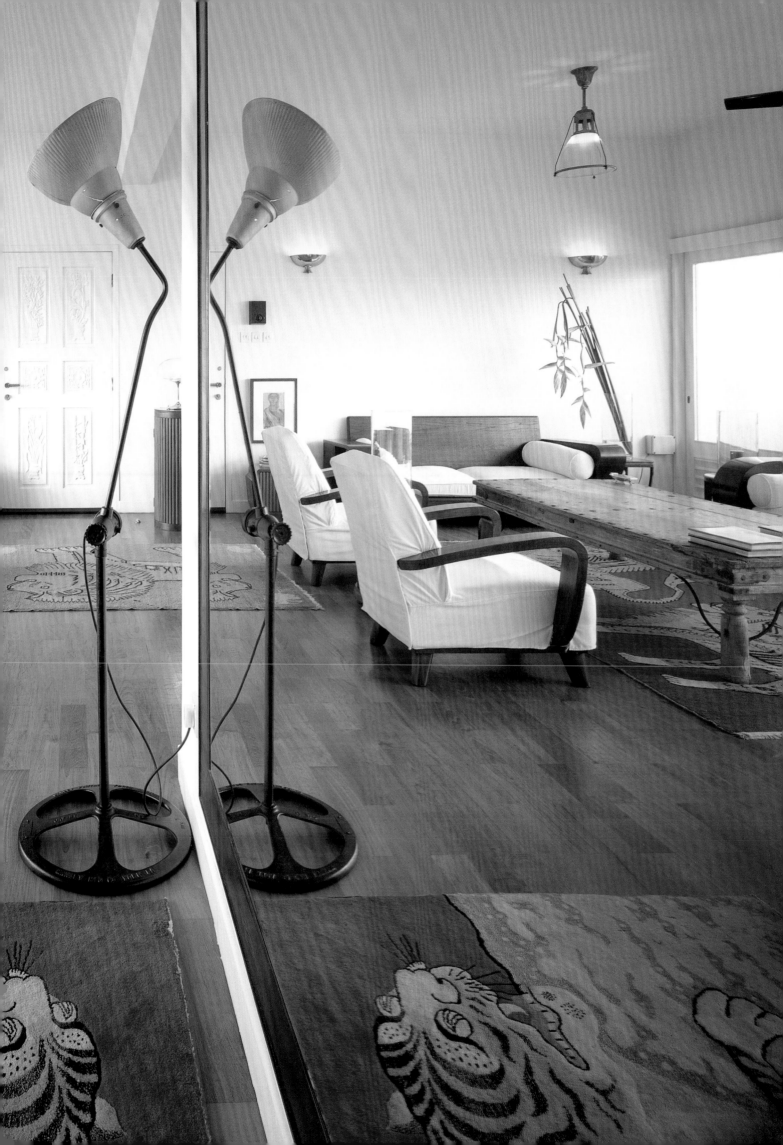

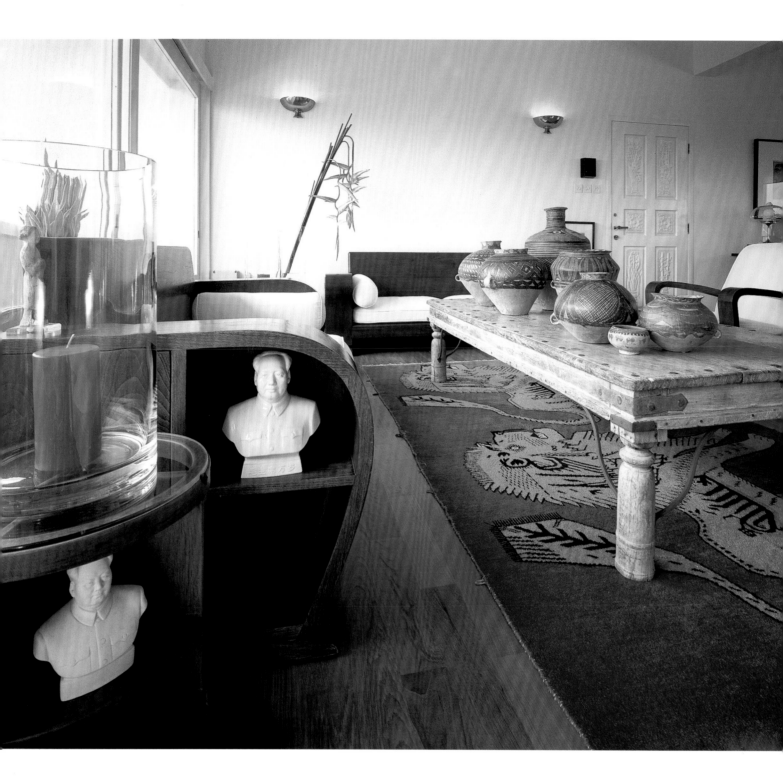

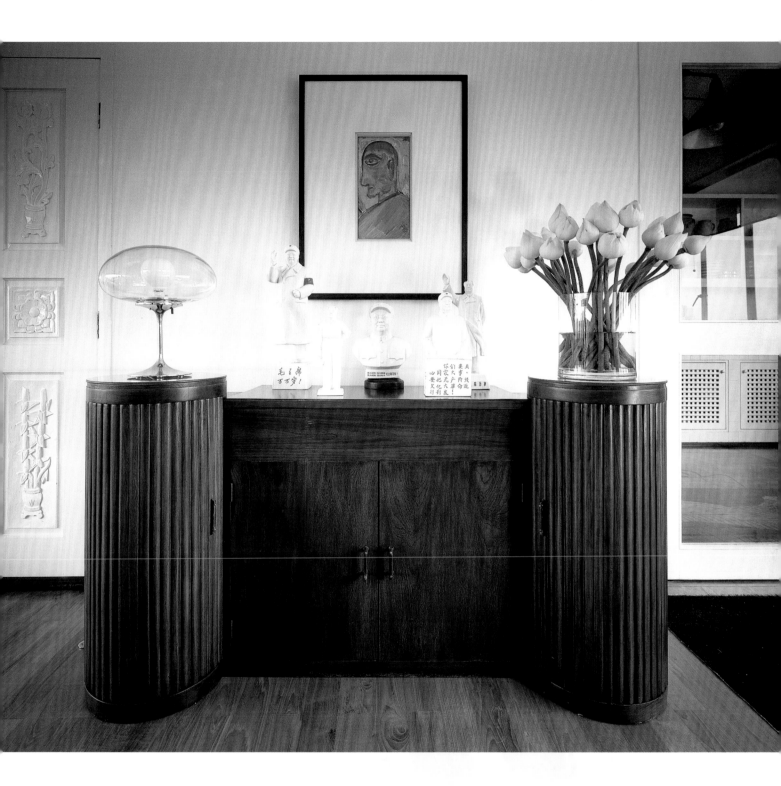

The wooden side cabinets (above, left and right) were found in a local antique shop. The collection of Mongolian rugs—some almost 100 years old—feature lions and tigers.

The owners' extensive collection of white, Mao Zedong figurines and busts (left, detail) began 10 years ago in a Hong Kong flea market. Although the collection numbered over 170 pieces at one point, it has been whittled down to much more manageable proportions to display at home.

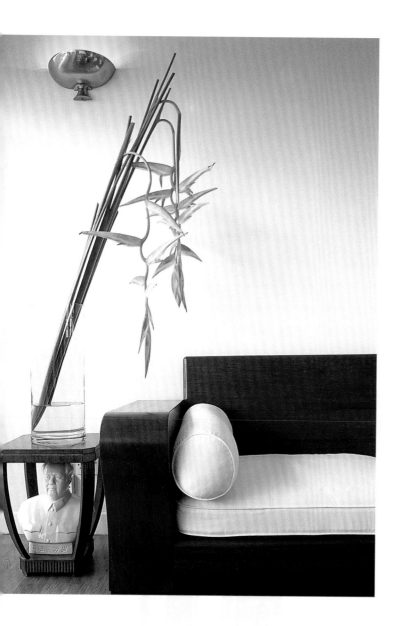

The Asian-American owners of this Singapore city pad have created a relaxing home that reflects different cultural elements and eras. In a light-filled corner of the living room (above), a canvas upholstered sofa, dark wood side table and minimal florals are simple and uncomplicated.

The monochrome palette continues in the dining room (right) which is often used for entertaining friends. At night the apartment takes on a softer, cosier glow, with lighted candles providing the main sources of illumination. After dinner, guests move onto the balcony to enjoy night-time views of the city. "With the twinkling city lights far below, and fuelled by good wine and conversation, chilling out becomes so much easier," says one of the owners.

Opposites Attract

Texture, style, colour and proportion were guiding factors in Lina Kanafani's choice of Chinese furnishings in her London home. A pair of red and green Chinese wedding cabinets and a bamboo reclining chair were sourced from Belgium and the Lebanon respectively. "At the time the cabinets and chair were purchased, Chinese furniture was not as common in London as it is now," she explains. "The fact that the two cabinets were almost identical but of different colours was ideal for my living space so I fell in love with them."

The two wedding cabinets cleverly offset the proportions in the living room. "Once installed, their presence added the right elevations needed to balance the rest of the (low height) furniture. To create a more dramatic visual effect, antique lacquer boxes, modern lights and sculptures were installed on top. Kanafani, owner of the London-based interior store Mint, prefers to experiment with different mixtures of work by new designers, modern classics and ethnic pieces—both at home and at work. "I invariably find, through personal taste and experience, that ethnic furniture serves as the right spice for a contemporary environment. The combination is always unexpected and often visually quite exciting as it adds a personal touch and some soul to the coolness of the modern."

For Kanafani, the attraction of opposites produces a sense of harmony: "Using a mix of various textures—such as wood, glass, leather, chrome—is essential to achieving a visual balance," she explains.

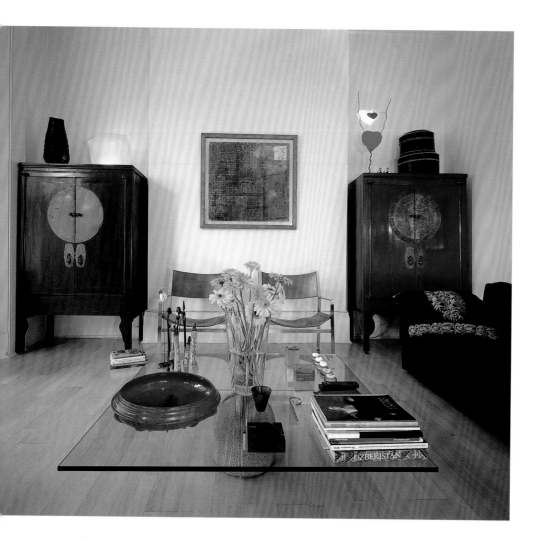

A pair of red and green Chinese wedding cabinets found in Belgium (left) fit perfectly into Lina Kanafani's living room alcoves. "Their colours are a source of warmth and add playfulness to the general ambience of the room," she explains. In practical terms, they are used to store the music system, speakers, CDs, books and magazines. For Kanafani, aesthetics is more important than value: "They may not be 'important' pieces as far as Chinese furniture is concerned, but they have perfectly achieved the effect I was after."

This reclining bamboo Chinese chair (right) was found in the Lebanon and transported back to London. It is the use of different textures in an interior, that is key to creating a visual balance, says Kanafani.

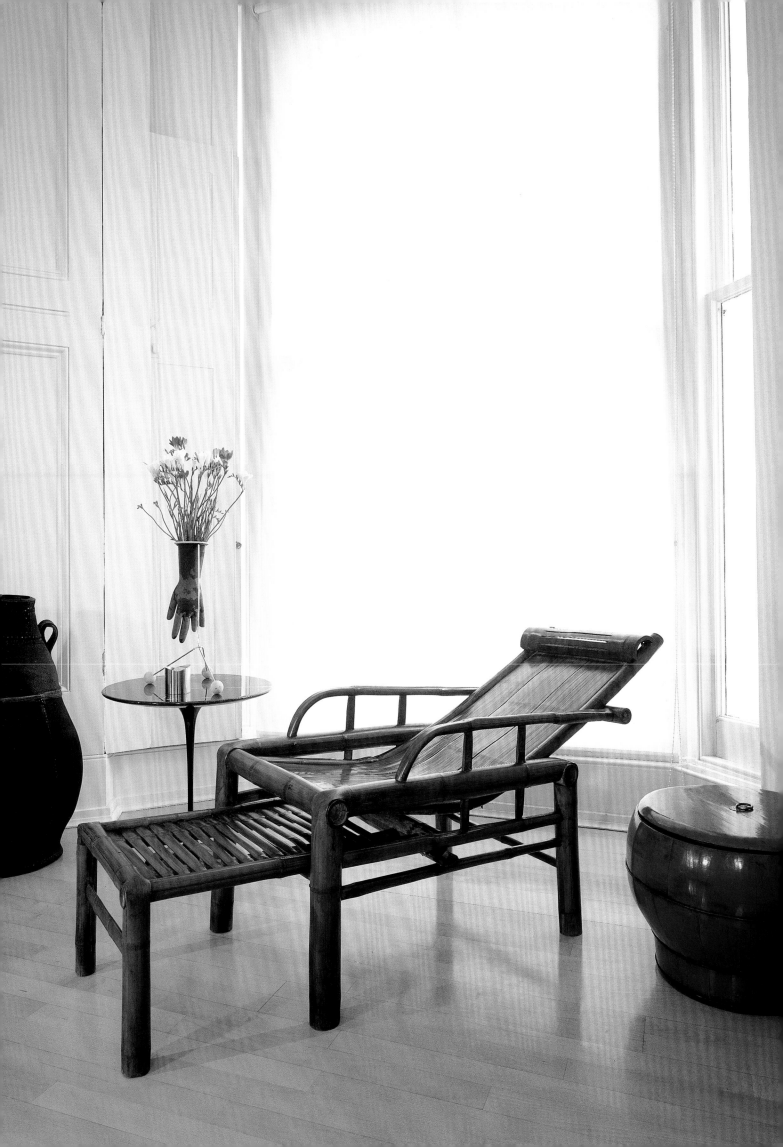

A Global Vision

Hong Kong-born and based architect Douglas Young has a global vision; he believes that Oriental culture offers valid alternatives to Western ideas. "People today have instant access to information and products from all around the world. Such cross currents have brought about a cultural exchange that enables the ancient wisdom of the East to be recognized in many parts of the world," he notes. "And what is interesting is that when Eastern and Western theories are pragmatically combined, the resulting 'fusion' is greater than the sum of its parts."

In his Mid-Levels home, Young has adhered to this global philosophy by sourcing a mix of antique and contemporary Chinese furniture and accessories, Japanese signature pieces (a George Nakashima bench and cabinet) and retro European furnishings (a 1950s marquetry screen by Jean Michel Frank, an early 20th-century nest of tables). He also patronizes local Hong Kong artists whom he believes should be supported by the buying public and has a wide collection of works including a huge acrylic canvas by Yank Wong in his living room.

Young has taken his message of cross-cultural Orientalism to a wider audience through his chain of contemporary homeware stores that celebrate local style. Called GOD (the phonetic translation means 'to live better' in Cantonese slang), the stores stock modern home furnishings with subtle Chinese and Asian characteristics. "In a world of diminishing borders and barriers, people would not want anything other than a global lifestyle," says Young. "Now they have access to the rest of the world they want a piece of the action, or risk missing out on so much."

Architect Douglas Young's decorative vision is one that is fast gaining a following among hip Hong Kongers. "I aim to find old Chinese things that look modern," he says. In his high-ceilinged living room (right), he displays a carpet found in a Hong Kong flea market with an antique bamboo cabinet and a vibrant acrylic canvas by artist Yank Wong. Furnishings include a retro style black leather chair and a contemporary cream sofa and ottoman. In the hallway, rear, is a George Nakashima bench.

Young favours natural materials: piles of old calligraphy books line tabletops, *zitan* and *huanghuali* wood brush pots fit neatly into wooden trays and old scrolls are crammed into a blue and white vase (above, detail).

The dining room (right) is separated from the open plan kitchen by a wide, head-height partition which incorporates shelves on the kitchen-facing side. Clean-lined wooden chairs covered in white canvas surround the wooden dining table. Displayed in a 1970s-designed shelf unit is Young's collection of antique and modern celadon and cream ceramics. From the ceiling hangs modern industrial-style lighting. To the right, an opaque glass panel allows light to flow into the space. On the table, ginger flowers, with their distinctive Oriental aroma, fill test tube jars housed in a metal box. Young's fusion of antique and modern Chinese, Japanese and European furnishings are testament to his commitment to global design.

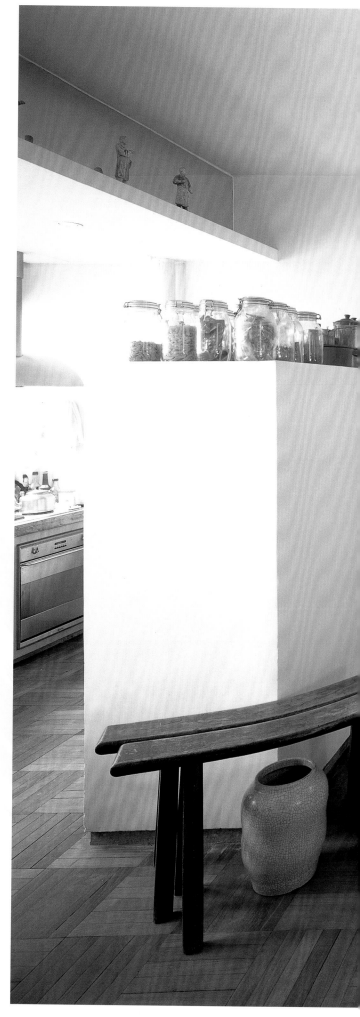

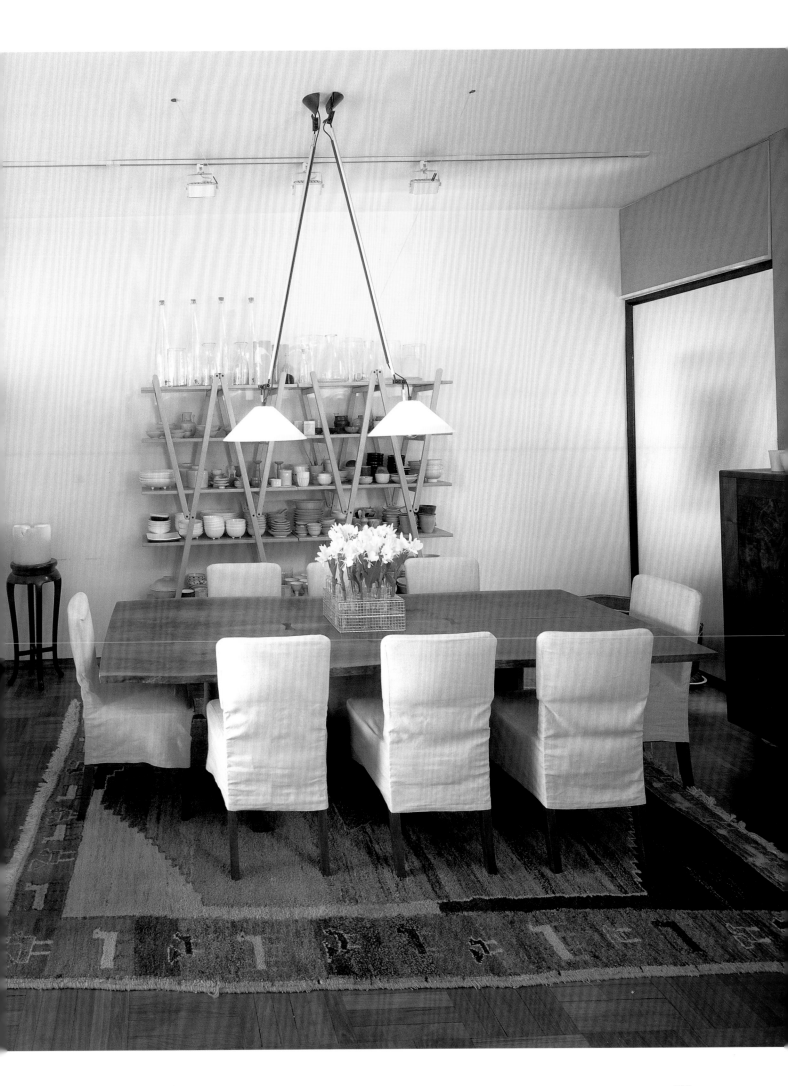

Decorating China Style

DESIGN IDEAS FOR CONTEMPORARY CHINESE-INSPIRED INTERIORS

China's rich and complex history has provided inspiration for a vast array of decorative motifs. From the ornate red and gold palette traditionally associated with Chinese style to the serene Orientalism favoured on the international scene today, designers the world over are coming up with varied interpretations of centuries-old ideas. And no more so than in the East: a new breed of globally aware China-based designers is proving the driving force behind the development of the genre. Whereas once they looked Westwards, they are now turning their attention closer to home and drawing on their creative roots to produce a new vocabulary of design that is exciting, innovative and energetic—and draws heavily on Chinese style.

Here we feature a visual array of Chinese furniture and decorative ideas, from highly collectable antiques to modern minimal interpretations of Chinese style. Materials are diverse, but tend to favour the natural. It's a veritable cornucopia of ideas: There are valuable hardwoods, tactile softwoods, stunning embroidered silks, finely crafted ceramics, hand-woven carpets with striking geometric designs, wallpapers, handpainted tiles, exotic lacquerware, and of course jades, bronzes and gemstones.

(Clockwise from top left): Two bone and bamboo-stemmed calligraphy brushes balance on a traditional doctor's pulse-pillow in the Shanghai home of Jean Philippe Weber. Linen napkins printed with miniature Chinese furniture motifs; from The Red Cabinet. Wool-knit and Chinese silk scatter cushions rest on a Victorian chaise longue in Eileen Bygrave's colourful Hong Kong apartment. From the Hong Merchant, old suitcases have contemporary appeal.

Ming and Qing Furniture

With its minimal lines, cubilinear shapes and predominant use of dark hardwoods, classic furniture is an increasingly popular choice for the home. Indeed, some of it looks so modern that it could have been designed today. Whilst only a few people can afford—or have the desire—to become collectors of rare Ming pieces, there are interesting items on the market from the later mid to late Qing dynasty that are more reasonably priced and have wide-ranging appeal.

Collectors such as Grace Wu Bruce (who has galleries in Hong Kong and London) and Kai-Yin Lo have chosen to live with classic Chinese furniture and in so doing offer valid directions for living with antiques. London-based Chinese art and antiques dealer Nicholas Grindley retails internationally and is an authority on the subject; another good source is Beagle Gallery in London. For something more decorative, Hong Kong's Chine Gallery run by Anwer and Zafar Islam stocks 18th- and 19th-century antique furniture from Shanxi Province, a landlocked area southwest of Beijing, renowned for its fine furniture-making traditions since the Tang and Song dynasties.

There are also many designers and retailers who offer reproduction pieces which are streamlined, sculptural and beautiful to live with. The Imix Club, based on Hong Kong's Hollywood Road antique district offers high quality Ming style furniture made of blackwood and burlwood. Says owner Kenneth Lee: "No production lines are present, each and every piece of furniture is hand-crafted with the utmost attention."

1. Classic recessed leg side table made of *ju mu* (southern elmwood). From Soochow, Jiangsu province, 18th century. Photo: Altfield Gallery. 2. Square corner cabinet covered in original red lacquer with gilt decoration of scrolling lotus design. From Shanxi province, 18th century. Photo: Altfield Gallery. 3. A Qing dynasty latticework window screen does double duty as a wallhanging above a traditional Chinese couch bed. Photo: Chine Gallery. 4. One of a pair of horseshoe backed armchairs made of *hong mu* (blackwood) with soft-strung cane seats. From Zhejiang province, 19th century. Photo: Altfield Gallery. 5. Scroll form Kang table, made of softwood with a lacquer finish. From Shanxi province, 19th century. Photo: Altfield Gallery. 6. A Ming-style, horseshoe backed armchair. Photo: Imix Club.
7. Traditional red silk lanterns hang from the ceiling and offset the collection of lacquered Qing dynasty furniture on display in Chine Gallery. Photo: Chine Gallery.

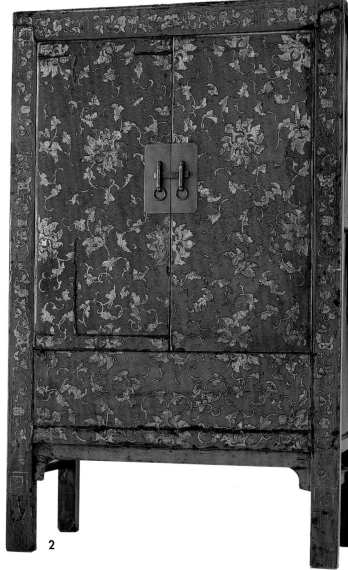

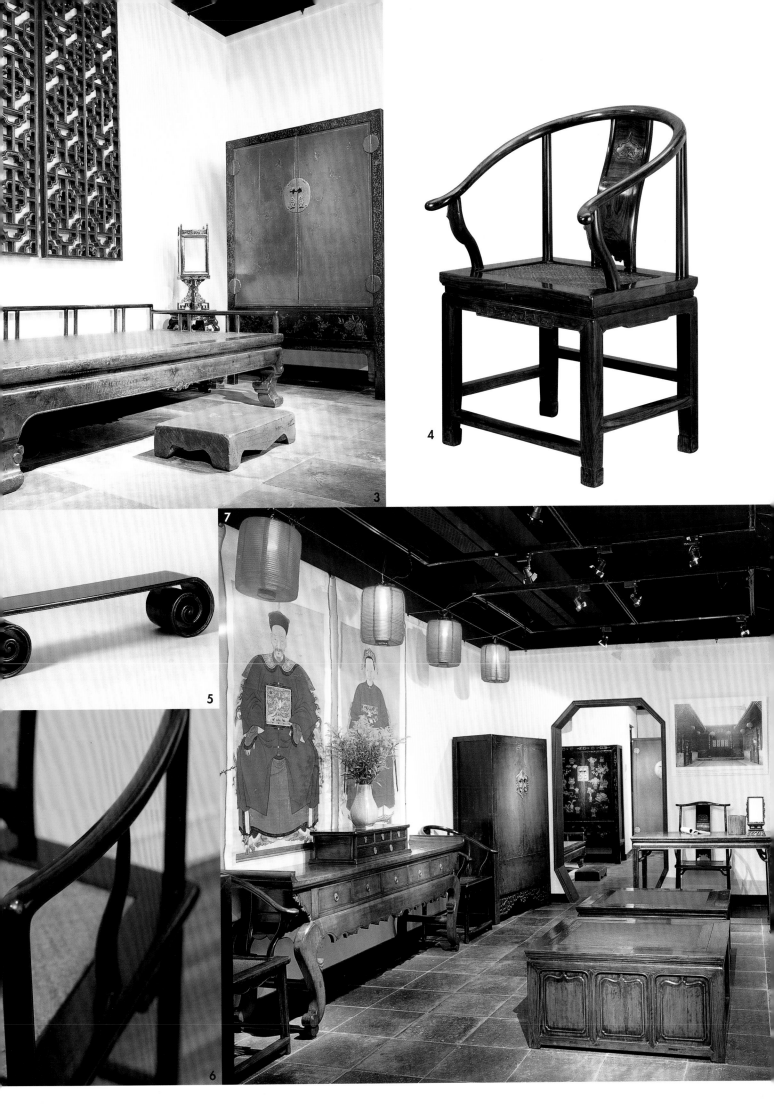

China Country Style

The chunky lines and strong shapes of country-style softwood furniture are a winning furnishing choice. The muted tones of cedar, camphor and elm woods exude a peaceful simplicity and work well in a contemporary interior. In Hong Kong, William Chiang, who co-runs leading antiques company China Art, displays natural 'raw' furniture against a backdrop of a minimal concrete floor and modern lighting. He is determined to bring the appeal of 'raw' Chinese pieces to the modern marketplace, and prefers to keep restoration to a minimum to bring out the beauty of the wood.

Bamboo furniture is also being reassessed for its aesthetic qualities. Light, strong, flexible and sustainable, beautiful bamboo has been used for centuries in China for furniture, baskets and floormats. China grows more than 400 species of bamboo, which symbolizes longevity and, according to feng shui, brings luck and prosperity to the home. Wooden furniture abstractly styled or carved like bamboo first appeared in the early part of the Qing dynasty (1644–1911) and reached the height of fashion during the Yongzheng (1723–1735) and Qianlong (1736–1795) periods where imitations of materials and finishes were practised throughout the decorative arts. Today's design-lovers use soft-edged bamboo furniture and accessories to bring natural warmth to an interior, and employ modern bamboo-print fabrics and wallcoverings to bring a touch of the outdoors inside.

1. Mid 19th-century *yu mu* medicine cabinet with red labels, China Art. 2. In the bathroom of her London home, Shirley Day has inserted a wash basin into an early 19th-century Chinese cabinet. 3. A collection of Chinese country hats and wickerware offsets the vibrant green walls in Sitwell House, Warwickshire, UK. 4. Traditional rice measuring baskets in their unfinished state at China Art in Hong Kong. 5. A chunky provincial style bamboo sofa makes an interesting endboard for a bed in Sitwell House. 6. A Kang table rests under sloping beams in this Tudor barn in Warwickshire, UK.

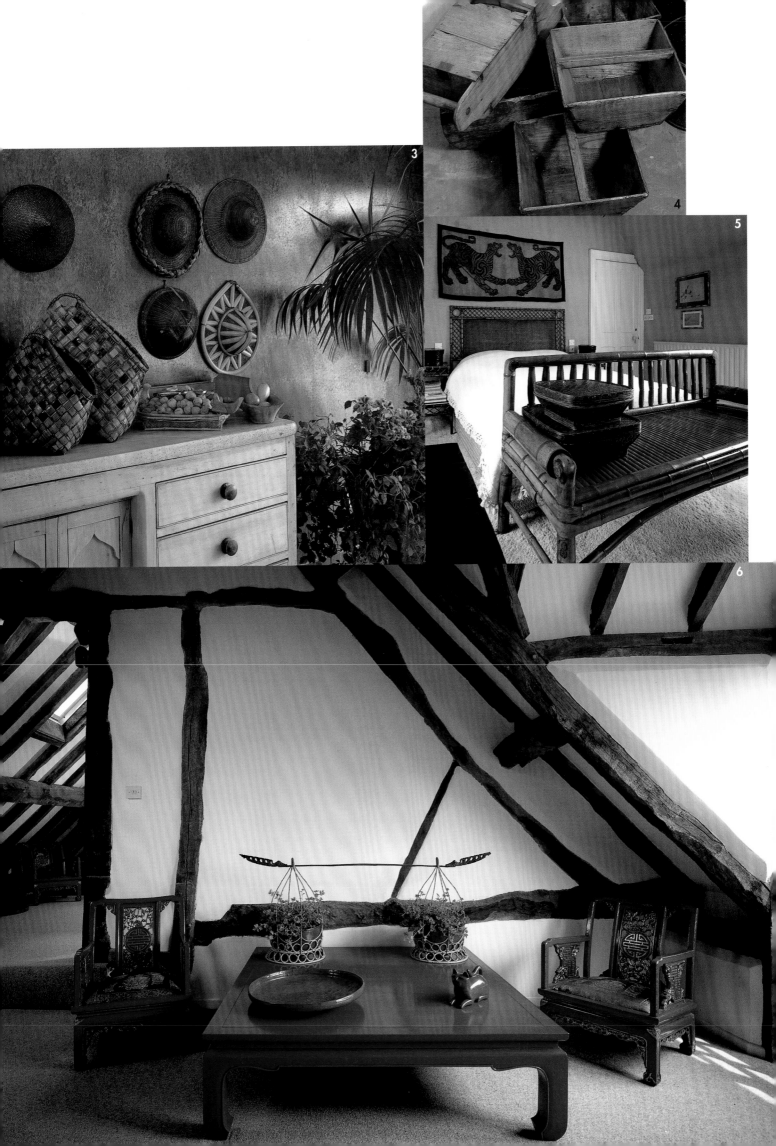

Accents and Accessories

Oriental accessories—both antique and contemporary—add Chinese accents to an interior without dominating the decorative scheme. Collectibles such as scholar's objects—the necessary accoutrements collected by Chinese scholars to help them study in style—are popular among connoisseurs who purchase high-end pieces through auctions, and with regular folk who scour antique stores and curio shops for interesting-looking items to display at home.

Wooden brushpots and boxes began to be made in the Ming dynasty (1368–1644) and such traditions continue today. A vast variety of materials was used for accessories such as porcelain and wood brushpots, jade brush handles, ivory seals, bamboo wrist rests, inkstones and boxes to store all these implements (scholars travelled frequently, so they needed to transport their beloved possessions). In Shanghai, Jean-Philippe Weber displays a wide selection of scholar's objects and other accessories (Qing hatboxes, opium pipes and paraphernalia, brushes, lamps and early 20th-century suitcases) in his home, which doubles as a showroom for his Hong Merchant furniture business. With outlets in Hong Kong and London, Altfield Gallery is also a good source of antique accessories.

Lacquerware trunks and boxes are also a popular decorative choice. Lacquer is a natural substance, a sap obtained from the lacquer tree *Rhus vernicifera*, native to China, which is still a world leader in lacquer resources. Layers of lacquer are applied usually to a wood base, each being allowed to dry before it is polished and another coat applied. The resultant hard shiny surface can be either unadorned or beautifully carved. Many examples of deep red (cinnabar) lacquer bowls, trays and boxes date from the Ming dynasty.

1. Seals and brushes, once used by Chinese scholars, make interesting decorative displays. 2. Modern porcelain tableware is based on traditional Chinese designs. 3. A collection of 19th-century turtleshell and ivory opium pipes and cleaning instruments on display in the Hong Merchant, Shanghai.
4. 18th-and 19th-century-brushpots made of *huanghuali*, *hong mu* and bamboo, to hold calligraphy brushes. Photo: Altfield Gallery. 5. Furniture collector Kai-Yin Lo's miniature ivory table, with pieces of carved coral. 6. Calligraphy print napkins fastened with a napkin ring in the form of a traditional Chinese knot. From The Red Cabinet. 7. Silver-tipped chopsticks and chopsticks rests. Photos 2 and 7: Andrew Chester Ong/ Esther van Wijck, courtesy of *ELLE Decoration* Hong Kong.

Handwoven Carpets

Handwoven carpets with striking designs are the perfect addition to modern urban interiors. The art of weaving in China dates back to the 13th century where rugs were knotted by nomadic tribes and used for both decorative and functional purposes. Today, they come in many forms, styles and price brackets: the main regions of production are in the north of China, from the provinces of Ningxia and Xinjiang, and also the city of Baotou in Inner Mongolia. Carpets from Tibet were traditionally used for sitting and sleeping on, to meditate on, to use as door and window covers as well as for saddle cloths and horse blankets. Their intricate yet highly stylized patterns appeal to the modern aesthetic with designs being either geometric or pictorial, often incorporating Buddhist and Taoist symbols or animals such as dragons, phoenixes and tigers.

Abstract designs—often found in rugs from Tibet and Xinjiang—work particularly well in a contemporary environment. Hong Kong galleries such as Zee Stone and Plum Blossoms offer a good selection of Tibetan rugs of all shapes, styles and sizes but such items are also widely available internationally. Most of the Tibetan carpets on the market today date to the 19th and 20th centuries; older rugs can be identified by their exclusive use of vegetable dyes. For the contemporary touch, Hong Kong based artists Brad Davis and Janis Provisor of Fort Street Studio have come up with a collection of totally modern, totally luxurious wild silk carpet designs inspired by Chinese calligraphy, woodgrain and nature related motifs. Also available through David Gill in London, Joyce in Paris and through Stark Carpet in New York, Fort Street Studio's carpets push traditional weaving techniques to new limits with their subtle hues, unexpected colour combinations and painterly effects.

1. Square seat temple rug with crossed *dorjie* design once used by monks whilst chanting or worshipping. Woven in Baotou, Inner Mongolia, 19th century. Photo: Altfield Gallery. 2. Chinese painting carpet blends old weaving techniques with contemporary brush strokes and colour combinations. Photo: Fort Street Studio. 3. Checkerboard rug from Tibet, woven with thick local wools and using natural dyes, 19th century. Photo: Altfield Gallery. 4 and 5. Temple pillar rugs woven in Ningshia and Baotou in the late 18th to early 19th century; these would be wound around a supporting pillar so the body of the dragon joins up. Photos: Altfield Gallery. 6. Graphically strong Chinese carpets make striking additions to contemporary interiors, as seen here in the London home of Shirley Day. 7. 'Woodgrain' carpet by Fort Street Studio made of hand-knotted wild Dandong silk.

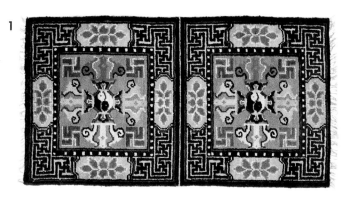

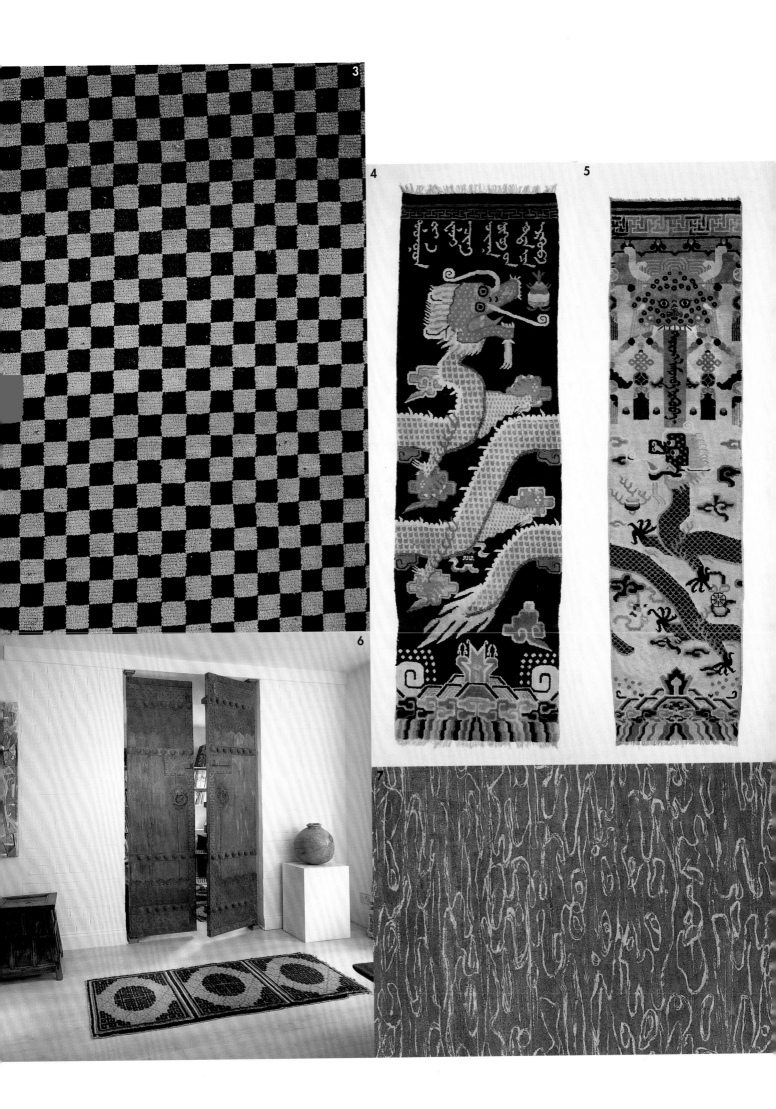

Tableware and Ceramics

The Chinese have always been masters of the ceramic arts and their influence has had a huge impact on design world-wide. From the Tang dynasty's (618–907) bold multi-coloured pottery (known as *sancai*, or three-colour lead glaze) to the monochrome wares of the Song dynasty (960–1279) with serene ivories, celadons and duck egg blues, such elegance endures. Ming dynasty (1368–1644) fine blue and white porcelains are instantly recognizable today as are Qing dynasty (1644–1911) delicate *famille rose* (pink), *famille verte* (green) and *famille noir* (black) and *sang de boeuf* (oxblood red), which were produced for domestic and export use. The choice for the consumer is vast; from collectable antiques to reproduction ceramics to pared-down interpretations designed for the modern home.

For the classical look, Altfield Gallery in Hong Kong and London produces antique finish porcelain following traditional manufacturing techniques from the Ming and Qing dynasties. The pieces are all hand-glazed and show the depth, texture and occasional inconsistencies of glaze often associated with antiques. David Leung, Milan-based fashion designer and owner of contemporary Hong Kong homeware store Graham 32, has come up with a 'Monochromatic Porcelain' tableware collection based on Jingdezhen ceramics. (Jingdezhen was the centre of Imperial porcelain production for over a thousand years.) Clarissa Wong of The Red Cabinet has sourced minimalist elegantly simple pure white china teapots and teacups—tea may have been introduced to Europe in the early 17th century but has been part of Chinese life since the earliest of times. And Douglas Young of GOD, designs contemporary collections of pared-down Oriental-style ceramics, which are simple, practical and useful.

1. Blue and white underglazed pot with lid from the Kangshi period (second half of the 17th century). Photo: Altfield Gallery. 2. Time for some jasmine tea using The Red Cabinet's minimal, all-white teaware. Served on an elmwood tray. 3. Imperial porcelain techniques from Jingdezhen, China, have been used to produce a contemporary collection of bold blue tableware. Photo: Graham 32. 4. In architect John Chan's Peak home, the table is set with decorative orange and gold teacups and saucers. 5. A collection of 17th-century blue Kangxi monochrome ceramics is displayed in Grace Wu Bruce's apartment. Their pure, simple shapes are typical of the period. 6. Kai-Yin Lo designed a side table based on an illustration in a 19th-century tile. The tile was then used for the tabletop.

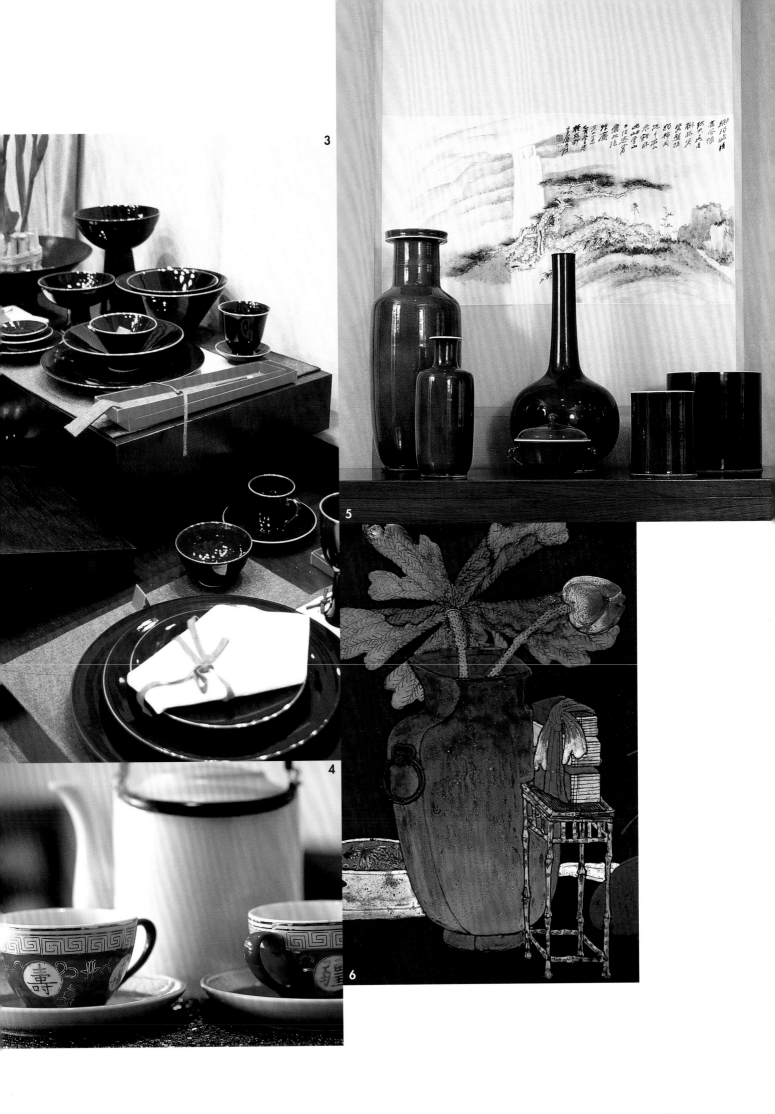

Silks and Textiles

Superb silk embroideries from China have been famous since Roman times. Silk first came to the West along the trade route known as the Silk Road—so termed because China exported so much of this fabric to the West—which linked the Roman Empire with the Imperial court of China. By the 18th century, Europeans couldn't get enough of the colourful embroidered silks featuring dragons, phoenixes and flowers. Little has changed today, with vivid Chinese-inspired silks cropping up in everything from clothes, shoes and bags to curtains, floor cushions and bedding.

Antique silk shawls and throws, noted for their highly detailed stitching and vibrant colours, are ultra collectable.

Chinoiserie style fabrics are also popular: for example, French textile company Pierre Frey produces contemporary collections based on 18th-century handpainted silks. Shanghai-based designer Wan Pierce takes traditional motifs and hand embroiders them onto fabrics such as cashmere, goatskin and silk linens producing a range of luxurious cushions under the label "zayu", which in Tibetan means 'dwelling with intelligent people'. And for everyday use, Clarissa Wong of The Red Cabinet retails linen napkins printed with miniature Chinese furniture motifs, and imprints bold red and purple cushions with longevity symbols.

1. Luxurious goatskin and cashmere cushions with dragon and floral motif by Zayu. 2. Silk panel woven in the Kossu or slit-technique during the 18th century. Photo: Altfield Gallery. 3. Detail of an antique Chinese textile found in a trunk in Calke Abbey, England. 4. Chinese characters and symbols prove valid direction for modern fabric designs. Kanji fabric from Scalamandre's Road to Cathay Collection. Photo: Altfield Interiors. 5. Nine dragon robe (chi'fu); the decoration is embroidered onto the blue silk fabric, late 18th century/early 19th century. Photo: Altfield Gallery. 6. Detail of a delicately embroidered 1920s-made Chinese export shawl owned by Louise Kou. 7. Pearl Lam used an 18th-century Chinese silk shawl to upholster a Throne Chair by Mark Brazier-Jones.

Contemporary Touches

The clean, classical lines of Chinese furniture have been embraced by modern furniture and homeware designers who blend Eastern accents with a minimal design ethos. Such collections bring a touch of tranquil Oriental style to modern, urban living. Ideas such as low level seating and multifunctional furniture appeal to contemporary sensibilities, as do luxurious materials such as exotic hardwoods, leather, suede and nickel. London-based architect Spencer Fung produces innovative furniture collections which draw on his Chinese roots. "My heritage clearly creates the serenity in my work," he explains. "There is a calm order to it." Fung also retails through Pucci in New York and to date, his sober yet elegant furniture includes the Chi cube lamp; the Zen coffee table, the Lotus stool and the Java bench.

In Hong Kong, architect and retailer Douglas Young of GOD offers an extensive range of Asian-inspired homeware that has proved a big hit with hip urbanites. His collections celebrate regional identity by allowing subtle Chinese identities to show through. Architect Johnny Li also draws on his Chinese heritage by producing a collection of custom-made furniture which is inspired by traditional architecture. He adds a modern twist by using modern materials such as cherrywood, maple, stainless steel and Perspex. In Shanghai, homeware store Simply Life offers functional, simple homeware that is "slightly Oriental but not overtly so" and in London, Lina Kanafani of interior store 'mint' prefers to mix ethnic pieces with modern classics and new designs to add a touch of spice to a contemporary interior.

1. Modern designs with tranquil Chinese accents define furniture such as the 'Zen' coffee table by Hong Kong-born, London-based architect Spencer Fung. Photo: Spencer Fung Architects. 2. A mahjong table for the modern home by architect Douglas Young. Photo: GOD. 3. The 'Chi' lamp was inspired by the familiar cubilinear shapes of traditional Chinese furniture. Photo: Spencer Fung Architects. 4. Revamping old ideas using modern materials: a circular neck pillow is covered with woven rattan and a small pillow is covered with wooden beads in a new take on the ubiquitous beaded seat covers much loved by Hong Kong taxi drivers. Photo: GOD. 5. Rice filled neck pillows have long been used for nighttime comfort. GOD reinvents them in vivid pink and purple silk. Photo: GOD. 6. The Java Collection of outdoor furniture by Spencer Fung. Photo: Spencer Fung Architects. 7. Chinese style goes sci-fi: the Lotus Stool uses ultra-modern materials but is inspired by traditional designs. Photo: Spencer Fung Architects.

3

4

5

6

7

Decorative Motifs

Auspicious symbols are an integral part of Chinese decorative taste and adorn everything from furniture to porcelain to lacquerware to textiles. In traditional Chinese society, bad spirits were thought to abound and so every item was decorated with such symbols to ward off evil. In her book, *Classical and Vernacular Chinese Furniture in the Living Environment*, collector and scholar Kai-Yin Lo notes that auspicious symbols were also a common visual vocabulary in traditional China, more readily understandable than writing as the majority of the population was illiterate.

Symbolism has been used for centuries but it was heavily used towards the end of the Qing dynasty with its associated political uncertainties in a bid to enhance the chances of good health, longevity and a peaceful life.

Among the most common symbols are the dragon, which symbolizes the *yang* (male) energy, and the phoenix, which represents the *yin* (female) force. The fish signifies abundance and wealth; peach blossom symbolizes spring, marriage and immortality; peace is represented by vases; and the butterfly, the bamboo, the sacred fungus *lingzhi* and the persimmon tree, are all symbols of longevity. The persimmon, says Kai-Yin Lo, is one of the earliest plant motifs in China, dating back more than 1,800 years to the Han dynasty. Whilst interesting for their visual merits alone, a knowledge of the stories behind the symbols adds to the appreciation of Chinese antiques. Contemporary designs continue to feature auspicious motifs and can be found in almost every area of home furnishings.

1. Ornate carved and gilded panels are a common feature in Peranakan houses. 2. Bamboo horseshoe backed armchair with solid wood lacquered seat from Shanxi province. Behind it is a reproduction Japanese bamboo motif screen. Photo: Altfield Gallery. 3. An early 20th-century turquoise ceramic garden stool is used by architect John Chan as side tables. 4. A *lingzhi* fungus motif is carved into a Ming dynasty 6-post canopy bed at the Asian Civilisations Museum, Singapore. 5. A gilded bat is carved into a window frame in the Baba and Nyonya Heritage Museum, Malacca. 6. A late 19th-century Chinese export fan with painting on a black lacquer, gilt decorated frame. Photo: Altfield Gallery. 7. Gilded and painted standing screen, leather on wood, with lacquered finish. From Quandong province, 20th century. Photo: Altfield Gallery.

Acknowledgements

AB Concept
G/F, 31 Wing Fung Street, Hong Kong.
Tel (852) 2526 7226; fax 2526 8969
info@abconcept.com.hk

Altfield Gallery
248–9 Prince's Building, Hong Kong.
Tel (852) 2537 6370; fax 2525 8751
www.altfield.com

Altfield Gallery
Unit 2–22, Chelsea Harbour Design
Centre, London SW10 0XE, UK.
Tel (020) 7351 5893; fax 7376 5667

Baba and Nyonya Heritage Museum
48 & 50, Jalan Tun Tan Cheng Lock
75200 Malacca, Malaysia.
Tel and fax (60 206) 283 1273

BAM-BOU Restaurant
1 Percy Street, London W1P 0ET, UK.
Tel (020) 7323 9130; fax 7323 9140
www.bam-bou.co.uk

Beagle Gallery
303 Westbourne Grove,
London W11, UK.
Tel (020) 7229 9524; fax 7792 0333

Grace Wu Bruce
701 Universal Trade Centre
3 Arbuthnot Road, Hong Kong.
Tel (852) 2537 1288; fax 2537 0213
also at:
12A Balfour Mews,
London W1Y 5RJ, UK.
Tel (020) 7499 3750; fax 7491 3896

John Chan Design
5/F, Worldwide Commercial Building,
34 Wyndham Street, Hong Kong.
Tel (852) 2521 0050; fax 2526 7425

China Art
G/F, 15 Hollywood Roa, Hong Kong.
Tel (852) 2542 0982; fax 2854 1709
www.chinaart.com.hk

The China Club
13/F, The Old Bank of China Building,
Bank Street, Hong Kong.
Tel (852) 2521 8888; fax 2522 6611

Chine Gallery
42A Hollywood Road, Hong Kong.
Tel (852) 2543 0023; fax 2850 4740
www.chinegallery.com

Contrasts Gallery
Suite 2306–2309, Jardine House,
1 Connaught Place, Hong Kong.
Tel (852) 2826 9162; fax 2801 4457

The Design Association Inc
Mego Decoration (China) Ltd.
1801 Times Square
93 Huai Hai Zhong Lu
Shanghai 200021, China.
Tel (8621) 6391 0282;
fax 5351 1589
design_ken@yahoo.com

Dialogue
501 Yu Yuet Lai Building,
43–55 Wyndham Street, Hong Kong.
Tel (852) 2521 4002; fax 2521 4141
dialogue@asiaonline.net

Fort Street Studio
Harbour Industrial Centre,
4th Fl, No. 16,
10 Lee Hing Street, Hong Kong.
Tel (852) 2889 5150; fax 2508 1457
fortss@glink.net.hk
also at:
David Gill
60 Fulham Rd, London SW3 6HH, UK.
Tel (020) 7589 5946
Joyce
Jardins du Palais Royal,
9 Rue de Valois, 75001 Paris, France.
Tel (331) 4015 0372
Starck Carpet
979 Third Avenue,
New York, NY 10022, USA.
Tel (212) 752 9000

Face Restaurant
#4 Building, 118 Ruijin Er Lu,
Ruijin Guest House,
Shanghai 200020, China.
Tel (86 21) 6466 4328;
fax 6415 8913
lanna@uninet.com.cn

Spencer Fung Architects
3 Pine Mews, London NW10 3JA, UK.
Tel (020) 8960 9883; fax 8960 9889
mail@spencerfung.co.uk

Graham 32
32 Graham Street, Hong Kong.
Tel (852) 2815 5188; fax 2815 5318
www.graham32.com

Nicholas Grindley
13 Old Burlington Street,
London W1X 1LA, UK.
Tel (020) 7437 5449; fax 7494 2446

The Hong Merchant
No. 3, Lane 372, Xing Guo Lu,
Shanghai 200052, China.
Tel (86 21) 6283 2696;
fax 6283 9721
jpweber@uninet.com.cn

Kelly Hoppen Interiors
2 Munden Street, London W14, UK.
Tel (020) 7471 3350; fax 7471 3351

The Imix Club
Shop 4, G/F,
Chinachem Hollywood Centre,
1–13 Hollywood Road, Hong Kong.
Tel (852) 2559 0945; fax 2559 0156
www.theimixclub.com

Jonkers Restaurant
17 Jalan Hang Jebat,
Malacca, Malaysia.
Tel and fax (60 206) 383 5578

Minneapolis Institute of Arts
2400 Third Avenue South
Minneapolis, Minnesota 55404, USA.
Tel (612) 870 3200
www.artsmia.org

Mint
70 Wigmore Street,
London W1H 2SF, UK.
Tel (020) 7224 4406; fax 7224 4407

Caroline Ma
3C, 345 Tai Hang Road, Hong Kong.
Tel (852) 9027 2332; fax 2893 4061
carma@netvigator.com

Nail Assemblage Int'l
409, Yu Yuet Lai Bldg,
43–55 Wyndham Street, Hong Kong.
Tel (852) 2526 8326; fax 2234 9139
nail@netvigator.com

Nube
58 Tai Cang Lu,
Shanghai 200021, China.
Tel (86 21) 5383 8788;
fax 5383 8988
nube@nubedesign.com
www.nubedesign.com

Paxton Locher Architects
10 St Georges Mews,
London NW1 8XE, UK.
Tel (020) 7586 6161; fax 7586 7271
mail@paxtonlocherarchitects.com

Plum Blossoms
Shop 6, G/F Chinachem Hollywood
Center, 1 Hollywood Road,
Central, Hong Kong.
Tel (852) 2521 2189

The Red Cabinet
Shop 5, Chinachem Hollywood Centre,
1–13 Hollywood Road, Hong Kong.
Tel (852) 2536 0123; fax 2536 0212
www.red-cabinet.com

The Red River Company
5 Tung Fai Garden,
17 Po Yan Street, Hong Kong.
Tel (852) 2559 7799; fax 2559 7699
wan@the-red-river-company.com

Simply Life
9 Dong Ping Road,
Shanghai 200031, China.
Tel (86 21) 3406 0509;
fax 5456 0972
www.simplylife-sh.com

Alexander Stuart Designs
5/F, 15B Wellington St, Hong Kong.
Tel 2526 6155; fax 2548 9410
alec@stuart.com.hk

Hotel Tugu
Jalan Pantai Batu Bolong,
Desa Canggu, Bali, Indonesia.
Tel (62 361) 731 701/3;
fax 731 704
bali@tuguhotels.com

Xin Ji Shi Restaurant
Xin Tian Di Plaza, No. 9 169 Long Tai
Cang Road, Shanghai, China.
Tel (86 21) 6336 4746;
fax 6336 8474

Young Associates/GOD Ltd
48 Hollywood Road, Hong Kong.
Tel (852) 2544 5615; fax 2543 9337
info@god.com.hk
www.god.com.hk

Yin Expressions Ltd
702–703, 39 Wellington Street,
Hong Kong.
Tel (852) 2773 6009; fax 2773 6211
kaiyinlo@netvigator.com

Zee Stone Gallery
G/F, Yu Yuet Lai Building,
43–55 Wyndham Street, Hong Kong.
Tel (852) 2810 5895; fax 2522 4750
www.zeestone.com

Thanks go to all the designers, shops
and galleries listed here and also to all
the people who kindly allowed us into
their homes during the production of this
book. In addition, extra thanks go to the
following people for their support:

In Hong Kong: Douglas Young and
Angy Heng of GOD; Kavita Daswani;
Brad Davis and Janis Provisor of Fort
Street Studio; Amanda Clark of Altfield.

In Shanghai: David and Wan Pierce;
Sam, Chris and Maya Torrins; Michelle
Garnaut and Bruno Van Der Burg of
M on the Bund.